EVERLASTINGS

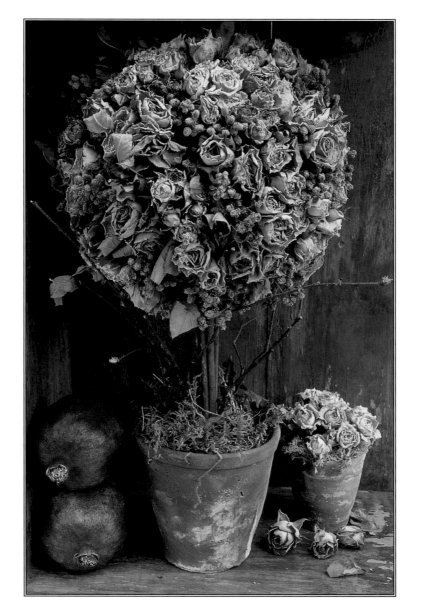

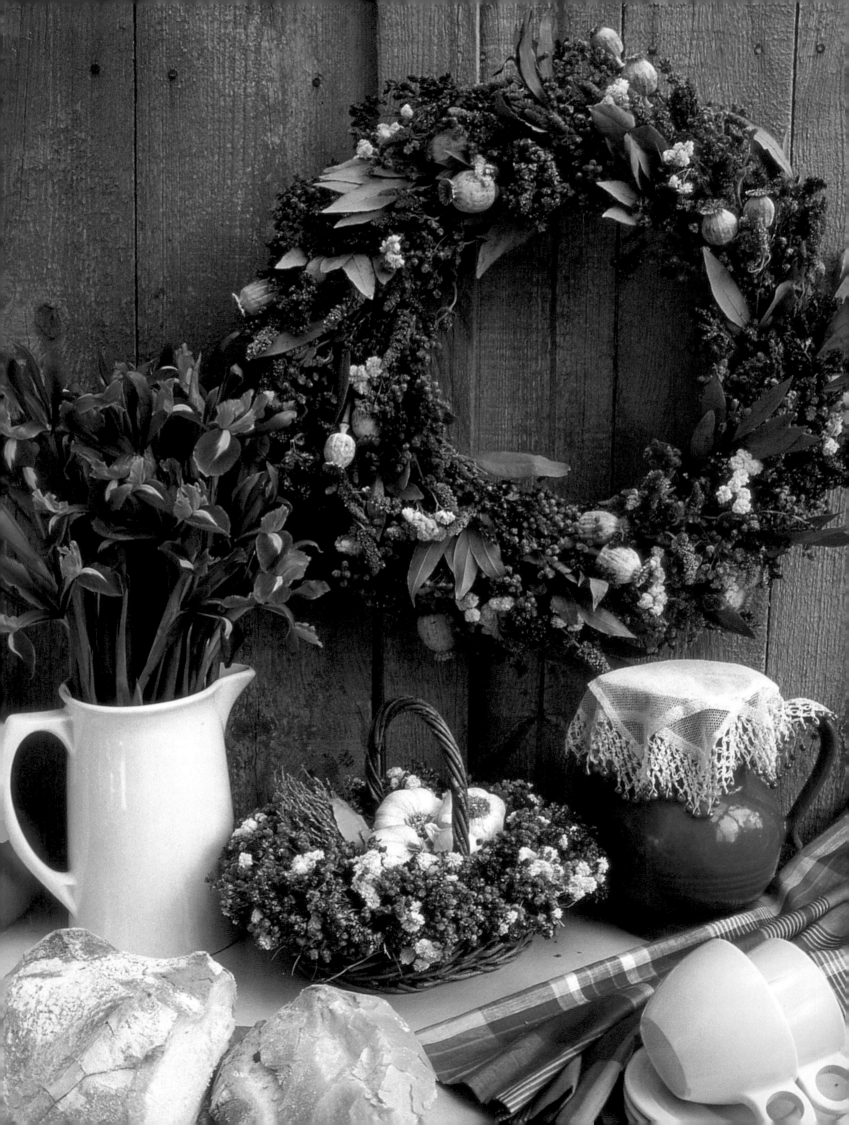

EVERLASTINGS

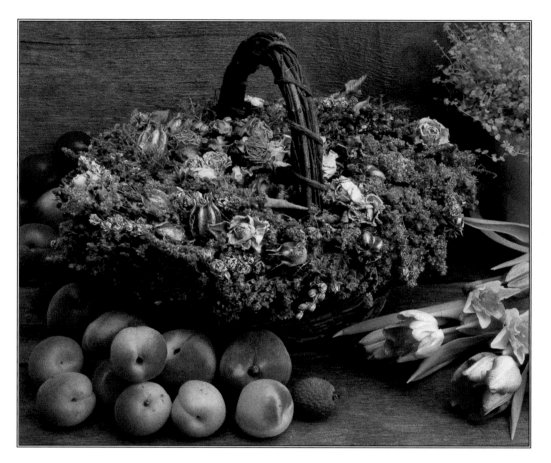

natural displays with dried flowers

TERENCE MOORE

PHOTOGRAPHY BY

MICHELLE GARRETT

HERMES HOUSE

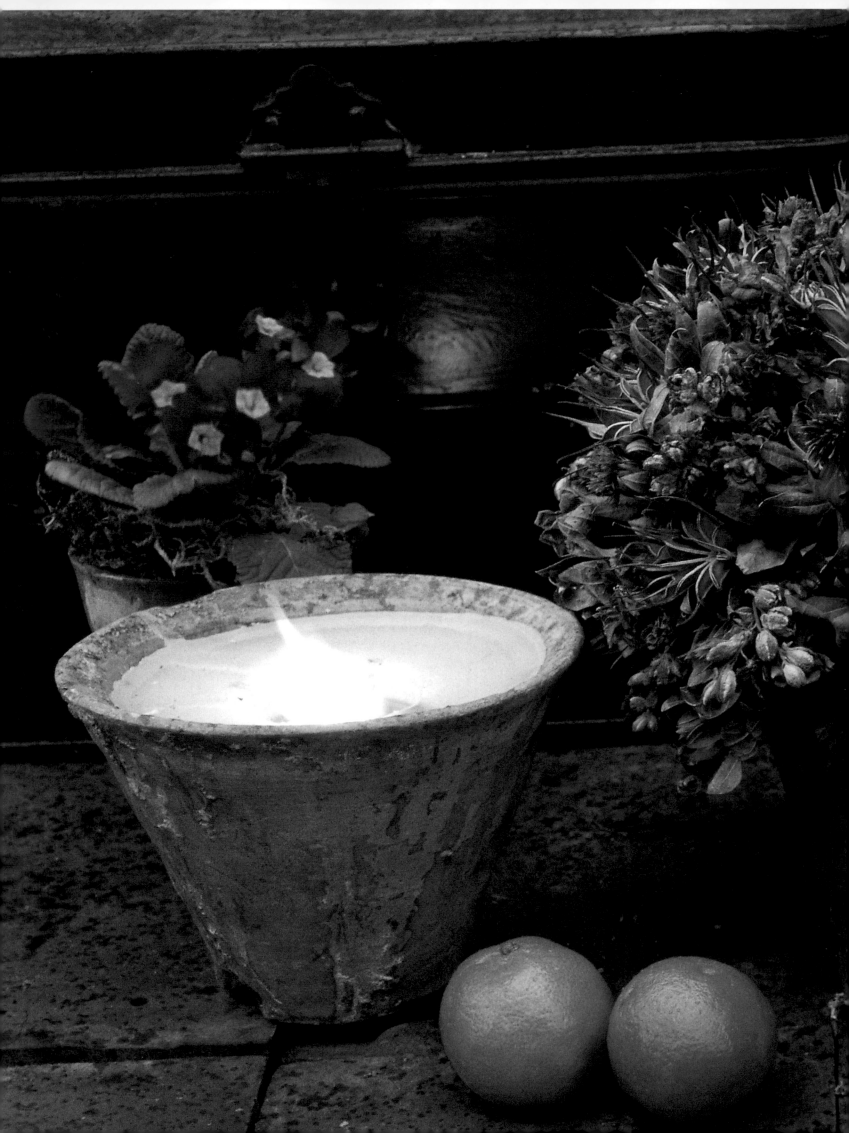

INTRODUCTION

By using flowers, mosses, leaves, grasses, fungi, fir cones, nuts and fruits, seashells, starfish and a wealth of innovative dried materials, you can create stunning and individual floral decorations. The following pages guide you through the types of material available and the equipment and techniques you will need to make beautiful arrangements for yourself and others.

Right: Make an unusual garland with nuts and fir cones, for a festive setting.

Below: The most simple pot of roses makes an eye-catching display using the colours of your choice.

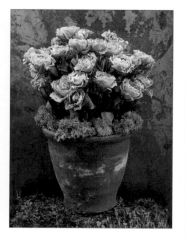

BEING CREATIVE

Over the past few years, an enormous range of high-quality dried material has become widely available in florists' shops. It is now possible to buy exotic dried fruits from the Far East alongside traditional home-grown dried flowers such as roses, solidago and lavender. The availability of so much inspiring material has completely transformed the old image of dried arrangements, and wonderfully innovative displays can be seen in both modern and country interiors.

To help keep the costs down you can dry some of the materials yourself. The simplest method is to air-dry flowers and foliage by hanging them upside-down in bunches, loosely wrapped in open-ended paper, in a warm, dry place. This technique works for most plants but some, such as ferns, become very brittle.

As well as the bewildering choice of home-produced and exotic materials available from florists, you can also collect a great deal of useful material yourself on a woodland walk or on a beach. Autumn especially is a good time to find woodland treasures in lovely rich gold and earthy-brown colours. Fungi, twigs, fir cones, driftwood, seashells and seed pods have interesting shapes and textures which you can use in many displays, with or without flowers. Red chillies, now readily available in supermarkets, add a vivid splash of colour to a Christmas display and can even be used on their own for a bold, modern look.

Most materials are used dried, except for green moss, twigs and branches such as blue pine (spruce). These are much easier to work with fresh and they will dry out naturally in the display. If you are making a display which you know is not intended to last, for a special occasion such as a swag for a large party or wedding, you can use fresh green foliage.

Right: Fill a tall basket with long, draping flowers for an attractive overflowing look.

Below: Adorn candle pots with perfumed dried flowers.

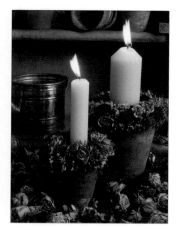

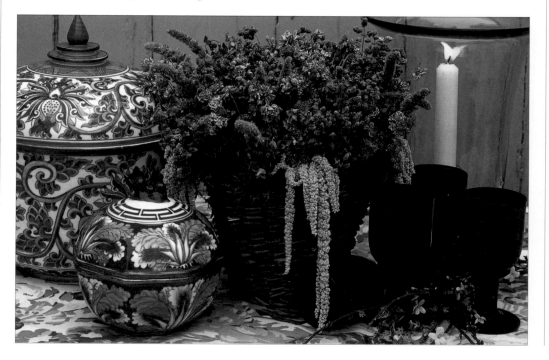

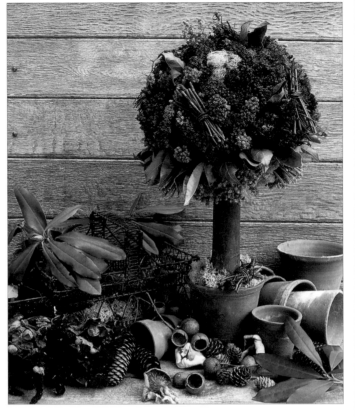

DESIGNING

You often require more material than you think for a display, so it is a good idea to start with a small project first. As you begin to learn some techniques and you gain confidence with them, you can tackle some more ambitious displays using more expensive materials. Plenty of space is needed in which to work, when you are making large projects, so that you can lay out your materials around you.

Feel free to adapt the materials listed for each project and don't be afraid to experiment; you will soon find the confidence to create your own individual displays which exactly suit the position they are intended for.

A major innovation in dried flower arranging in recent years is the glue gun. This is a vital piece of equipment, enabling you to assemble dried materials quickly and easily. Several designs are created entirely by this method, others employ a mixture of techniques.

DEVELOPING SKILLS

Take the time to master the basic skills described in the Techniques section, and refer back to them when they are mentioned in a project. Give yourself time also to read the instructions for the project thoroughly. As you work, clear away all the cut-off stems and other waste material so that you can stand back frequently and look at your design in progress. View it from different angles, thinking about the visual relationships of colour, shape, height and texture. It is very easy to keep adding material while losing sight of the overall plan.

Aim to build up a display so that delicate flowers such as roses and peonies are added last, reducing the risk of damaging the flowerheads. Try, if possible, to complete a display in one day; it is often hard to go back to it without changing course slightly. Once you have finished a display, it is best not to rework it any more than you have to in case you spoil its initial freshness and vitality. Knowing when to leave a display alone is a skill that soon comes with practice.

If you are new to arranging, there are plenty of simple, straightforward projects to start with which will help you acquire a good range of skills before moving on to more ambitious displays. Once you have gained confidence with your tools and the basic techniques, you will be able to design and create your own personal works of art from the wonderful variety of dried materials ready to inspire you. All you really need to create a long-lasting display that you can be proud of is the courage to plunge in and make a start.

Above: Baskets can be filled with almost any material, from a collection of exotic flowers to the most simple mossing.

Top left: Dried herbs combine attractively with flowers to create some of the most striking topiary designs.

Above: Terracotta pots, dried flowers and raffia make a rustic and welcoming swag.

9

MATERIALS

· · ·

The range of dried flowers and materials is enormous and your local florist will be able to advise you.

BUYING MATERIALS
There are a few general rules to bear in mind when selecting materials. Make sure the stock is bright in colour and not too brittle. Check the flowers for moth damage, especially roses and peonies. Look inside the flowers for grubs or eggs. All dried flowers will lose some material when handled, but avoid any that drop a lot of petals.

If shop-bought flowers have dried out, hang them in a moist room such as the kitchen or bathroom for a day or two to absorb some moisture and make them much easier to work with. Don't leave them longer or they may become too damp and start to rot. If they feel too soft after a couple of days, reverse the process by placing them in a dry, warm airing cupboard.

USING FRESH MATERIALS
Branches, twigs and moss can be used fresh, in fact they are much easier to work with when a little damp. Displays using these items must be left in a warm, dry place to dry out.

DRYING MATERIALS
Air-drying is the easiest and most successful method, in a place with a constant flow of warm, dry air, such as an airing cupboard or a space above a slow-burning oven. Dry woody items on a wire rack; they may take some time. Flowers can be tied and hung upside-down and will take much less time. If the drying space is light, cover or wrap the materials with newspaper, making sure that air can still circulate around them. Experiment – even daffodils can be dried, producing wonderful results.

Ambrosina has a strong and attractive scent that is wonderful to work with.

ACHILLEA FILIPENDULINA
(Golden yarrow)
This mustard-yellow plant has been a favourite for many years. The large heads fill spaces quickly in any large, country-style arrangement. They are easy to keep dust-free.

ACHILLEA PTARMICA
Clusters of small, bright white flowers on dark green stems. Use with care; the bright white tends to stand out when combined with other materials. They have a very long life but need to be kept away from damp or the white will turn to pale brown very quickly.

ALCHEMILLA MOLLIS
(Lady's mantle)
This is a beautiful material to use; it can be added to all types of displays and gives a soft feel. However, in time, the colour will fade to a soft yellow-brown. Take care when using, as it tends to break quite readily. Alchemilla is very easy to grow.

AMARANTHUS
(Love-lies-bleeding)
Most commonly seen either in natural dark green or dyed dark red. May be long and upright, but also available as a long, soft tail. Be selective when choosing bunches; their thickness and length vary tremendously. For small display work, use the thinner variety. *Amaranthus caudatus* is particularly attractive and has a pale green colour.

AMBROSINA
Widely available in two versions, short and long, this is a pale green plant. As with all green material, avoid strong light. In a centrally heated house it will dry out and become very fragile, so keep it away from the heat.

ANAPHALIS MARGARITACEA
(Pearl everlasting)
A fluffy white flower that is extremely easy to grow. The flowers dry in the garden on the stem. Make sure you pick them before they go to seed, or you will have a room full of fluff.

BUPLEURUM GRIFFITHII
This green plant is a useful filler. Care needs to be taken when using it in light conditions, because the green will fade fast. Each stem has a large number of heads with small seeds.

CARTHAMUS
Available with and without flowers; the dark ginger flower is used to make dye. A stunning addition to a display, the bunches tend to be fairly large and need to be split and wired. Choose flowers which have deep green leaves and dark orange flowers.

The greeny-yellow centre of anaphalis makes it match well with other materials.

CHINESE LANTERN
(Physalis)

The vivid orange colour of the paper-thin lanterns will not last if exposed to strong light. It is a fairly easy plant to grow in the garden.

COBRA LEAVES

These large preserved (dried) leaves are very useful for wrapping and also for coating containers. Other types of leaf are also available.

The globe-shaped heads of Echinops are a deep steely-blue at their best.

COPPER BEECH
(Fagus sylvatica)

The dark brown leaf makes a good backdrop. In their natural condition, the leaves tend to curl as they dry. They are best preserved (dried) and will then keep indefinitely and will be more easy to work with.

ECHINOPS RITRO
(Globe thistle)

Handle with care as the delicate blue heads are prone to break apart. The new season's stock handles much better. Echinops are quite expensive but are also very easy to grow in the right conditions.

ECHINOPS SPHAEROCEPHALUS

The same family but much larger, with spiky silvery-blue heads. They take spray colour very well. Handle with care.

Larkspur is a popular flower and is available in a range of attractive colours.

EUCALYPTUS

Available mostly as a preserved (dried) product, this wonderful leaf normally comes in two colours, green and brown. A joy to work with, because it gives off a beautiful scent when the stems and leaves are bruised. The scent will last for months. Ideal for large displays that require long stems.

EVERLASTING *see* Strawflower

GLOBE ARTICHOKE
(Cynara cardunculus)

These make a huge statement and deserve to be displayed alone. The outside comes in a range of green and purple; the centre is a mass of delicate mauve fronds. To dry them, hang them upside-down, wrapped in paper with the bottom open over a constant flow of warmth for 2–3 weeks.

GOLDEN MUSHROOMS

These are often found with ready-fixed stems; if yours have no stems add them with a glue gun. A light spray of clear florist's lacquer will bring out the rich colours.

GRASSES *see* Wheat

HOLLY OAK
(Banksia serrata)

This very large leaf is usually preserved (dried). It makes a good substitute for holly and will not lose its shape or dry out.

HYDRANGEA MACROPHYLLA

One of the most useful dried materials, in a range of colours from very dark pink through to a pale almost-grey and a variety of tones to dark blue. Can be dried very easily at home, in a light-free, warm area. The large heads have a very long life.

IMMORTELLE
(Xeranthemum)

Small, star-shaped, mostly purple or white flowers with an extremely long shelf life, these tolerate bright light very well. Often used as a filler because they are inexpensive, but the strong purple colour will dominate a display.

KUTCHI FRUIT

An exotic caramel-coloured seed pod with a vanilla aroma.It combines well with woodland materials.

LARKSPUR
(Consolida)

Very close to the delphinium, these flowers come in a range of colours but are most commonly blue, pink or white. If the bunches are a little crushed, revive them with very gentle steaming. Probably one of the most useful display flowers, it is a pretty flower and ideal for summer displays.

You can spray Holly Oak with paint or gild lightly with gold for a special look.

11

Not only does Lavender look and smell so attractively, but it is easy to work with.

LAVENDER
(Lavandula)
Dutch lavender is a pale-coloured lavender, with uniform stems and a strong scent. French lavender (*Lavandula stoechas*) is a magnificent rich blue. Take care when buying, because the quality often varies. Lavender is a popular display filler.

MARIGOLD
(Tagetes erecta)
Bright yellow or orange, this makes a spectacular splash of colour. Choose flowers with as little damage as possible. They look almost fresh and can even be arranged alone in a terracotta pot.

MARJORAM
(Origanum marjorana)
This dark purple and green herb works well with dried materials such as roses, peonies, nigella and lavender.

MINT
(Mentha)
This pale purple flower looks very uninspiring alone, but combined with other materials it makes a good partner. It gives off a lovely scent.

MINTOLA BALLS
These woody seed pods look similar to small coconuts. They are often supplied with wooden stakes.

MOSSES
The main types of moss used in this book are sphagnum, tillandsia, green wood, lichen and reindeer moss. Although all can be purchased dried, only tillandsia moss is really suitable for use in this condition; the other varieties are best used slightly damp then left to dry out in the display. You can also buy different coloured mosses to suit your display.

NICANDRA
(Physalodes)
This green seed pod is a smaller alternative to the orange Chinese lantern. The pale colour can be used with many other colours and the shape gives a distinctive texture to an arrangement. Keep it away from direct sunlight. In time, the green will turn dark brown but for a seed pod this is quite acceptable.

NIGELLA DAMASCENA
(Love-in-a-mist)
A real favourite, these seed pods combine purple and green colours with an unusual shape. However, they dislike bright light and will fade very fast. A good material for special-occasion displays. Enhance or change their colour using spray paints.

NIGELLA ORIENTALIS
The same family as love-in-a-mist, but a completely different shape. All-green, it is susceptible to loss of colour. Usually it has quite a short season, so is not always available.

OAK
(Quercus)
This leaf is used in a similar way to preserved (dried) copper beech. It tends to be a little thicker and will stand the test of time even better. It often has a little brown dye added to give a dark, rich colour.

OREGANO
(Origanum vulgare)
This well-loved herb makes a dried plant that can be used over and over again. It has a very unusual texture and a beautiful scent. The colour will keep indefinitely. Any unused pieces can be kept for a pot-pourri, mixed with lavender and rose petals.

PEONY
(Paeonia)
These have a very short season. Although expensive to buy, they are quite easy to dry at home, if you are careful. Mostly dark pink, they can also be a rich pinky-cream. Moths love peonies so make sure that there are no eggs in the flowers.

POPPY SEED HEAD
(Papaver)
Although these are very common, they range from dark powder-grey through to greeny-grey, and will suit most colour schemes. Avoid spraying them with clear florist's lacquer, which will destroy the powdery bloom. Do not use the seeds on food.

PROTEA COMPACTA
(Cape honey flower)
This woody head will last for ever and needs only a light dusting to maintain its good looks. A range of different sizes is available. Use a strong pair of cutters to cut the stems.

Nicandra have a pale colour and attractive rounded seed pods.

RAT'S-TAIL STATICE
(Psylliostachys suworwii)

These dark to pale pink flowers come in a huge variety of lengths. Although they will be fairly straight when fresh, they tend to drop after a time. They look their best in small bunches and add a distinctive texture to a display.

ROSA PALEANDER

These are the miniature version of the standard dried rose and not generally prone to moth attack. They are available in a huge range of colours. Watch out for the thorns. They look particularly good combined with the larger roses.

ROSES
(Rosa)

One of the most expensive of all dried flowers, they are also the most exquisite. A wide range of different colours is available. Always save them until last so that the rose heads do not get broken and so that they remain most central to your design. Most varieties will welcome a little steaming, which revitalizes them and releases a beautiful scent. Roses are prone to attack from moths and need to be inspected for eggs from time to time.

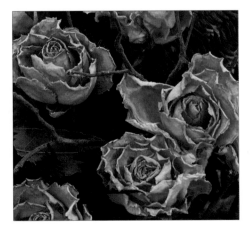

Pink roses are combined with preserved leaves here to create a warm effect.

Red roses make any arrangement special and are ideal for displays made as gifts.

SANFORDII

Small clusters of bright flowers. The golden yellow colour has a very long life, but the flowerheads need to be supported by other materials or their weight will bend the stems.

SEA HOLLY
(Eryngium)

Clusters of small blue thistles, this is a plant to be handled with gloves! Sea holly has a long life, with the colour lasting a long time. As it fades it becomes grey-green turning to pale brown. *Eryngium alpinum* has purplish-blue, cone-shaped flowerheads and a frilly "collar".

SILENE PENDULA
(Campion)

This tiny pink flower looks as though it is fresh, even when dried. It will lose some petals but not enough to matter. The colour keeps for a long time and you only need to add this flower in small quantities. The small flowerheads create a soft look in a display. Give the flowerheads some support, to stop them hanging down.

SOLIDASTER

A hybrid species made by crossing solidago and aster, this pale yellow flower keeps its colour well. Bunches are fairly large and each stem has dozens of flowers that can be wired into small bunches. A good filler.

STRAWFLOWER
(Helichrysum)

This is one of the best-known dried flowers and has slipped from favour with many arrangers. However, the range of colours is vast and it has a very long life. Used in bunches, it can look quite stunning.

SUNFLOWER
(Helianthus)

These popular large yellow flowers have only recently been added to the list of dried materials. The yellow petals tend to be quite small and to fade, but sunflowers are very good for large extravagant displays. The stems can easily be extended by pushing a cane up into the hollow stem.

TOLBOS
(Top brush)

A spiky form of protea that is becoming more widely available. It has a furry centre and usually bears a number of heads on each stem.

WHEAT

Wheat is only one of a number of grasses available. Although very attractive, these grasses need to be used with care. Unfortunately, their green colour has a very short life, and they have given dried displays a bad reputation as their colour quickly fades to brown.

Strawflowers look striking in small groups and are long-lasting.

EQUIPMENT

• • •

You will find it easier to create successful displays if you use the appropriate equipment. The following basic items are available from good florists' shops or suppliers:

CANDLEHOLDERS
These plastic fittings are available in a range of sizes. They have a star-shaped base which is easily pushed into dry foam to hold a candle.

CANES
These are used to create a square or triangular frame for a garland, or to fix terracotta pots.

CHICKEN WIRE
This is a useful base for a swag or to hold flowers in large containers.

COPPER OR STEEL RINGS
These comprise two thin wire rings, used as a strong base for garlands.

FLORIST'S CLEAR LACQUER
A fixative, specifically for dried materials. It holds loose material in place and also helps to keep it clean.

FLORIST'S TAPE (STEM-WRAP TAPE)
This useful tape is not adhesive, but the heat from your hands will secure it to itself as you wrap it around the stem of a plant. It is used to conceal florist's wires and also to seal stem ends. The tape is available in various colours, including green. It is made of plastic or crêpe paper, which will stretch to provide a thin covering.

FLORIST'S WIRE
Available in different lengths and gauges. Use wires as thick as you can comfortably work with, and buy long wire, which can be cut. The heavier the material, the thicker the wire.

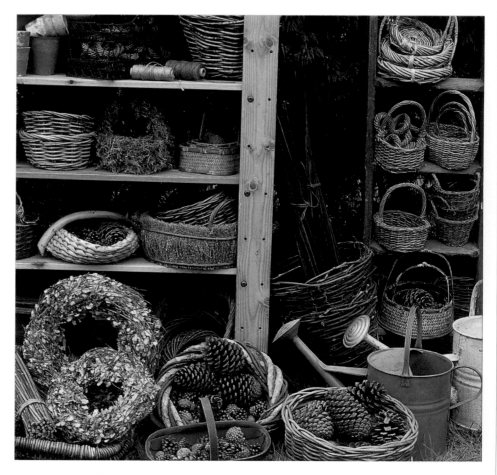

GLUE GUN
A hot glue gun dramatically reduces the time needed to make a display. Better-quality guns are more expensive; a gun with a trigger feed for the glue is easiest to use. Take care not to burn yourself.

KNIVES
You will need two sharp kitchen knives, one short and one long, for cutting plastic foam.

MOSSING (FLORAL) PINS
These are used to hold material, especially moss, in place.

PLASTIC FOAM
Available in rectangular blocks, spheres and cones. Don't use foam that is intended for use with fresh flowers, as it tends to crumble.

Above: The shape and size of wicker baskets, terracotta pots and cane rings are an influential part of the final design.

PLIERS
These are used to secure and twist florist's wires and chicken wire.

RAFFIA
An attractive binding material, particularly if you want a rustic look. Keep the strands long for an attractive flowing and wispy effect.

SCISSORS
Many florists prefer to use sharp, strong scissors, for cutting stems and other materials.

SECATEURS
A strong pair of spring-loaded cutters will cope with tough material.

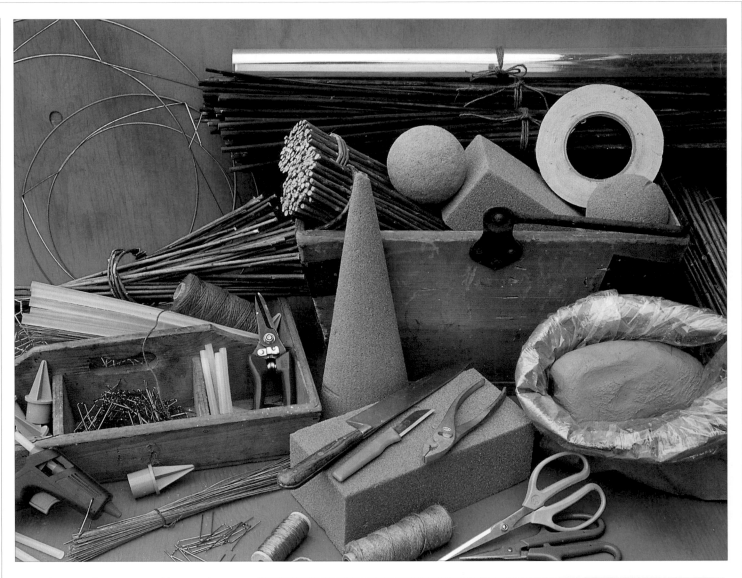

Above: Whenever possible, use the specified tools and materials – it always makes a display much easier to create.

Right: Dressings and ribbons can be found for all occasions and requirements.

SETTING CLAY
This is used to set trunks in pots for topiary displays. Leaving the clay bases to dry can take over 10 hours.

SILVER REEL (ROSE) WIRE
This comes in a range of gauges but it is generally a more delicate wire than florist's wire. Experiment with different thicknesses until you find one with which you like working.

STRING
Gardening string comes in various brown and green colours that blend well with dried materials.

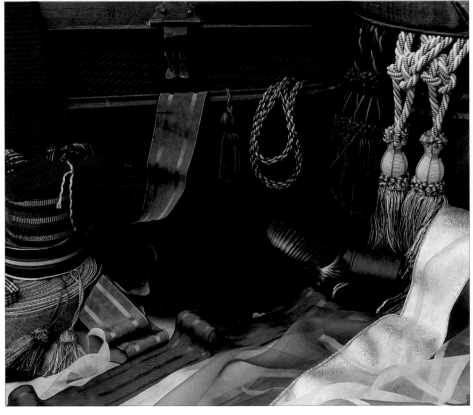

TECHNIQUES

· · ·

PREPARING A POT

A block of plastic foam should be carefully cut to fit the terracotta pot you intend to arrange your materials in. Many other types of china, porcelain and clay pots can be used. Even plain glass containers make good bases, although the preparation is a little different. When using clear glass, the foam needs to be cut smaller than the inside area of the container and the space between the foam and the sides filled with moss or pot-pourri to hide the foam. When using fine china or glass, take great care not to force the foam into place, in case the container breaks. Always work on a non-slip surface.

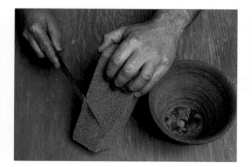

1 Hold the foam block next to the pot and trim it to roughly the same shape using a sharp kitchen knife. Be cautious and cut small pieces off, leaving the foam block a little larger than the inside of the pot.

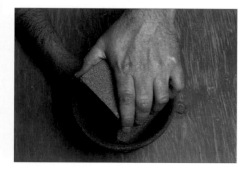

2 Push the trimmed foam firmly into the pot so that it goes right to the bottom. If it is a little large, carefully trim some more.

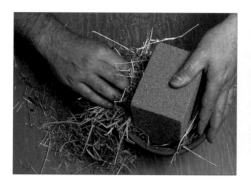

3 Pack the spaces around the foam with hay or moss, pushing it down firmly. For a really permanent fit, put a little glue on to both the pot and the foam.

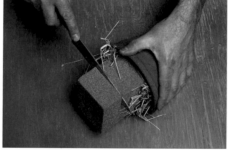

4 Trim the foam to the required height. If you need to trim it level with the top of the pot, use the rim of the pot as a guide for the knife.

PREPARING A BASKET

Cut a block of plastic foam to fit the shape of the basket. Make sure the foam is firmly fitted in the basket; if you have trimmed it too small, pack the area around it with hay or moss, so that there is no risk of the display falling out.

When choosing a basket, check that it stands evenly on a flat surface. If it does not, it is sometimes possible to trim a piece away; if not, the trimmed foam will often correct the shape, but will need to fit tightly.

If the weave of the basket is fairly open, pack the area around the foam with moss so that the foam cannot be seen.

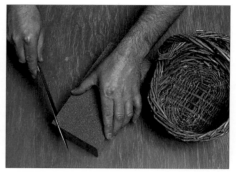

1 Place the block of foam next to the basket and trim it to roughly the same shape using a sharp kitchen knife. If the basket is large, you may need more than one block of foam.

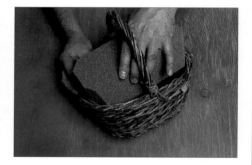

2 Push the trimmed foam into the basket. If it is a little over-sized, trim a little more foam but try to keep it on the large side, so that it is a tight fit. Depending on the shape and size of the basket, you may need to trim foam away around the top.

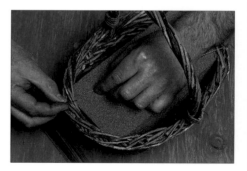

3 Push a wire through the side of the basket and across the top of the foam, twisting the ends back around the tightened wire. This will hold the foam in place, but may not be needed if the foam is a tight fit.

Filling a Container with Moss and Chicken Wire

Moss is an alternative to foam as a base. It is useful when the container is large and would require a lot of foam. However, a moss base isn't as good at holding bunches in place as foam, and can be tipped upside-down.

If the container is very large, there is no need to use moss at all; in this case the chicken wire will be needed to fill the basket so that it can support the stems of the materials.

To make a chicken wire ball for a topiary tree, try to make the shape as spherical as possible.

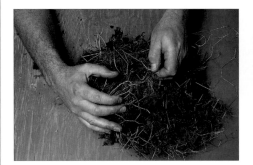

1 Cut the chicken wire into a square approximately twice the surface area of the open top of the container. Put an amount of moss to fill the container, plus a little more, in the centre of the wire. Fold the four corners in, creating a ball shape.

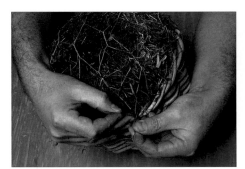

2 Push the ball into the basket, with the open, folded side underneath. Using wires, "sew" the chicken wire frame to the edge of the basket, about every 10 cm (4 in) around the rim.

Covering a Container with Moss

Old or poor-quality baskets or boxes, of all shapes and sizes, can be turned into useful display containers when covered in moss. To enable the moss to keep its green colour it should be kept well away from direct sunlight.

Before starting work on the outside of the basket, fill the inside with the foam, moss or mesh. This will ensure that the outer covering is disturbed as little as possible when it comes to making the display.

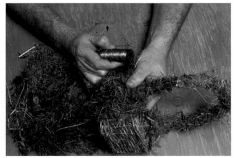

1 Attach silver reel (rose) wire to the container and cover part of it with a good handful of moss. Wrap the wire around the container, fastening the moss in place. Repeat the process until the whole container is covered, paying particular attention to the edges and corners.

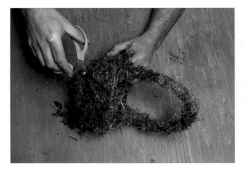

2 Tie the wire to the top edge of the container and trim the moss evenly with scissors. Any small gaps can be filled by tucking moss under the wire or by gluing the moss in place using a glue gun. Trim any loose pieces.

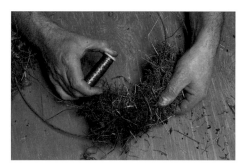

Preparing a Copper or Steel Garland Ring

Copper or steel rings are a strong and inexpensive way of creating a good base for garlands. They are available in a large range of sizes and need to be covered in moss or hay.

1 Tie silver reel (rose) wire to one of the copper wires of the ring. Take a good handful of moss or hay and hold it on to both the top and the bottom of the ring, to form an even layer. Wrap the wire around the ring, fixing the moss in place. Repeat all the way round the ring.

Covering a Picture or Mirror Frame with a Chicken Wire Swag

A picture or mirror frame can be covered with moss as the base for a dried flower arrangement. The best base is a simple, heavy frame.

1 If the frame is a little flimsy, use wood screws and glue to strengthen it. Make four chicken wire and moss swags to fit the top, bottom and sides. Push one swag firmly around one side of the picture frame.

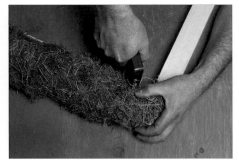

2 Make sure the swag is long enough, then use a staple gun to hold it in place. Make sure that the staples trap a piece of chicken wire and hold it firmly to the wooden frame each time you fire the gun. Repeat every 5–8 cm (2–3 in).

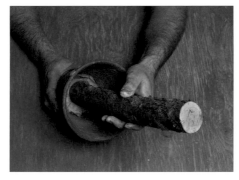

MAKING A TOPIARY BASE
Choose the container for your topiary carefully, since this will dictate the finished shape and size of the piece. The easiest method for fixing the materials to the trunk is a foam sphere. As a general rule, the ball of flowers or material should be a third larger in diameter than the diameter of the top of the container. The container, the trunk and the floral sphere should each be a third of the total height of the finished display.

Select tree trunks that are on the thick side; these give a better balance to the finished piece.

When using large or precious pots, first set the trunk into a plastic pot that you can put inside your good-quality pot without any fear of breakage. This also has the advantage that the display can easily be removed to another container.

Instead of using a plastic foam shape as the base for your topiary design, you can also make a base out of a chicken wire ball filled with moss. Attach the chicken wire ball firmly to the top of the trunk, using a staple gun.

Remember to turn the finished topiary pieces regularly to ensure that they fade evenly, and keep all dried materials out of direct sunlight.

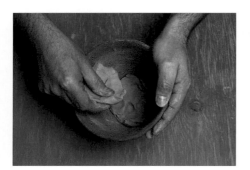

1 Cover the base of your chosen container with a handful of setting clay, to make a layer about 2.5 cm (1 in) thick.

2 Push the bottom of the tree trunk into the clay. As long as it is in the centre, it doesn't have to be completely upright.

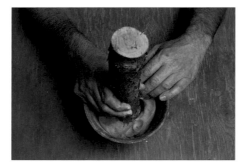

3 Cut some clay and roll into sausage shapes. Pack around the base of the trunk, pushing them down and filling the space between the sides of the container and the trunk. Repeat until at least half the depth of the pot is filled. Leave the clay to set hard – this may take between several hours for a small pot and up to two days for a large one.

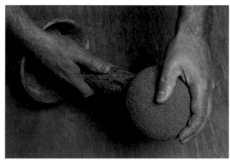

4 Support the trunk with plastic foam, to fill the container, if you like. Push the foam sphere down on to the top of the trunk. Remove the sphere, blow away any loose foam particles from the top of the trunk and the hole in the foam. Place a spot of glue on the end of the trunk and push the sphere back into position. It is now ready for your design.

MAKING A HAY ROPE OR COLLAR
The method for making a hay rope and a hay collar is exactly the same, except that the collar needs to be thicker and the ends joined together to form a circle. Hay is inexpensive and versatile, so it is well worth mastering this basic technique, used for garlands and swags.

1 Take a good handful of hay and scrunch it up to form a sausage. Wind silver reel (rose) wire (or string or raffia) around this and tie in place. Twist the wire round the hay, leaving spaces of about 1 cm (½ in) between each twist. Keep adding more hay as you build up the length of rope. Make sure that the rope is firm and the wire is very tight. The hay should not give at all when you squeeze it.

2 Continue to add more hay, keeping the width of the rope even, until you reach the required length. If you are making a rope for a swag, it need only be about 5 mm (¼ in) in diameter. For a garland or a very large swag, the diameter needs to be about 2.5 cm (1 in). Whatever you are making, pack the hay as firmly as possible to make a good base for the decorative materials that you will be using. When the rope or collar is completed, trim any loose hay and fasten the end of the wire securely.

Below: A decorated collar on a basket makes an attractive storage container.

MAKING A CHICKEN WIRE SWAG

This method of creating a swag base makes a large surface to work with, useful if your materials are chunky or you need to cover a large area.

1 Carefully cut the required length and width of chicken wire, folding in the sharp edges.

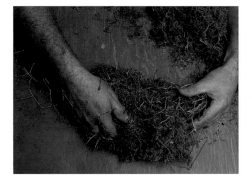

2 Fill the centre of the wire mesh along its length with moss, as evenly as possible.

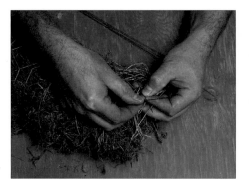

3 Fold the long edges into each other, creating a sausage shape, and join them together with short wires. You may need to remove or add moss, so that the shape is even.

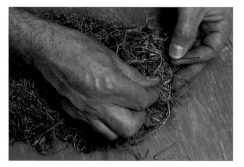

4 Use one or two short wires to make a hanger. Push the wire(s) through the chicken wire and twist the ends together to create a loop.

MAKING A ROPE SWAG

This is the best base for a swag to which you are going to tie the decorative materials. The covering need not be too thick; the bulk for the swag will be provided by the stems of the materials. Don't be tempted to make the swag too short – a swag about 1 m (1 yd) long will look balanced in most projects.

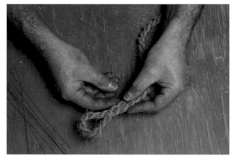

1 Cut the rope to the required length, allowing enough for a loop at each end. Use a wire or glue to secure the loops.

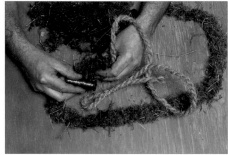

2 Tie silver reel (rose) wire to the rope and wrap it around a good handful of moss, keeping the rope in the centre of the moss. Work along the whole length of the rope until it is completely covered with moss.

MAKING A BASKET BORDER WITH A ROPE SWAG

You can use a moss-covered rope swag to extend the edge of a basket, making it easier to fix dried materials in position.

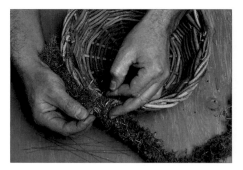

1 Make a rope swag as above. Attach the rope to the edge of the basket by pushing wires through the basket under the rope. Twist the ends together on top, trim off the loose ends and push any sharp pieces back into the moss. Repeat every 5–8 cm (2–3 in) round the edge of the basket.

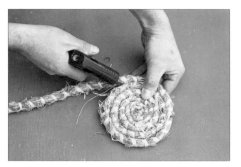

MAKING A HAY AND RAFFIA BASKET

1 Make a length of hay rope, about 2.5 cm (1 in) in diameter, tying with raffia as needed. Coil and glue the rope to form the base of the basket. Cut and glue the end when it has reached the required size.

2 Make a second hay rope and glue the end to the base. Coil and glue the rope into a cylinder, with the same diameter as the base. When the required height is reached, taper the end of the hay rope and glue.

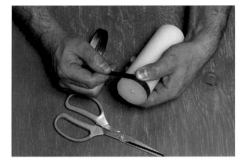

WIRING FLOWERS

This is the most important skill to master when dealing with dried flowers. Practise on a handful of stems trimmed from a bunch of fresh flowers until you have a neat, tightly wired bunch.

1 Take 4–6 stems and cut them to the length you require. Hold them firmly together with one hand and pass the wire behind them, so that the wire and the stems are at right angles. The short end of the wire should be about 3 cm (1¼ in) above the stems.

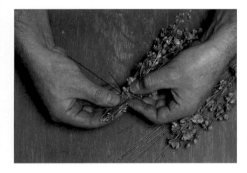

2 Hold the wire and stems together between the thumb and forefinger of one hand. Bend the long end of the wire towards you, loop it around the stems and push it away from you.

3 Pull the short end of the wire up so that it lies lengthways along the stems. Now wrap the longer length of wire 3–4 times diagonally around the stems, to hold them together. The wire should be firm but not so tight that it breaks the flower stems.

WIRING A CANDLE

This method firmly fixes a candle into foam, and makes removing the spent candle very easy.

The combination of candles and dried material is, of course, potentially very dangerous. Make sure that you never leave a display with a lighted candle unattended.

1 Wrap florist's tape (stem-wrap tape) at least once around the base of the candle, so that it sticks firmly to the candle.

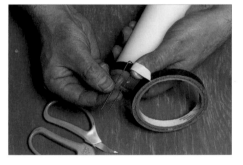

2 Place a mossing (floral) pin or a short bent wire under the loose end of the tape. Cover the top of the pin or wire with the tape so that it holds the pin or wire in place.

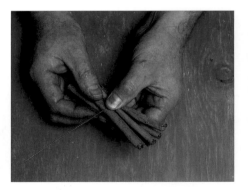

3 Repeat with at least three fixings for a small candle or six for a larger candle. Finish by pulling the tape around once more and trimming it neatly. Alternatively, you can also use a glue gun to fix the candle in the right position.

CENTRE-WIRING BUNCHES

By wiring a bunch of flowers in a central position you can achieve a fuller-looking bunch than one that has been wired at the base.

The advantage of this method is that you can put each bunch exactly where you want it, and need only commit it to the base when you are happy with that final position.

You can also tie on the bunches facing in different directions.

1 Trim the bunch to the required length. Put the stems together, each at a slight angle to the one before. Halfway along the total length, fold the wire around the bunch. Hold the bunch firmly in one hand, while the other hand folds the wire.

2 Cross the two ends over and firmly twist the wires together to produce a strong support. You can use a pair of pliers to twist the wires together, but take care to ensure that you don't break the stems under the pressure of the tight wire.

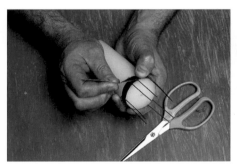

3 Use stronger wire to bunch together cinnamon sticks and other woody material, including twigs and even small branches. Twist the ends of the wire together with pliers, taking care not to damage the dried material. Once the material is in place use glue to fix it permanently. Cover unattractive fixings with a raffia or ribbon bow.

WIRING LEAVES

Leaves such as magnolia often arrive with little or no stem. This technique creates a stem to work with so that you can make bunches. Be careful not to trim away more of the leaf than is necessary; just enough to fix the wire.

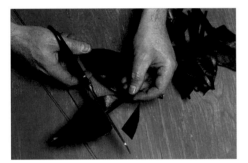

1 Trim the bottom third of the leaf away on one side of the stalk and repeat on the other side, to leave a thick long stem. Bunch the leaves together and centre-wire. For a full look, alter the angle of each leaf.

WIRING FRUIT AND NUTS

Many fruits can be wired easily but nuts need to be drilled or make a hole very carefully with a bradawl (awl). It is advisable to hold the nut in a vice. You can also use a glue gun to fix fruit or nuts directly in place.

1 If necessary, make a hole through the base of the fruit or nut. Push a wire through so that an even amount of wire comes out either side.

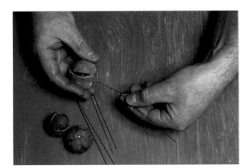

2 Cross the two ends of the wire and twist them together to form a strong support.

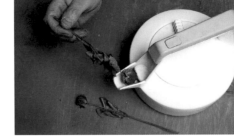

STEAMING FLOWERS

This simple technique can greatly improve dried roses or peonies, which are imported in large boxes and often arrive at their destination looking rather squashed. Never try to open the very centre of the flower which is often discoloured.

1 Bring a kettle to the boil. Hold the rose by its stem, head downwards, in the steam for a few seconds, until the outside petals start to waver.

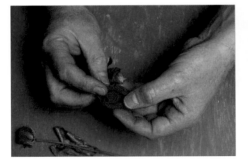

2 Remove the rose from the steam and gently push back the outer petals, one by one. If necessary, repeat the process.

CARE AND MAINTENANCE

How long a display of dried materials will last largely depends on the care that it receives. Avoid direct sunlight and keep your display in a dry and damp-free atmosphere and it should last at least one or two years.

After about a year, your display will need cleaning. Set an electric hairdryer on cold and move it backwards and forwards over the display. Use a small paintbrush to clean away dust also. Remove any bits that are old or broken. Spray florist's sealer on your display for a further lift. Frosted spray paints can also transform a display that is too old to revive.

MAKING A FABRIC BOW

For a more formal setting, a fabric bow looks smart. Crinkled paper can be used for a more quick and inexpensive method.

1 Fold a piece of fabric equally into three lengthways, making sure that the raw edge is not too close to one of the folded edges. Fold the length again, dividing it into three so that the middle section is approximately one-third larger than the outer two.

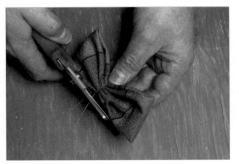

2 Grip the fabric in the middle, pressing it into a bow shape. Still holding the shape, wrap a thin wire around it and twist the ends together. Make sure that the creases on the front of the bow are even. Twist the wires tightly together with pliers and tuck the sharp ends into the bow.

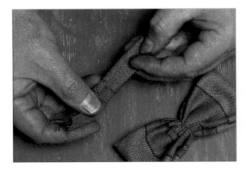

3 Fold a much smaller piece of fabric into three lengthways. It should be wide enough to look well balanced as the centre of the bow. Wrap this around the bow, covering the wire. Trim the ends at the back then glue the two raw ends together.

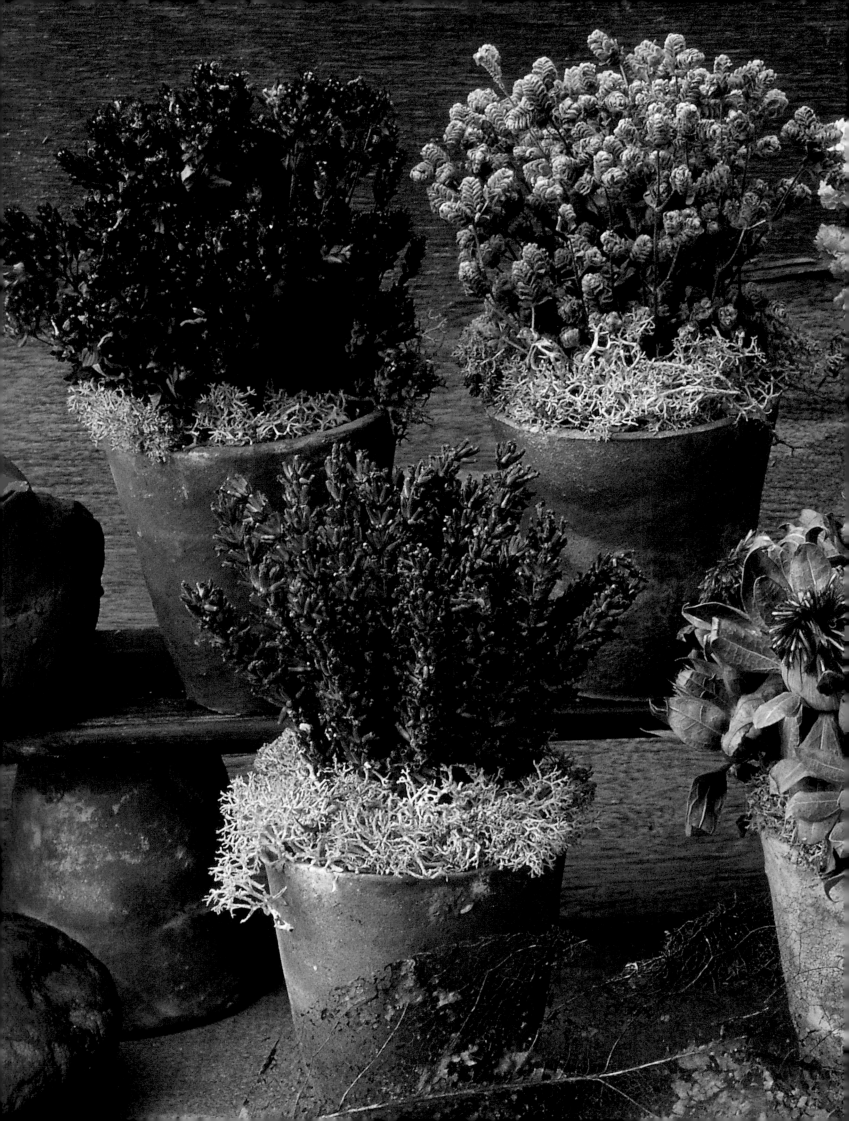

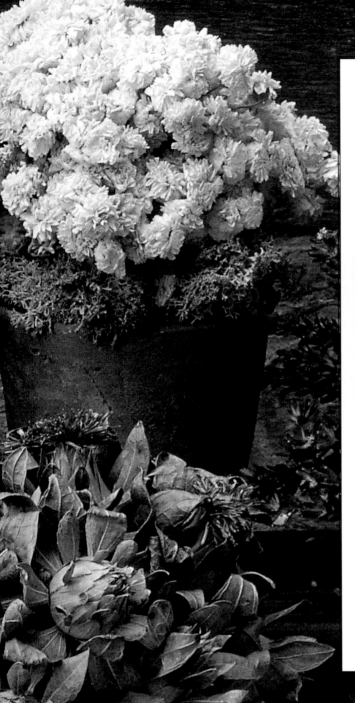

POTS OF INSPIRATION

· · ·

Whatever the occasion or the season, dried
materials always look good in a traditional
terracotta plant pot. Choose between abundant
country-style displays, reminiscent of summer
gardens, or more formal geometric shapes. Pots
are also ideal for standing candles in; place them
singly or group several candle pots together to
welcome your guests and create a
festive atmosphere.

INTRODUCTION

· · ·

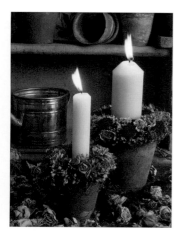

*Above: Rose-perfumed
Candle Pots*

Below: Winter Candle Pot

Pots are extremely versatile and can be highly decorative. You can fill a whole pot with bunches of colourful dried flowers, or with subtle autumnal arrangements of woodland materials. There are various ways of holding the materials in place, some very simple and others more professional. The following projects show examples of different florists' techniques, for example using plastic foam and wires, to create the desired effect.

Antique earthenware and terracotta pots have a warmth and texture which perfectly complement natural dried materials. If you cannot find any suitable old pots, choose good-quality hand-thrown modern pots and leave them outdoors to weather for a while. To match a dark wood table, you can stain the pot dark brown. Terracotta pots often have rough bases so you will probably need to glue felt on the bottom to protect a table surface.

For some displays, glazed china pots may be suitable and it is worth keeping your eye open for different containers. For variety, you may find that a particular arrangement looks very handsome and modern in a shiny galvanized container.

Moss is used in many of the pots, sometimes as a feature of the display but also to hide the fixings or the foam base. Use it generously in handfuls as it will shrink slightly as it dries. There are various kinds of moss, just as there are endless

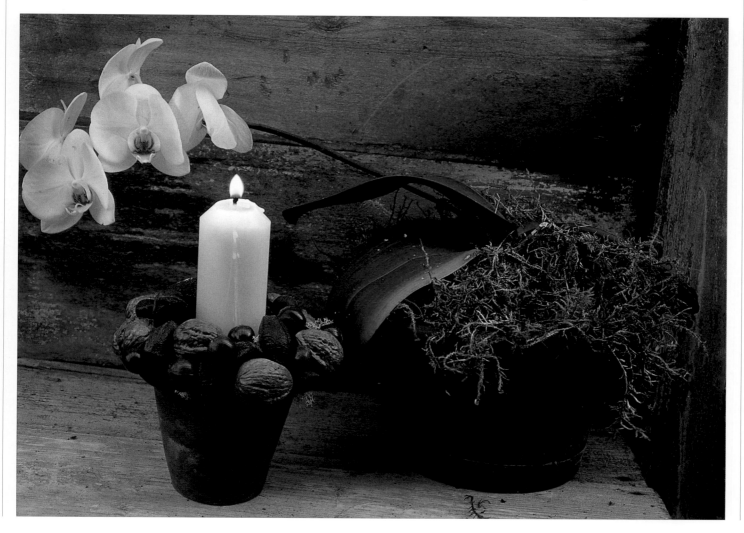

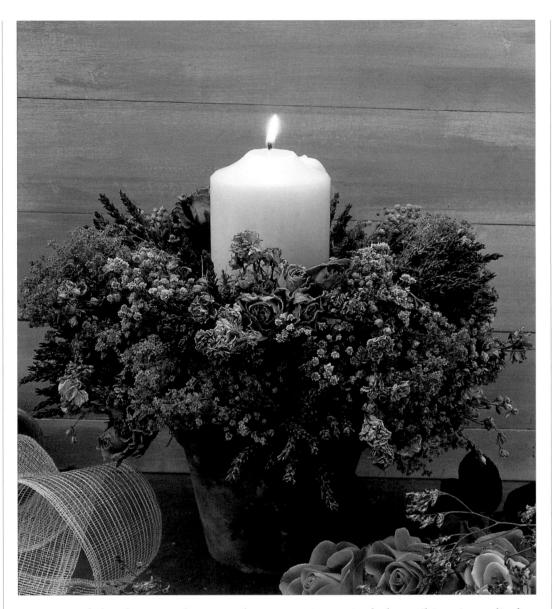

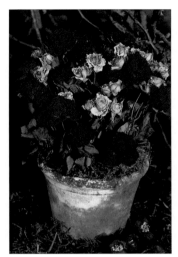

Above: Simply Roses

Left: Floral Candle Pot

varieties of dried materials – reindeer moss is particularly striking in a display. Florists' shops are a great temptation, but you can also collect plenty of interesting materials, such as fir cones, twigs, nuts and fungi, on a woodland walk. To attach dried materials around the rim of a pot, a glue gun is invaluable. It allows you to position individual nuts and twigs so that they overhang the edge.

The following projects illustrate a range of decorative arrangements which complement pots. As well as informal mixed arrangements, there are also instructions for making elegant structures such as a pyramid of fir cones.

Alternatively, you can make a collar or border to fit round the edge of the pot, leaving the centre space empty for a candle. Decorate the border with fir cones and nuts, or dried flowers and herbs, to create a magical effect in the candlelight. These candle pots are perfect for dinner parties or special occasions. For safety's sake, be careful to keep the dried materials away from the base of the candle, and never leave the candle or candles burning unattended.

Candle pots especially look wonderful if you spray the dried materials with clear florist's lacquer so they shine in the light. For an occasion such as Christmas, you can also frost the display lightly with gold, white or silver spray paint.

The displays on the following pages will also give you plenty of inspiration for your own ideas. There are pots here for every room in the house and garden, even a seashell pot for the bathroom.

Below: Hot Chillies

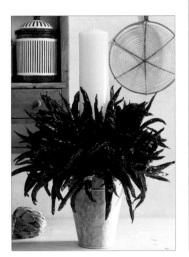

BUNCHES OF ROSES

. . .

MATERIALS

. . .

knife

. . .

1 block plastic foam for dried flowers

. . .

terracotta pot

. . .

dried roses

. . .

scissors

. . .

.91 wires

. . .

moss

. . .

mossing (floral) pins (optional)

You can, of course, use a combination of any two colours from the many different roses available.

A single dried material often looks its best displayed on its own, without any other decoration. Here peachy-pink and yellow roses are very simply arranged in a terracotta pot. The same technique can be used with a selection of materials, such as lavender or oregano for a scented variation. Flower pot displays are some of the most basic designs, but they can be extremely attractive.

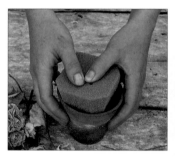

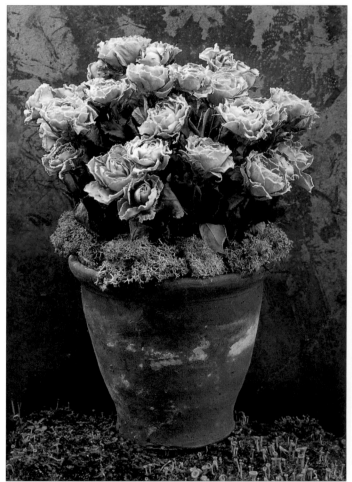

1 Trim the foam to fit snugly into the pot. Cut off any excess foam so that it aligns smoothly with the top of the pot. Press it down into the base of the pot so that it is just below the rim.

2 Steam the roses if they look a little old and dull. Lay out the roses in a pile on a clean surface and trim the rose stems to an even length.

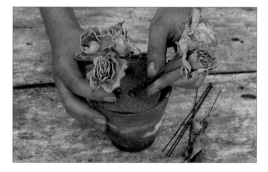

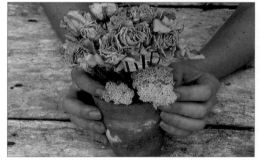

3 Wire the roses into small bunches of 3–4 flowers (see Techniques). Leaving an empty outer ring of foam, press the roses firmly into the centre of the foam, positioning them quite closely together.

4 Fix handfuls of moss into the foam around the flowers, using mossing (floral) pins or wires bent into U-shapes. The moss should just cover the edge of the pot.

OLD-FASHIONED POSY POT

· · ·

Dried flowers often look their best when the blooms are massed together and the stalks are not too prominent. In this charming, traditional treatment, rosebuds and lavender are tucked into a tiny terracotta pot. A trailing raffia bow makes a perfect finishing touch to the arrangement.

MATERIALS

· · ·

knife

· · ·

1 block plastic foam for dried flowers

· · ·

small terracotta pot

· · ·

dried rosebuds

· · ·

scissors

· · ·

dried lavender

· · ·

dyed raffia

· · ·

glue gun and glue sticks

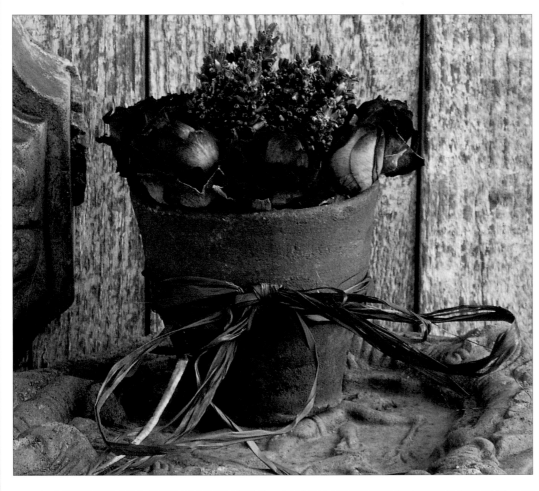

Sweet-smelling lavender and roses have been a favourite combination for many centuries.

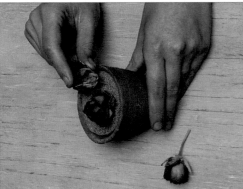

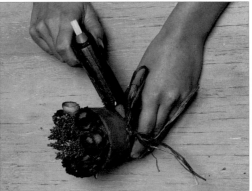

1 Trim the foam to fit snugly into the pot. Push the rosebuds into the foam around the edge of the pot.

2 Cut the lavender stalks to about 1 cm (½ in) and use them to fill the centre of the arrangement. Tie a raffia bow around the pot and secure at the back with glue.

SIMPLY ROSES
. . .

MATERIALS
. . .
knife
. . .
*1 block plastic foam for dried
flowers*
. . .
terracotta pot
. . .
about 30 dried roses
. . .
scissors
. . .
moss
. . .
*glue gun and glue sticks
or .91 wires*

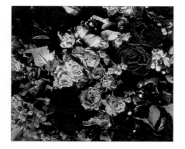

*Pink and red roses are a
striking colour combination.*

For a large display, you do not need to wire roses into bunches. Instead, place them carefully in the foam one at a time, spacing them well to create a good balance. For a really stunning effect, use different combinations of size and colour, and try to retain as much of the green leaf as possible.

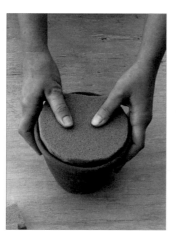

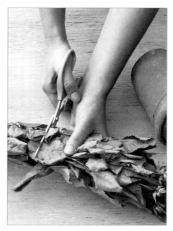

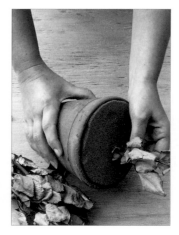

1 Cut the foam to fit the pot. Press it firmly down into the pot. Trim the top of the foam so that the foam and the top of the pot are level.

2 Steam the roses (see Techniques). Trim the stalks to different lengths, this way the flowerheads will not obscure or crowd each other.

3 Starting in the centre of the foam, press in the tallest rose. Work outwards, continuing to add the stems gradually, one by one.

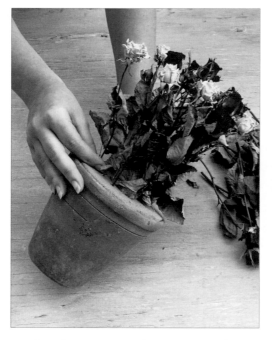

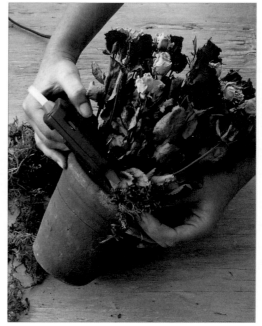

4 Continue to press the roses into the pot. If you are using more than one size and colour, keep checking to ensure that you have a good balance over the whole display.

5 Attach moss around the base of the roses using a glue gun. Alternatively, you could bend short wires to form U-shaped staples and push them into the foam to trap the moss.

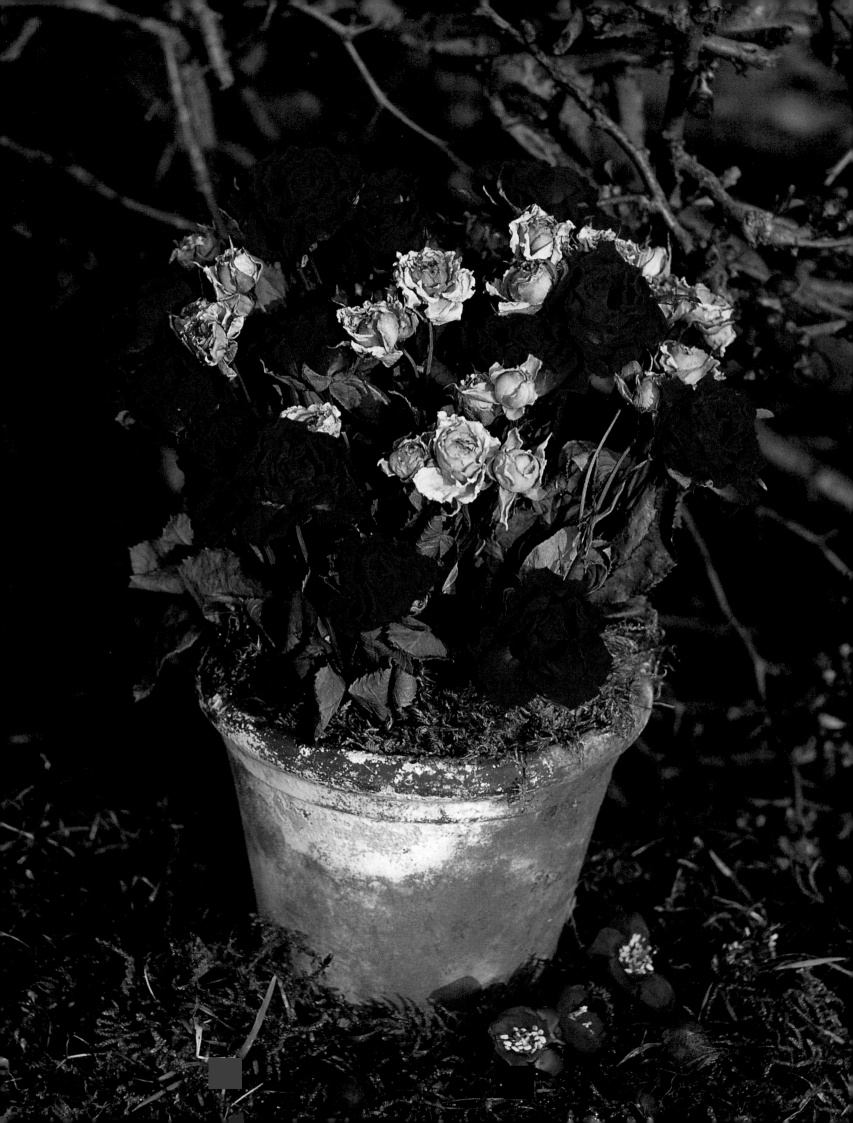

LAVENDER POT
• • •

MATERIALS

• • •

scissors

• • •

20–25 stalks dried lavender

• • •

small terracotta pot

• • •

.91 wires

• • •

knife

• • •

*1 block plastic foam for dried
flowers*

• • •

*glue gun, mossing (floral) pins
or .91 wires*

• • •

moss

*The beautiful colour of
lavender will fade if it is
exposed to too much light
so place the pot away from
direct sunlight.*

Lavender is rich and dramatically coloured enough to warrant displaying all by itself. You can use any variety but the deeper the colour, the more impact it will make. If the lavender's powerful scent fades in time, you can easily bring it back by adding just a few drops of perfumed oil to the display. Add the oil to the moss at the base for the best results.

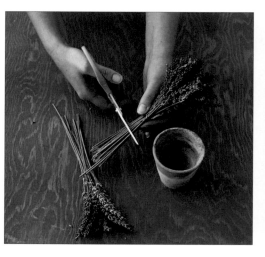

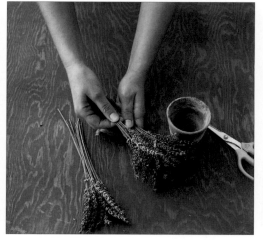

1 Trim the lavender stalks so that the heads will all come just above the rim of the pot and the bunch is even.

2 Wire together three small bunches each of about 6–8 lavender stalks (see Techniques).

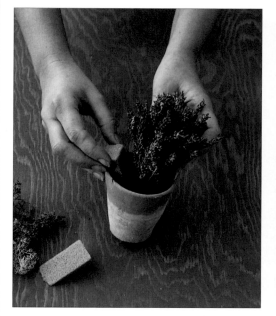

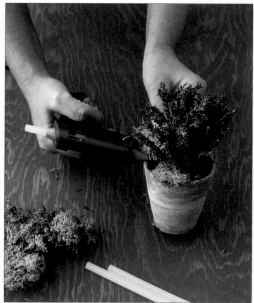

3 Cut three small wedges of foam. Place one in the base of the pot then place the lavender bunches together in the centre. Press the other wedges down each side to hold the lavender in place. The foam should be about 1 cm (½ in) below the rim of the pot.

4 Glue the moss over the top of the foam, around the lavender. Alternatively, you can attach the moss in place with mossing (floral) pins or short wires bent into U-shapes.

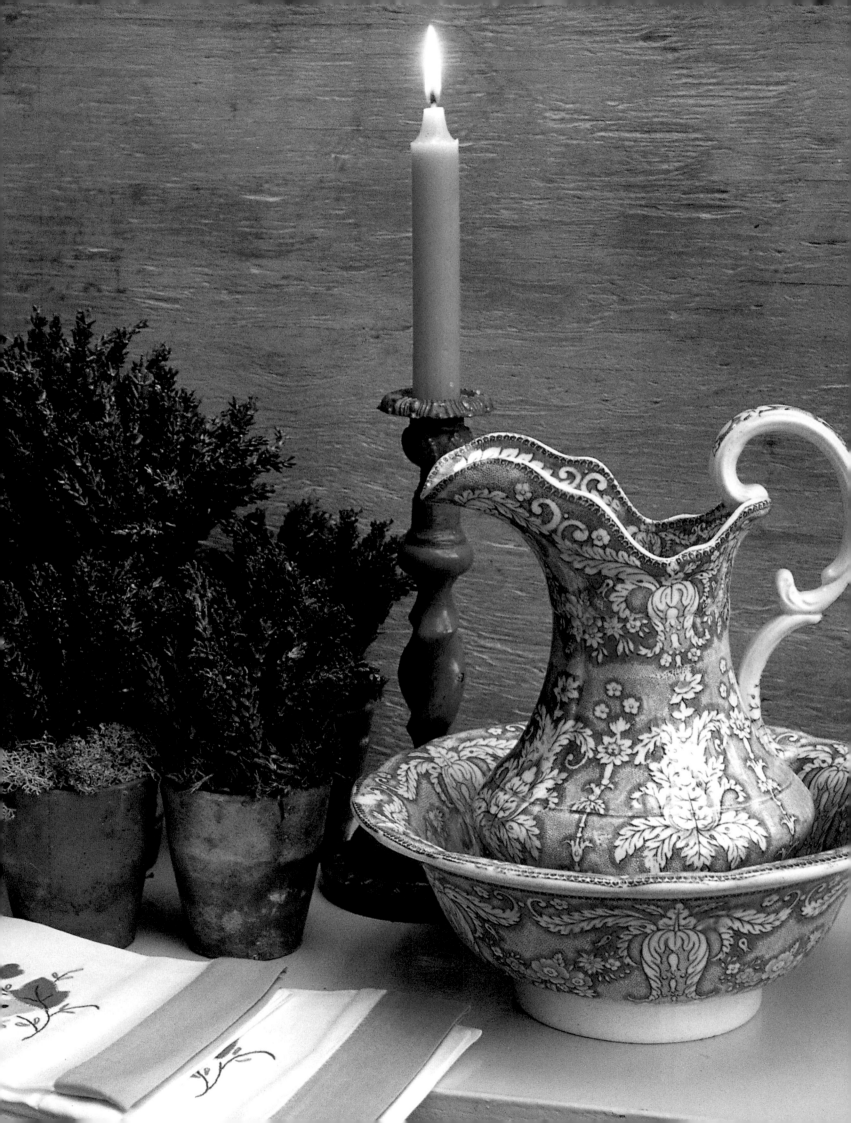

RUSTIC POT

· · ·

MATERIALS

· · ·

knife

· · ·

1 block plastic foam for dried flowers

· · ·

terracotta pot

· · ·

silver reel (rose) wire

· · ·

hay

· · ·

scissors

· · ·

dried yellow roses

· · ·

dried poppy seed heads

· · ·

.91 wires

· · ·

raffia

For a more sophisticated look, replace the raffia with a paper or fabric bow.

This unusual pot has a pleasing dishevelled appearance, with a layer of hay attached to the outside. It is tied with a large, natural raffia bow that covers the wire nicely, and would look wonderful on a dresser or kitchen cabinet. Attach the hay with glue over the wire, if you wish.

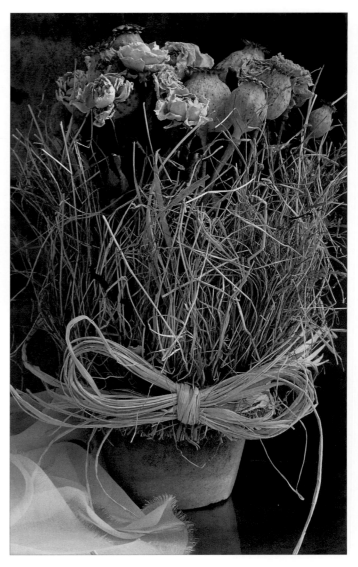

1 Cut the foam to fit the pot and press firmly in. Tightly wrap silver reel (rose) wire two to three times around the pot near the top to secure the wire so that it does not slip when you add the hay.

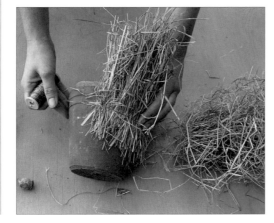

2 Lay the pot on its side and wire on the hay in generous amounts, trapping it tightly. When the pot is covered, tie the end of the wire as tightly as possible. Trim the hay with scissors so that the base of the pot shows. Don't trim the top.

3 Wire the roses and poppies separately into small bunches, leaving long stems (see Techniques). Fill the centre of the pot with flowers and seed heads and finish with a raffia bow.

HAYFIELD POT

· · ·

This country-style pot has a pleasingly dishevelled appearance, created by a tangled layer of hay attached to the outside. If you wish to be certain that the hay will not fall off, you can apply glue over the wire and into the hay.

MATERIALS

· · ·

knife

· · ·

1 block plastic foam for dried flowers

· · ·

terracotta pot

· · ·

silver reel (rose) wire

· · ·

hay

· · ·

scissors

· · ·

dried red roses

· · ·

dried poppy seed heads

· · ·

raffia

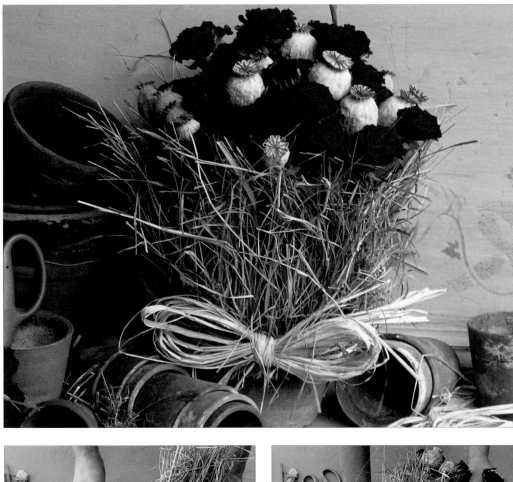

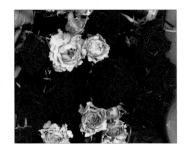

Vibrant red roses could be combined with faded pink varieties for a romantic finish.

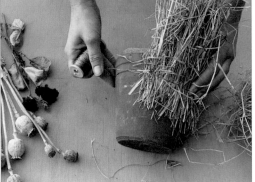

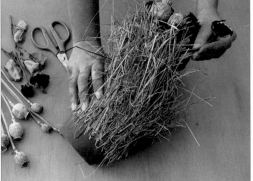

1 Trim the foam to fit snugly into the pot. Tightly wrap the silver reel (rose) wire several times around the pot near the top to secure. Lay the pot on its side and wire on the hay in generous handfuls, tightly trapping it under the wire.

2 When the pot is covered, tie the end of the wire as tightly as possible. Trim the hay from the base of the pot. Wire the roses and poppies separately into small bunches, leaving long stems so they show above the hay (see Techniques). Fill the centre of the pot with the flowers. Tie a raffia bow around the pot.

HOT CHILLIES

· · ·

MATERIALS

· · ·

knife

· · ·

1 block plastic foam for dried flowers

· · ·

galvanized container

· · ·

moss

· · ·

florist's tape (stem-wrap tape)

· · ·

mossing (floral) pins

· · ·

.91 wires

· · ·

creamy white candle

· · ·

dried red chillies

Dried chillies look very dramatic in any display, especially here where they are used on their own.

Like spurting hot flames, dried chilli peppers make a fiery display which would be ideally suited to a modern interior. The galvanized container and creamy white candle contrast beautifully with the rich red chillies. For a more earthy, natural look you can use a traditional terracotta pot. Wash your hands when you have finished in case they have come in contact with any hot chilli seeds.

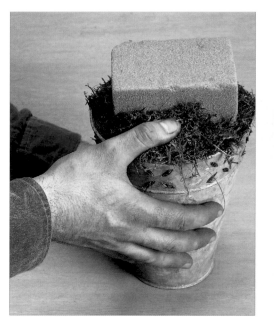

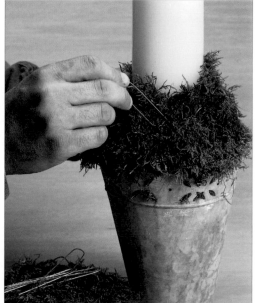

1 Cut the foam to fit comfortably inside the container. It should stand at least 2 cm (³⁄₄ in) above the rim. Wedge it inside with small offcuts of foam then fill the gaps with moss, packing it in tightly.

2 Wire the candle in the centre of the foam (see Techniques). Cover the foam around the candle with moss to create a mound, securing it with pins made from bent wires.

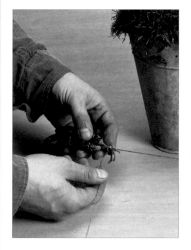

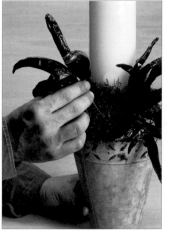

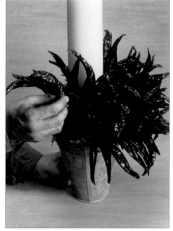

3 Wire the chillies firmly in groups of three (see Techniques).

4 Look carefully at the way the chillies bend before inserting them evenly around the base of the candle.

5 Complete the garland of chillies, readjusting the bunches if necessary.

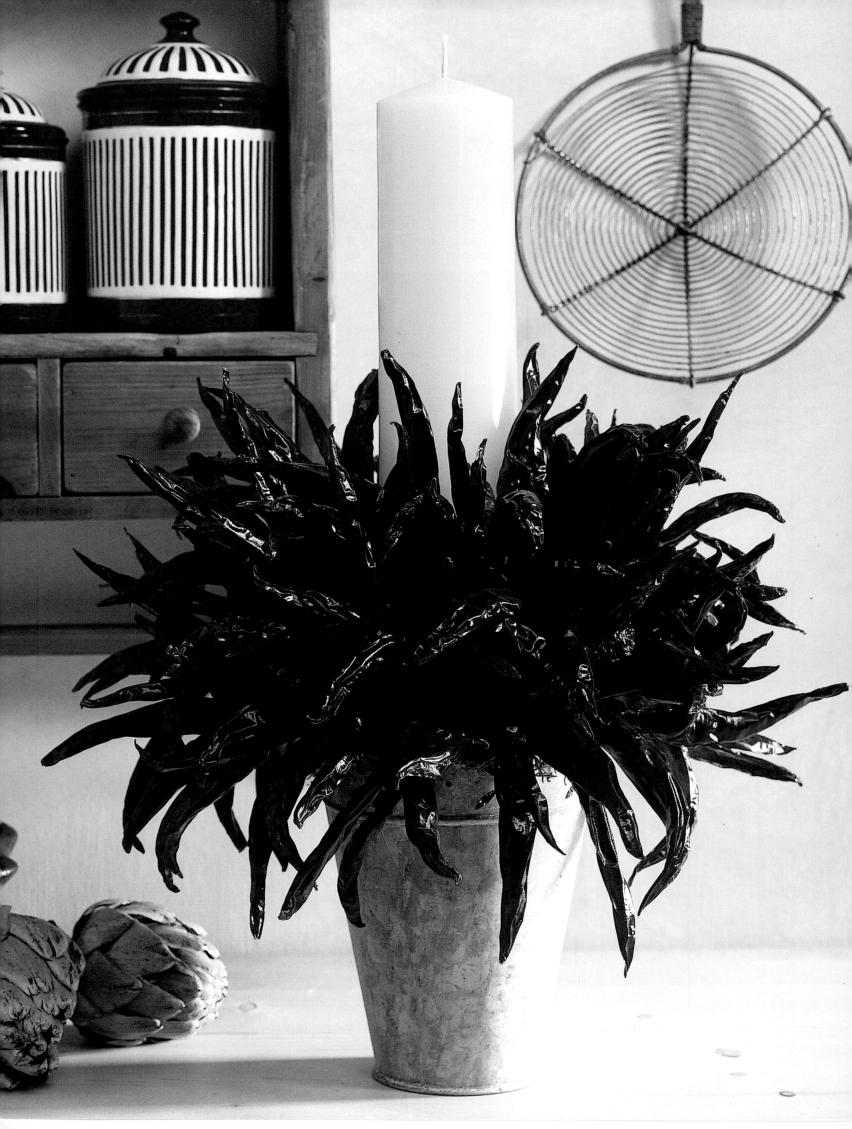

FLORAL CANDLE POT

· · ·

The flowers used in this pot will complement the candlelight to make a very romantic display.

This pretty pot would look lovely on a summer garden table, especially if you use a scented candle to keep away insects. The dried flowers are carefully inserted in sequence to build up the attractive shape. The candle has been pinned and taped in position so that it can easily be replaced once used. Remember to never leave a lighted candle unattended, even outdoors.

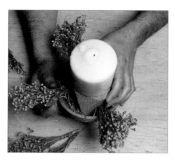

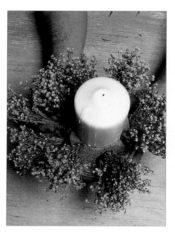

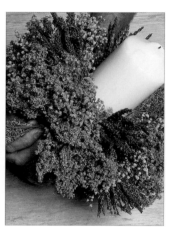

1 Trim the foam to fit the pot. Wire the candle into the foam (see Techniques). Push the foam into the pot, so that it is 8 cm (3 in) above the rim. Trim all the materials to 10–13 cm (4–5 in), depending on the size of the pot, then bunch and wire them (see Techniques). Starting at rim level, push four bunches of solidago into the foam.

2 Continue to add some solidago in the spaces near the base of the candle. This will create an S-shaped arrangement of flowers when viewed from the side, running around the display.

3 Fill the spaces between the solidago with about eight small bunches of *Alchemilla mollis*. There should be very little space left. Add eight bunches of lavender, again in an S-shape. Fill any large spaces with solidago or *Alchemilla mollis*.

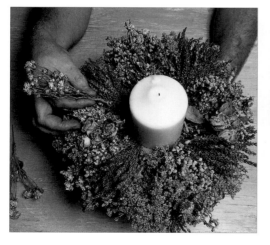

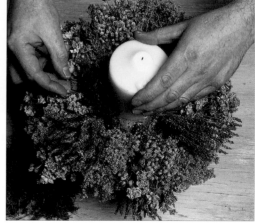

4 Add small bunches of miniature and standard roses at random to fill all the small gaps. If you use all the roses, add another material – in this display, larkspur was included.

5 Cover the base of the candle and the rim of the pot with green moss, using mossing (floral) pins to hold it in place.

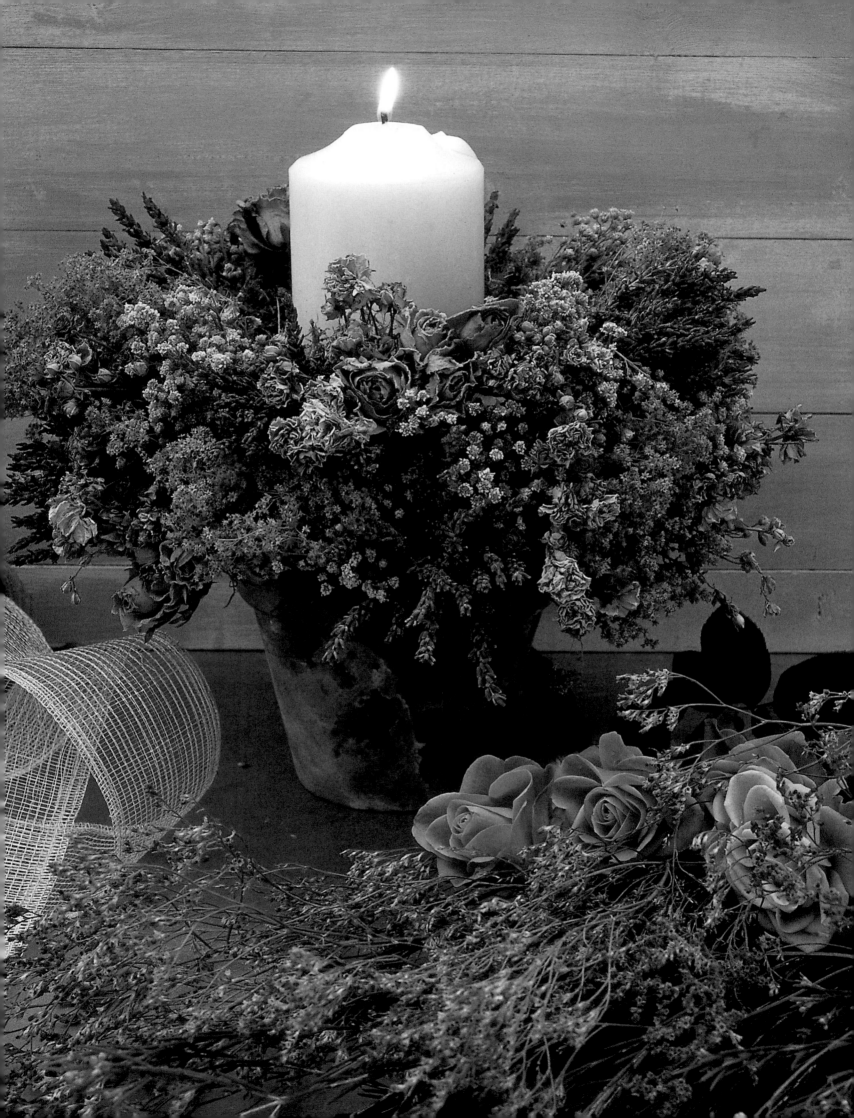

ROSE-PERFUMED CANDLE POTS

· · ·

MATERIALS

· · ·

hay

· · ·

silver reel (rose) wire, string or raffia

· · ·

scissors

· · ·

terracotta pot

· · ·

glue gun and glue sticks

· · ·

moss

· · ·

dried roses

· · ·

small-leaved green foliage

· · ·

rose-perfumed oil

· · ·

candle

Small roses can be inserted into any gaps in the design left by larger rose heads.

These two candle pots are variations of the same theme. One is a very simple combination of roses and foliage, while the other combines large as well as miniature roses, while using a larger candle. You could make a selection of small displays for dinner parties, using the larger pot as a centrepiece with vibrant green moss and small fruits arranged around the base. The wonderful long-lasting scent of the rose oil will be accentuated by the heat of the candle. Remember never to leave lighted candles unattended.

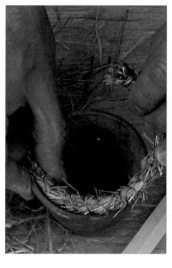

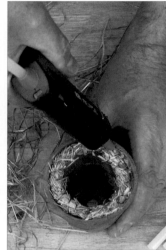

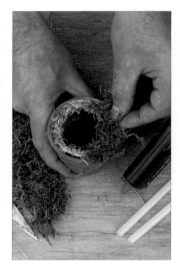

1 Make a small hay collar to fit inside the rim of the pot (see Techniques).

2 Glue the collar inside the rim of the pot, as close to the top as possible. Hold it firmly in place until the glue begins to harden.

3 Glue a layer of moss to the hay collar so that it also extends to cover the rim of the pot.

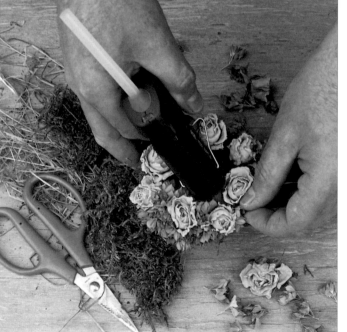

4 Cut the rose heads from their stems and glue them on to the moss, leaving enough room for the candle. Fill the gaps with foliage. If you are using miniature roses, add them after the foliage. Half-fill the pot with moss, pressing it down well to make a base for the candle. Sprinkle the moss with rose-perfumed oil. Finally, push the candle into the terracotta pot.

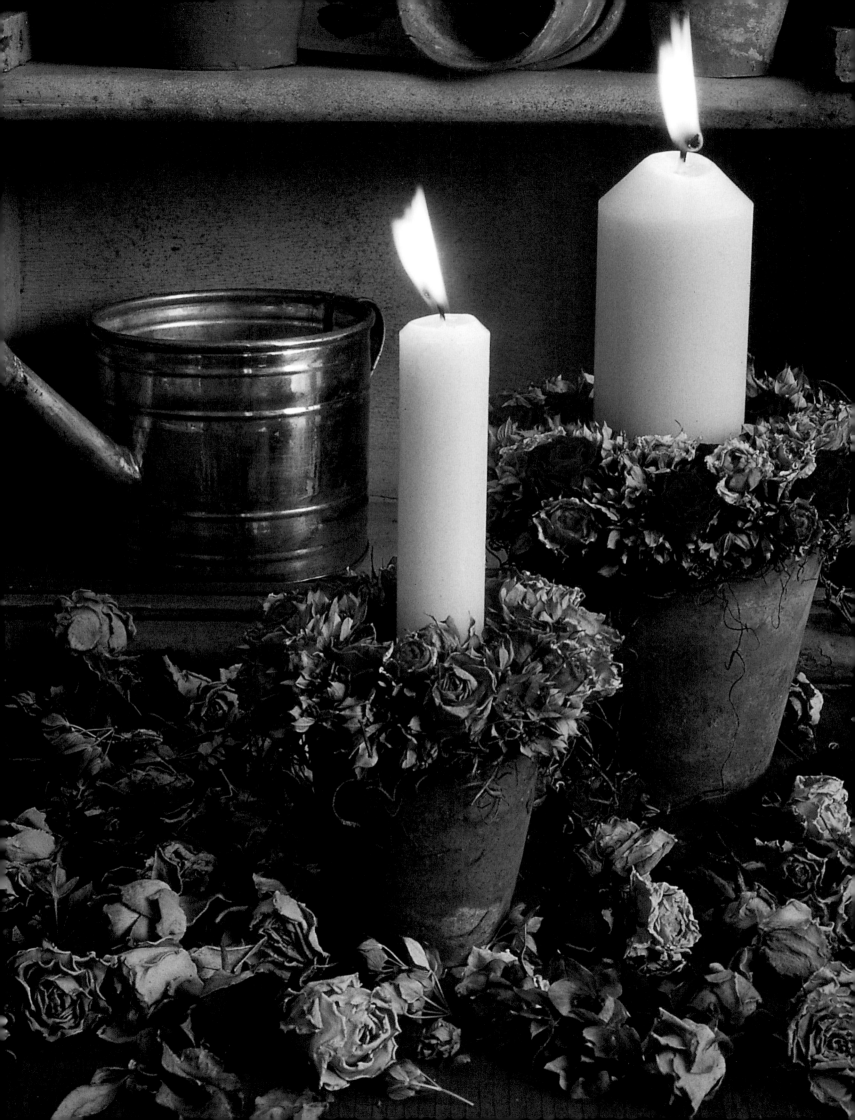

AUTUMN CANDLE POT
· · ·

MATERIALS
· · ·
knife
· · ·
*1 block plastic foam for dried
flowers*
· · ·
terracotta pot
· · ·
florist's tape (stem-wrap tape)
· · ·
mossing (floral) pins
· · ·
candle
· · ·
scissors
· · ·
.91 wires
· · ·
*dried materials, e.g. red
amaranthus, fir cones, lavender,
cinnamon sticks, twigs, chillies,
oranges, mushrooms, magnolia
leaves, holly oak leaves*
· · ·
raffia
· · ·
moss

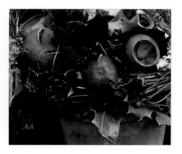

*This rich design uses plenty
of different materials, giving
a feeling of autumn harvest
and plenitude.*

This rich display symbolizes the harvest of flowers and fruit at this time of year. For a more glossy look, spray it with clear florist's lacquer then lightly highlight with gold spray paint. You could also use a candle perfumed with spices to add to the effect. Remember never to leave a lighted candle unattended.

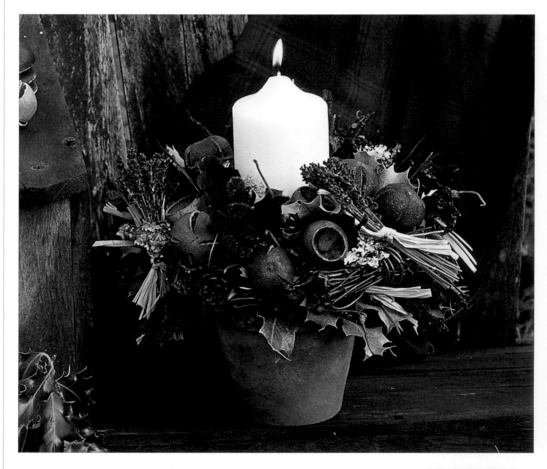

1 Trim the foam to fit snugly into the pot. Wire the candle in the centre of the foam (see Techniques). Fit the foam into the pot. Wire the dried materials individually or in bundles (see Techniques). Tie the lavender into bunches with raffia.

2 Insert the larger materials into the foam base, working on alternate sides of the display. Fill the spaces with the smaller materials. Finally add moss to hide the foam and candle base, using mossing (floral) pins.

WINTER CANDLE POT

· · ·

This welcoming little candle pot is made by gluing nuts to a hay collar, which is completely disguised once the project is complete. Decorate the pot with nuts in different shapes and sizes – those shown here are walnuts, brazil nuts and hazelnuts (filberts). Remember never to leave a burning candle unattended.

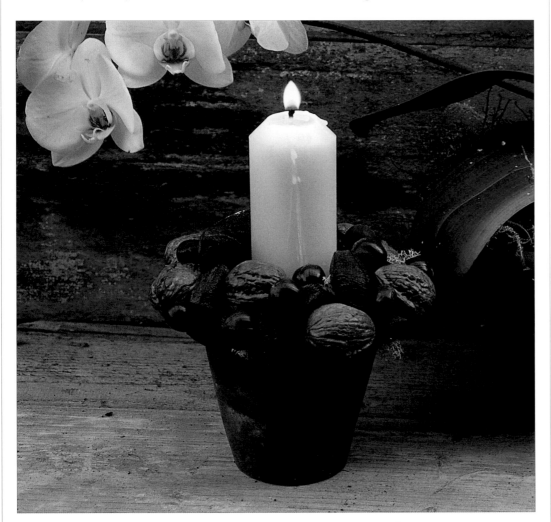

MATERIALS

· · ·

hay

· · ·

silver reel (rose) wire, string or raffia

· · ·

scissors

· · ·

small terracotta pot

· · ·

glue gun and glue sticks

· · ·

moss

· · ·

assorted nuts

· · ·

candle

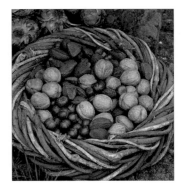

Nuts create a lovely festive effect, particularly when combined with the candle.

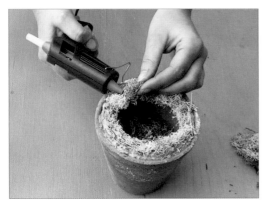

1 Make a small hay collar to fit the top of the pot (see Techniques). Glue it in place. Add some moss with glue.

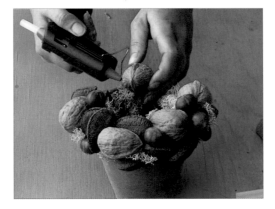

2 Glue nuts on top to make an attractive arrangement, letting them hang over the edge of the pot. Insert the candle.

CHRISTMAS CANDLE POT
• • •

MATERIALS
• • •
knife
• • •
1 block plastic foam for dried flowers
• • •
terracotta pot
• • •
florist's tape (stem-wrap tape)
• • •
mossing (floral) pins
• • •
candle
• • •
hay
• • •
secateurs
• • •
blue pine (spruce)
• • •
.91 wires
• • •
reindeer moss
• • •
small dried red roses
• • •
fir cones
• • •
dried mushrooms and dried kutchi fruit (alternatively, use cinnamon sticks and slices of dried orange)

Many other ingredients can be combined with blue pine (spruce), such as holly, to expand the Christmas theme.

Branches of blue pine (spruce), combined with red roses and fir cones, make a wonderfully rich centrepiece for the Christmas table. Use the blue pine (spruce) fresh so that you can enjoy its glorious scent. To match a dark wood table, paint the pot with dark stain and protect the table by fixing felt to the base of the pot. Remember never to leave a lighted candle unattended.

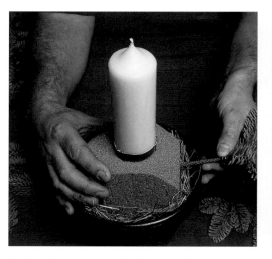

1 Cut the foam to fit the pot then wire the candle on top (see Techniques). Fix the foam into the pot, packing any spaces with hay. Group the blue pine (spruce) into pieces of various sizes. Trim the needles from the ends of the stems. Push the largest pieces into the base of the foam, so they lean down slightly.

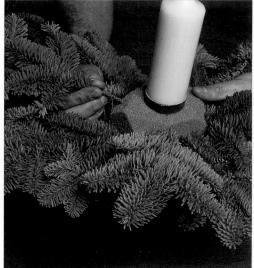

2 Add slightly shorter pieces of blue pine (spruce) to make a layer above the first. Continue to build up a pyramid shape, keeping the blue pine (spruce) well away from the candle. Use wires to strengthen or lengthen the shorter pieces.

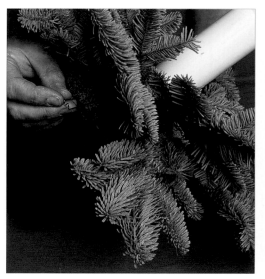

3 Fill any large spaces in the display with moss, attaching it with mossing (floral) pins. Put plenty of moss around the base of the candle to hide the tape.

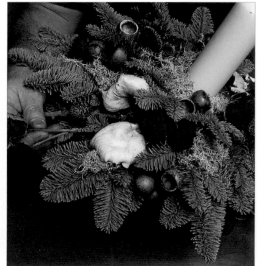

4 Wire the roses into bunches then wire the fir cones and other materials (see Techniques). Add to spaces in the display to create a balanced arrangement.

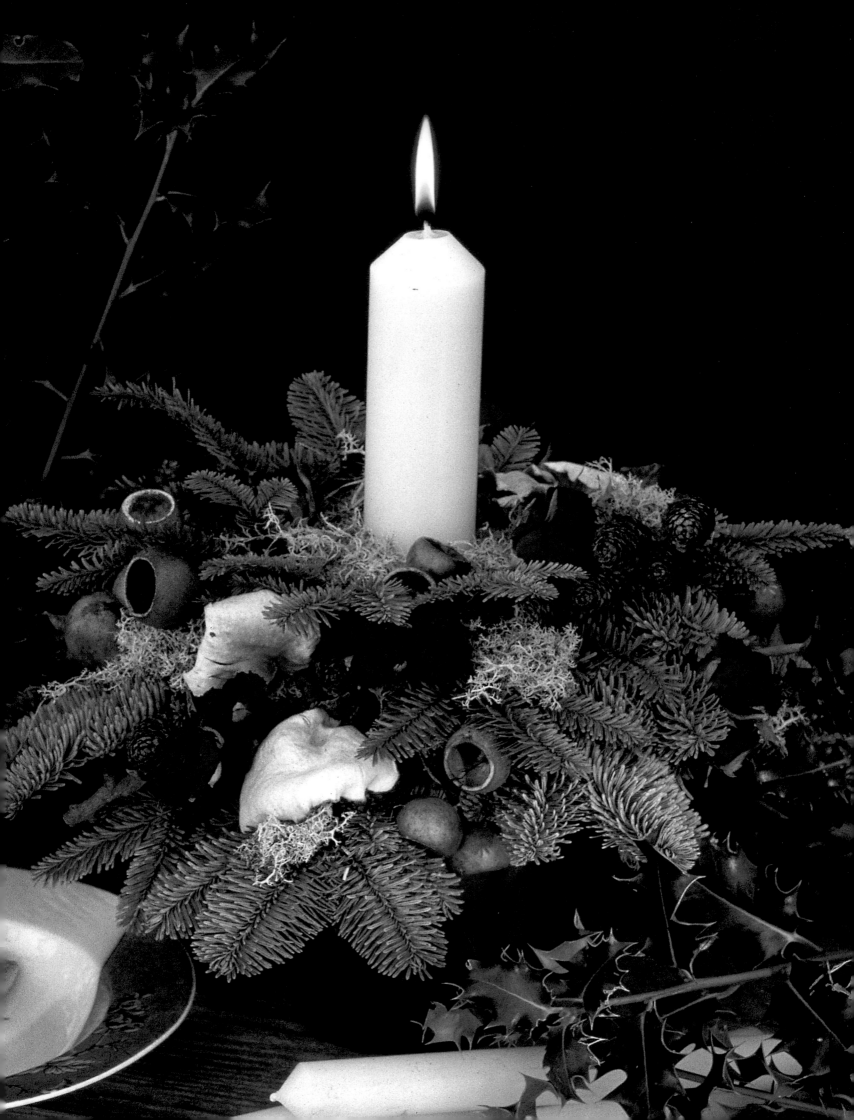

SEASHELL POT

· · ·

MATERIALS

· · ·

reindeer moss

· · ·

small terracotta pot

· · ·

hay

· · ·

*silver reel (rose) wire, string
or raffia*

· · ·

scissors

· · ·

glue gun and glue sticks

· · ·

seashells

· · ·

candle

*The intricate shapes of
seashells make them ideal
decorative materials and an
unusual alternative to flowers
and leaves.*

Dried flower arrangements are often not suitable for the steamy atmosphere of a bathroom or shower room, but seashells will be entirely at home. They come in a wonderful range of colours and shapes and you can collect your own shells on a seaside walk. Seashells are also available from specialist suppliers. Remember never to leave burning candles unattended.

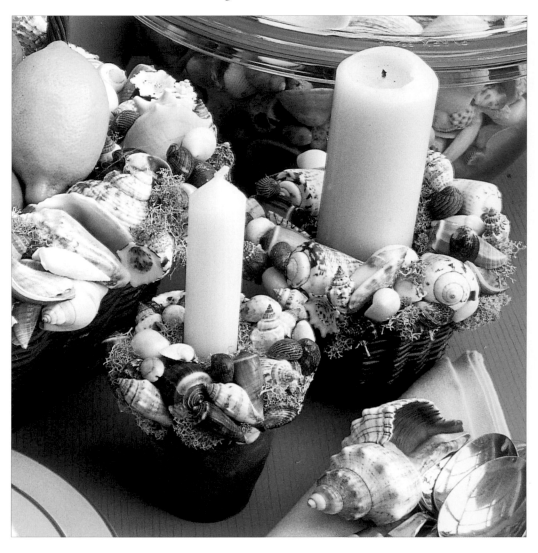

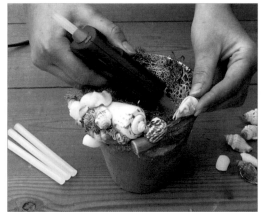

1 Take a good handful of reindeer moss and press it firmly into the pot until it is half full. Make a small hay collar to fit inside the top of the pot (see Techniques). Glue in place then use glue to cover both the hay collar and the rim of the pot with some moss.

2 Glue the largest shells on to the collar, leaving room for the candle. Fill in the gaps with smaller shells. Add a little moss where required. Insert the candle.

FIR CONE PYRAMID

. . .

This unusual pot is perfect for winter and Christmas decorations. The natural colours of the fir cones, moss and terracotta work beautifully together. For a delicate frosted effect, lightly spray the tips of the fir cones with white paint.

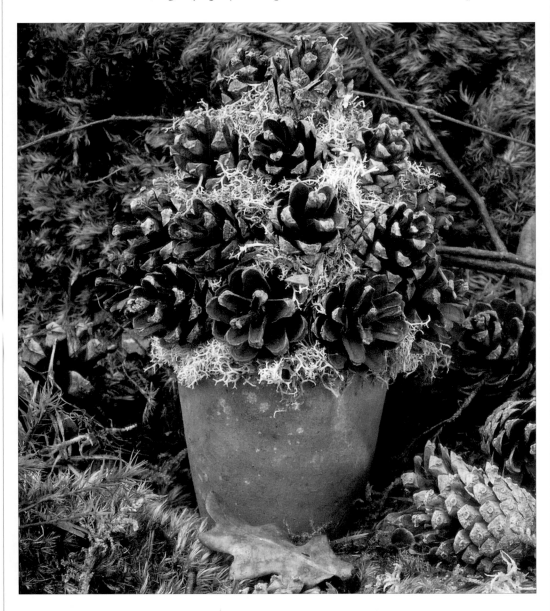

MATERIALS
. . .

knife

. . .

1 block plastic foam for dried flowers

. . .

terracotta pot

. . .

glue gun and glue sticks

. . .

moss

. . .

fir cones

Fir cones are often mixed with other materials, but this design celebrates their unusual shape.

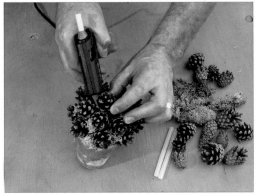

1 Cut the foam to fit tightly inside the pot. Make sure the top is flat as this will be the base for the pyramid of fir cones. Glue a layer of moss around the rim of the pot.

2 Glue a circle of fir cones on top, pointing outwards. Add a second circle, slightly overlapping the first. Continue to build up a pyramid shape until a full look is achieved.

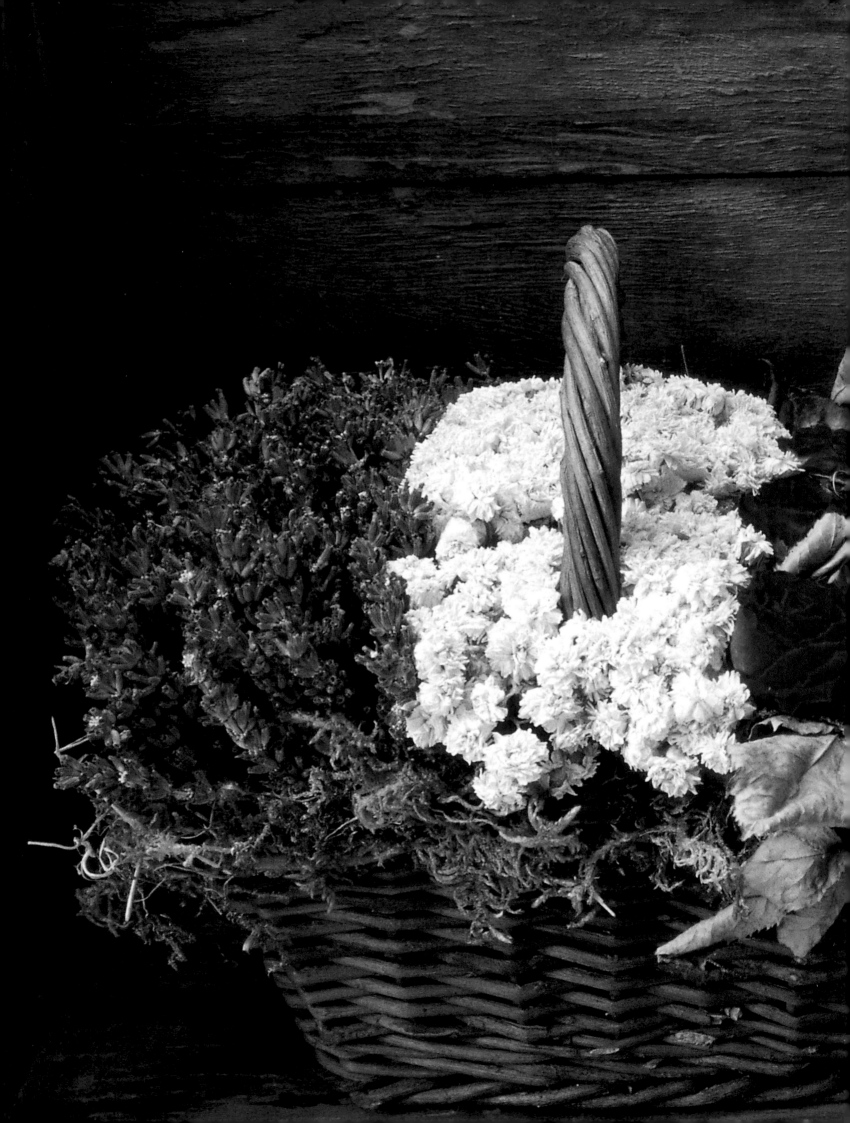

BASKETS OF ABUNDANCE

The natural texture of baskets makes them ideally compatible with all kinds of dried materials – summer or winter, colourful or muted. Fill a whole basket with an exuberant display and place it on the floor, in a fireplace or on a table. Alternatively, decorate the edge of the basket and fill it with fresh fruit or pot-pourri – a perfect gift or a symbol of hospitality.

INTRODUCTION

· · ·

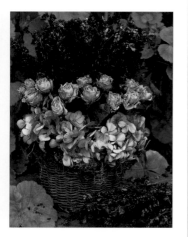

Above: Round Tiered Basket

Below: A variation on the Grand Garden Basket

Baskets come in a huge range of shapes and sizes, and part of the fun is to choose the right basket for your display. Some baskets may not be sturdy enough, depending on the weight of the dried materials you are using. Sturdy willow baskets are still made today and even an old, battered one with worn edges can be rejuvenated with a decorative border. The edges or handle (or even the whole basket) can be covered with moss, which is used to hide a multitude of other sins such as fixing wires and foam. Hunt out old baskets in junk shops and garden sheds – their distressed appearance can actually be an asset in some displays where a rustic look is called for, and they are sure to have character.

For an informal massed basket of dried flowers, one of the tricks of the florist's trade is to insert the bunches of flowers in S-shapes rather than straight lines so that the colours merge together naturally and there are no hard lines. Large flowerheads such as roses and peonies are usually added separately at the end so that there is no risk of them being damaged while you work on the rest of the display. If your dried roses are rather squashed or you would like them to be more open, you can gently steam them before using.

The essence of basket displays is for them to look abundant and generous, so use plenty of material and aim to fill the basket almost to overflowing. Handfuls of

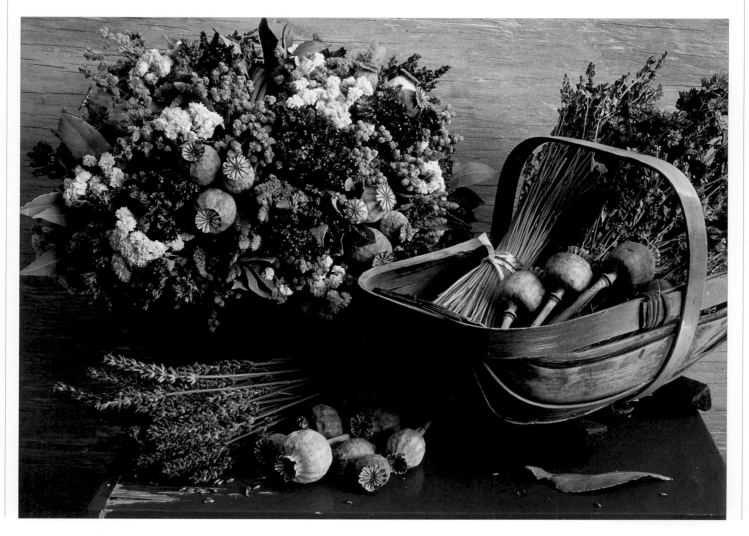

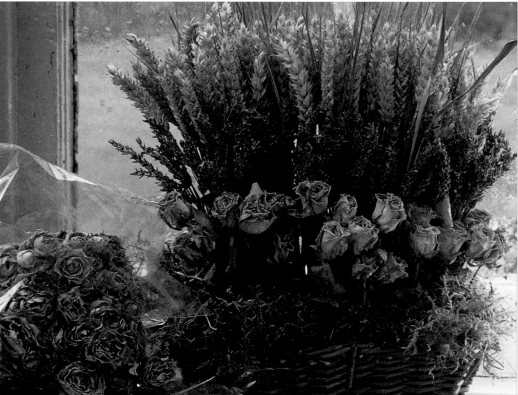

Above: Basket of Bulbs

Left: Flat-backed Tiered Basket

moss spilling over the edge will help to add to the luxurious effect. Experiment with unusual materials from the huge range available in florists' shops if you want to create an exotic display. If you are able to dry your own flowers and herbs from your garden this will, of course, be a considerable saving and also be very satisfying. Lavender is one of the most popular plants to grow and dry; if you have an abundance of flowerheads, lavender is wonderful used on its own to make a scented laundry basket. The tiny mauve-blue flowers also look very pretty in an old-fashioned arrangement with pale pink or red roses.

A large basket display is ideal for placing in an empty fireplace during the summer months, and if you use a chicken wire base it is very simple to replace individual stalks if any of the materials are damaged. You will need to regularly dust the display to keep it looking fresh.

As well as a host of inspirational ideas for all shapes and sizes of basket, this chapter also covers tiered displays in various forms, showing how it is possible to

Below: Pot-pourri Basket

adapt a traditional design in several ways to look different. A rectangular basket is the base for a large, flat-backed display in which the dried materials stand in formal rows one behind the other; this display would look good placed on the floor against a wall. The other tiered displays are both round, and are quite different in scale and character. Tiered displays may look impressive but they are one of the easiest dried flower designs to achieve and are therefore particularly recommended for a beginner.

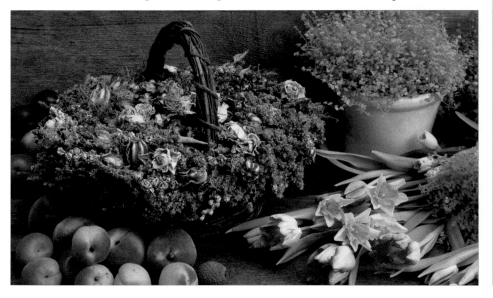

COUNTRY BASKET

· · ·

MATERIALS

· · ·

knife

· · ·

*1 block plastic foam for dried
flowers*

· · ·

round basket

· · ·

sphagnum moss

· · ·

scissors

· · ·

dried green amaranthus

· · ·

dried oregano

· · ·

dried pale green Amaranthus
caudatus

· · ·

dried larkspur

· · ·

dried miniature pink roses

· · ·

.91 wires

· · ·

green moss

· · ·

mossing (floral) pins

*Dried summer flowers and
herbs make a traditionally
beautiful display for any room.*

T his display will make the most of your wiring skills. Using lots of material in a fairly small space means that the wiring must be as neat as possible, so that all the stems fit into the foam base. The centre of the basket is filled with dried flowers, and the long trailing *Amaranthus caudatus* is placed around the edge.

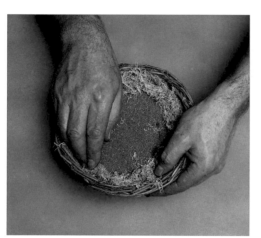

1 Trim the foam to fit snugly into the basket, leaving 2.5 cm (1 in) between the top of the basket and the foam. Pack moss between the edge of the basket and the foam.

2 Trim the flowers and herbs to about 20 cm (8 in) long. Wire each variety into small bunches (see Techniques). Starting with the least fragile flowers, push the stems into the foam. Add one variety at a time, using the oregano as the main filler.

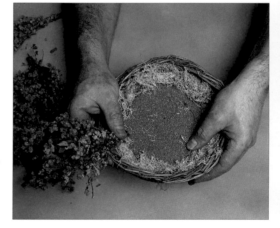

3 Begin to build up the display, saving the larkspur, *Amaranthus caudatus* and roses until last. Create a well-filled display, with little space between the bunches.

4 Push the *Amaranthus caudatus* into the foam around the edge of the basket so that it hangs down to touch the work surface. Add the larkspur to the display.

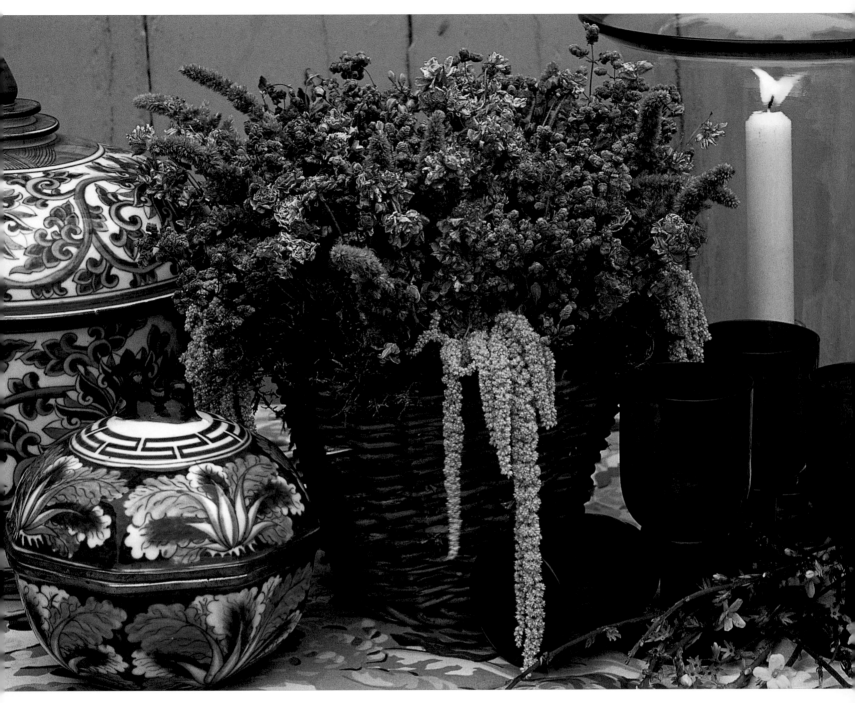

5 Add the roses evenly around the basket. Finally, use the green moss and mossing (floral) pins to fill the edge of the basket quite generously.

The draping effect created by the Amaranthus is exquisite.

CORNER DISPLAY

· · ·

MATERIALS

· · ·

wire cutters

· · ·

chicken wire

· · ·

*large basket, with or without
handle*

· · ·

dried green amaranthus

· · ·

dried pink larkspur

· · ·

*dried pale yellow and dark
red roses*

· · ·

dried lavender

*Amaranthus is an ideal filler
for many basket displays as its
long stalks accentuate a feeling
of height.*

This is an extremely simple arrangement to make, and has the advantage that
you can remake it as many times as necessary to create the right look, with-
out damaging the dried materials. This particular display has been made to look
the same from all angles; turn it occasionally, so that it fades evenly. If it is used as
a fireplace filler, you will need to clean it more regularly than other displays.

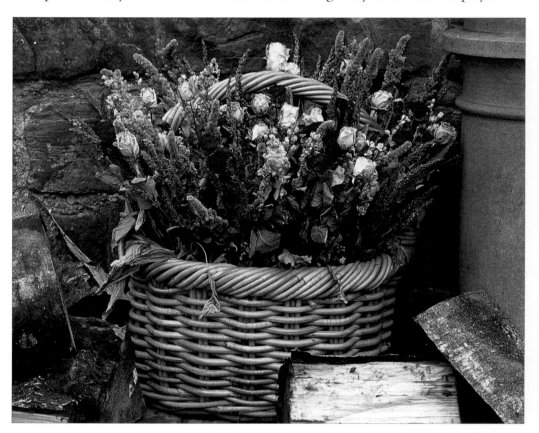

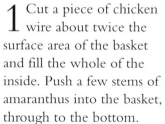

1 Cut a piece of chicken
wire about twice the
surface area of the basket
and fill the whole of the
inside. Push a few stems of
amaranthus into the basket,
through to the bottom.

2 Arrange the individual
stems of larkspur in the
spaces between the
amaranthus. Stand back
from the display from time
to time to check that the
balance is correct.

3 Add the roses and
lavender, putting some
rose heads low down at the
front of the basket for
added interest. Adjust the
display if necessary by
moving the flowers.

BASKET OF BULBS
· · ·

Plant early spring bulbs in small terracotta pots then bring them indoors to be displayed in a large basket with a decorated rim. Cover the earth in the pots with fresh moss so that the pots blend with the rich mixture of dried materials in the basket border. If you cannot obtain a basket with a broad rim, you can simply make a hay collar to support the decoration.

MATERIALS
· · ·
.91 wires
· · ·
small twigs
· · ·
glue gun and glue sticks
· · ·
large round basket, with a broad rim
· · ·
dried pomegranates
· · ·
dried lotus pods
· · ·
dried Protea compacta
· · ·
fir cones
· · ·
reindeer moss

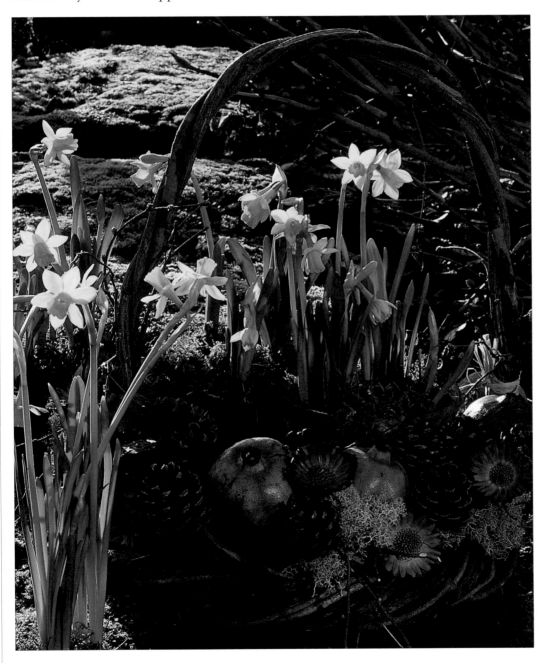

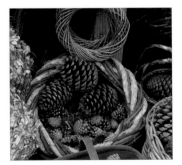

You can find all kinds of dried natural materials in woodland areas suitable for decorating baskets.

1 Wire the twigs into small bunches (see Techniques). Glue the wires to the rim of the basket at regular intervals to make an attractive border.

2 Divide the other dried materials into five equal groups. Space the pomegranates evenly around the rim and glue in place. Add the other materials to create a pleasing design, finishing with the reindeer moss to fill in small gaps.

HOLLY OAK AND ROSE BASKET

· · ·

MATERIALS

· · ·

knife

· · ·

1 block plastic foam for dried flowers

· · ·

basket

· · ·

scissors

· · ·

twigs

· · ·

.91 wires

· · ·

dried red roses

· · ·

preserved (dried) leaves

· · ·

moss

· · ·

mossing (floral) pins (optional)

· · ·

raffia

· · ·

glue gun and glue sticks

Instead of holly oak leaves, try using preserved (dried) copper beech leaves, here dyed green, to provide a neutral background for some roses.

Preserved (dried) leaves make unusual yet very attractive displays, and their bold abstract shapes lend themselves to sculptural arrangements. The leaves also act well as a counterbalance against the colours and softer forms of other materials. Here holly oak leaves are used, but beech, maple, ferns and many other leaves would be equally effective, depending on what's available.

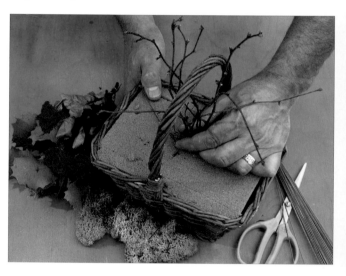

1 Cut the foam so that it fits tightly into the basket and press it firmly in. Add extra pieces of foam around the sides to make it sturdy, if you need to. Make sure that the surface of the foam is just below or level with the top of the basket, so that it will not be seen. Start the arrangement at the centre. Trim the twigs to similar sized lengths and then wire them in bunches (see Techniques) and push into the foam. Make sure that they are evenly positioned.

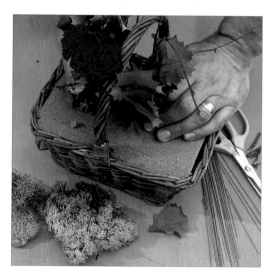

2 Trim the roses and the stems of the preserved (dried) leaves to the required length, remembering to allow extra to push into the foam. Steam the roses if necessary (see Techniques). Push them carefully into the foam, either wired into small bunches or one stem at a time. Start in the centre of the basket and work outwards. Turn the design frequently to check for any gaps and to make sure that the arrangement is well balanced.

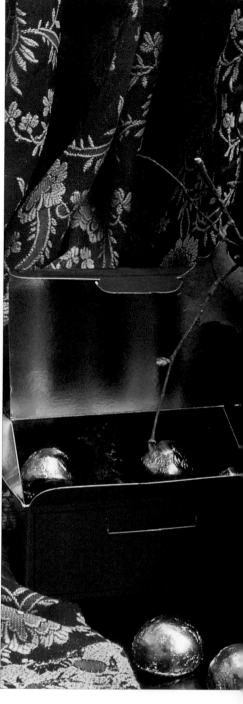

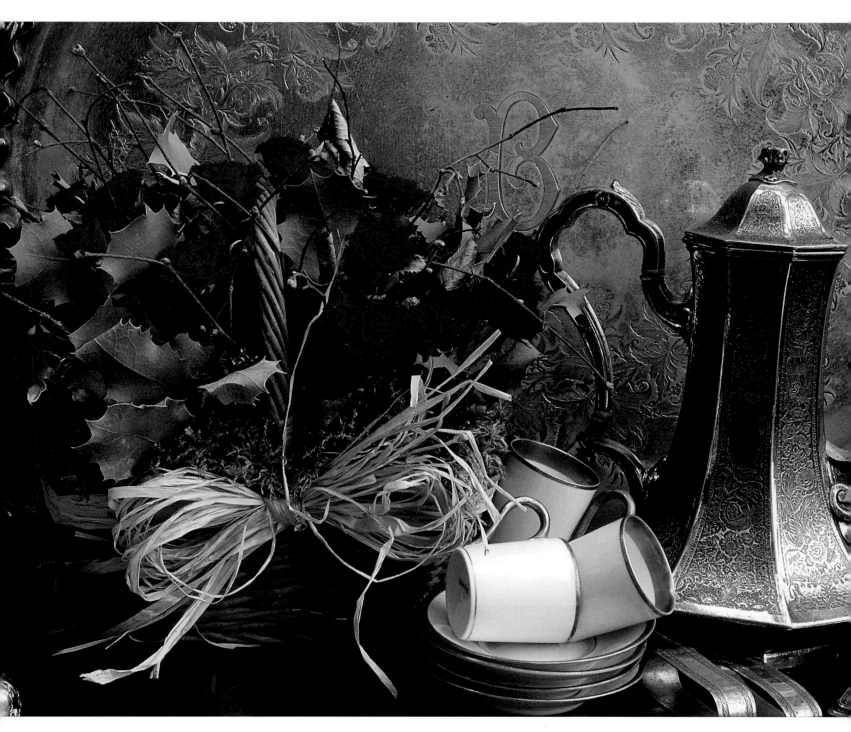

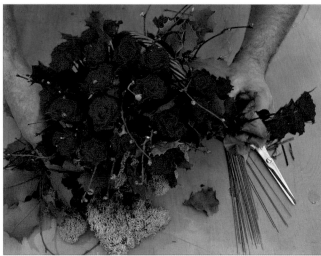

3 When you reach the edge of the basket, lean the flowers out slightly. Add moss to fill any small gaps around the edge of the display, holding it in place with wires bent into U-shaped staples or mossing (floral) pins. Cut twelve strands of raffia and tie in a bow. Glue to the centre of the basket.

The display will look stunning in a rustic setting.

CLASSIC COUNTRY BASKET

· · ·

MATERIALS

· · ·

knife

· · ·

1 block plastic foam for dried flowers

· · ·

round or oval basket

· · ·

hay or moss

· · ·

scissors

· · ·

dried larkspur

· · ·

dried red amaranthus

· · ·

dried oregano

· · ·

dried blue Eryngium *alpinum*

· · ·

dried red roses

· · ·

dried peonies

· · ·

.91 wires

· · ·

mossing (floral) pins

This lovely basket is filled with a mass of traditional flowers and herbs.

In this traditional basket, the aim is to create a well-filled display, with very little or no space between the bunches of dried material. Each variety is inserted in an S-shape so that the colours and forms appear to flow together, with no harsh lines between them. Add the larger, more dramatic roses and peonies last.

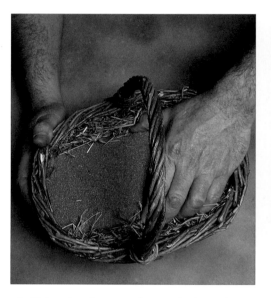

1 Trim the foam to fit snugly into the basket, leaving at least 2.5 cm (1 in) between the top of the basket and the foam. Fill any spaces with hay or moss.

2 Trim the materials to approximately 25 cm (10 in) long. Starting with the least fragile flowers, wire them into bunches (see Techniques). Push them into the foam, creating an S-shape with each variety across the basket.

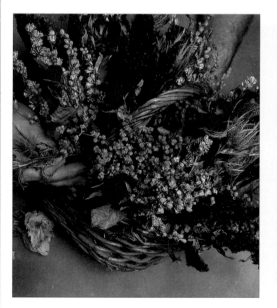

3 Build up the display, saving the roses and peonies until last. Finally, insert the roses and peonies, distributing them evenly across the basket.

4 Add moss around the edge of the basket, to hide the foam and as many stems as possible. Hold the moss in place with mossing (floral) pins. Let the moss hang over the side, to give a soft look to the edge of the basket.

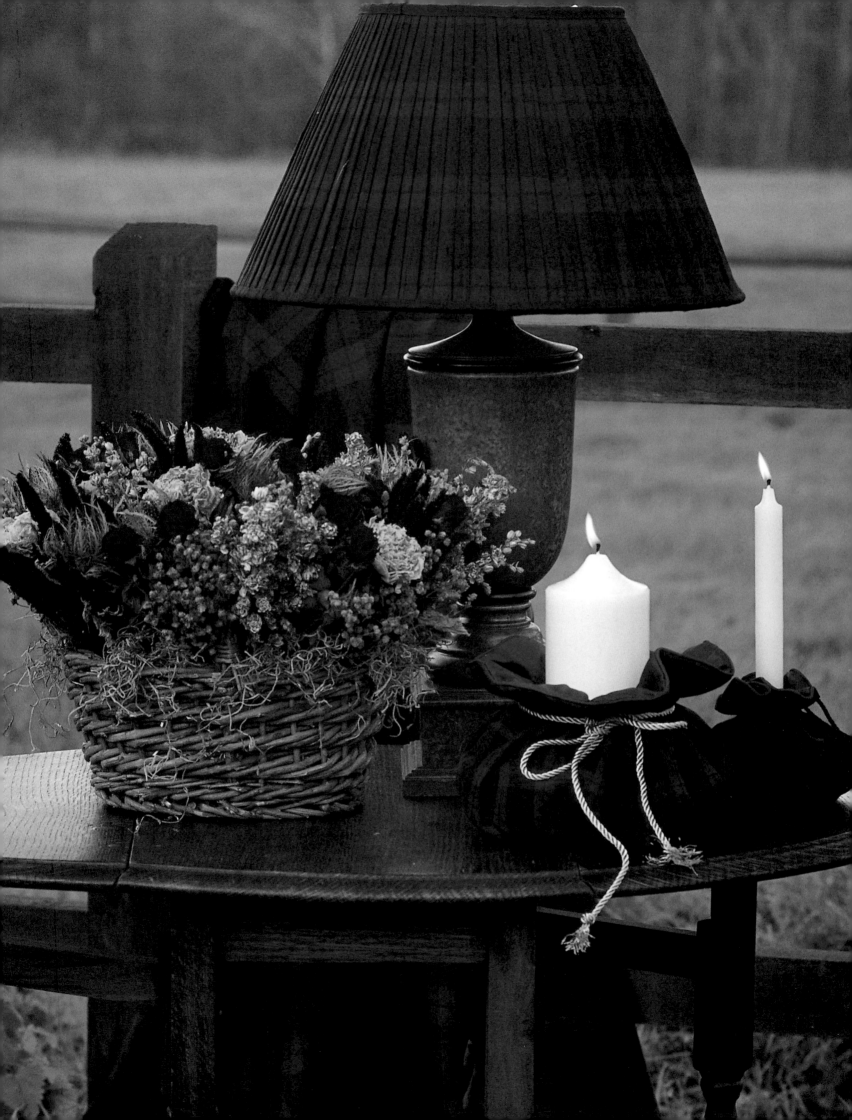

GRAND GARDEN BASKET

· · ·

MATERIALS

· · ·

knife

· · ·

1–2 blocks plastic foam for dried flowers

· · ·

round or oval basket

· · ·

.91 wires

· · ·

dried materials, e.g. Alchemilla mollis, hydrangeas, lavender, marjoram, nigella, peonies, pink roses

· · ·

scissors

The colours of the flowers will last longer if they are kept out of direct sunlight.

This is intended to be a bold, extravagant display, so use the best materials you can find to create an abundant mixture. Flowers including peonies, roses, lavender and hydrangeas have been used in this sumptuous basket.

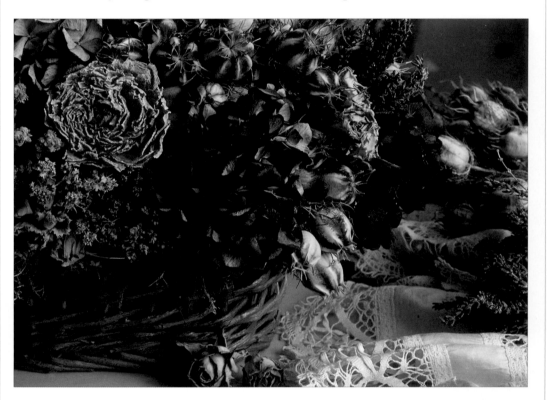

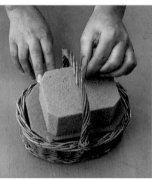

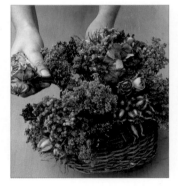

1 Cut the foam to fit snugly into the basket and press in firmly. Make sure the top of the foam is level, trimming the foam if needed. Place a second piece of foam, about two-thirds the size of the base piece, on top of the first. Fix firmly in place with U-shaped staples made by bending wires in half.

2 Separate each variety of dried material. Trim the stems so that they are all about 10 cm (4 in). Wire the smaller flowers into bunches about 5–8 cm (2–3 in) wide (see Techniques). Insert the bunches in an S-shape, working from one side to the other as you build up the layers.

3 Fill in the background colour first. Save the larger peonies, roses and hydrangeas until last or you may damage them as you work. The aim is to create a well-filled dome. Allow the flowers to hang well over the edge of the basket by working horizontally into the foam around the sides, as well as vertically.

SIMPLE SUMMER DISPLAY

· · ·

This beautiful display of pale pink roses and peonies, solidago and wheat is in fact a very simple project to make. Because it uses no foam or wires it is ideal for a beginner. The dark wooden logs positioned in the back of the basket give an extra, rustic texture to the design.

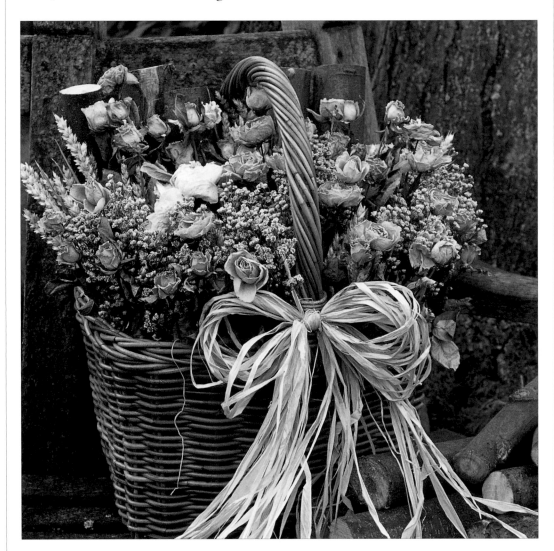

MATERIALS

· · ·

wire cutters

· · ·

chicken wire

· · ·

large basket, with handle

· · ·

dark wooden logs

· · ·

dried pale pink and yellow roses

· · ·

dried pale pink peonies

· · ·

dried solidago

· · ·

dried wheat

· · ·

scissors

· · ·

raffia

Large-headed flowers such as roses and peonies make it easy to fill space.

2 Position the logs upright, at the back of the basket. Push the dried material stems through the chicken wire to the bottom of the basket, trimming them to the required length. Place the basket on the floor and stand back frequently to check that the balance is correct and that the amount of filling is right.

1 Cut a piece of chicken wire approximately twice the surface area of the basket. Scrunch it up and place it inside the basket, completely filling it up.

3 Cut several long strands of raffia and tie to the base of the handle in a huge, simple bow. Allow the strands to flow loosely over the side of the basket.

DECORATIVE BASKET BORDER

. . .

MATERIALS

. . .

sphagnum moss

. . .

knife

. . .

rope

. . .

wide, shallow basket

. . .

.91 wires

. . .

scissors

. . .

dried lavender

. . .

silver reel (rose) wire

. . .

reindeer moss

. . .

mossing (floral) pins

. . .

dried red roses

. . .

glue gun and glue sticks

In many displays only the lavender flowers are visible, but in this pretty basket the stalks are also part of the design.

In this lovely basket criss-cross bunches of dried lavender, red roses and reindeer moss decorate the rope swag border, leaving the centre of the basket as a useful container for fresh fruit. Make sure the roses are glued on to the rope swag, not to the reindeer moss, otherwise they may fall off.

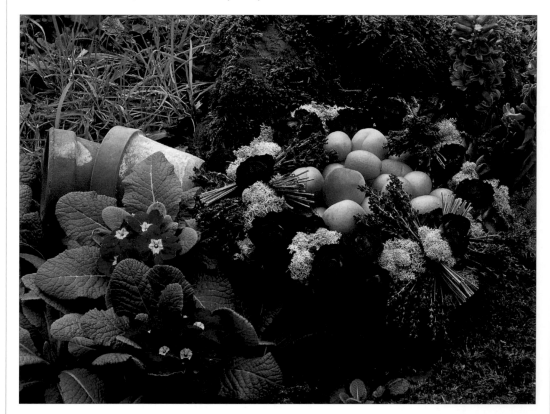

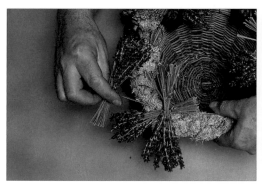

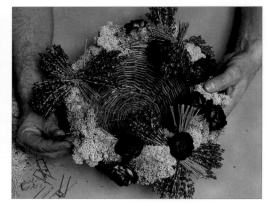

1 Using sphagnum moss, make a rope swag to fit round the top of the basket (see Techniques). Attach it to the basket with wires. Trim the lavender and centre-wire into small bunches using silver reel (rose) wire (see Techniques). Push the wire of one bunch lengthways into the moss, then add two more bunches so they cross at the same point. Repeat at equal intervals all around the border.

2 Add the reindeer moss, attaching it firmly with mossing (floral) pins. Cover most of the border but leave a few spaces for the roses. Steam the roses if necessary (see Techniques). Cut the rose heads from their stems and glue them directly on to the spaces on the rope swag.

POT-POURRI BASKET

· · ·

This country garden display will continue to remind you of summertime throughout the year. Fill the pretty basket with rose-scented pot-pourri, which will blend beautifully with the evocative scent of the dried roses and oregano that are included in the richly textured border.

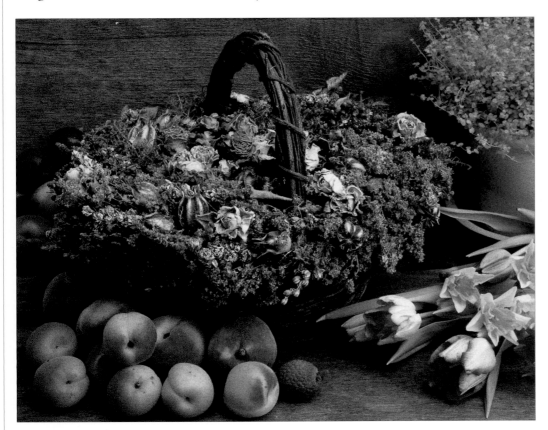

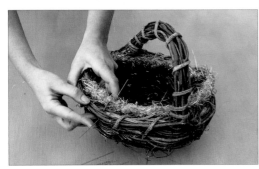

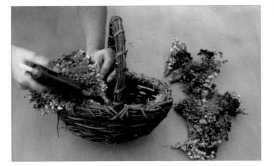

1 Make a hay collar to fit the inside edge of the basket (see Techniques). Attach it with wires through the basket just under the collar then twist the ends together. Repeat at regular intervals around the basket. The collar should be the same level as the top of the basket. Trim the ends of wire and bend them into the hay.

2 Trim all of the stems to 8 cm (3 in). Wire the *Alchemilla* and oregano separately in bunches (see Techniques).

3 Glue all the materials to the collar. Separate the large single flowers from the small bunches of *Alchemilla* and oregano to create a pleasing design. Fill any gaps with small flowers and moss. Finally, fill the basket with pot-pourri.

The combination of green moss and pink flowers is quite exquisite.

LAVENDER BASKET

· · ·

MATERIALS
· · ·
silver reel (rose) wire
· · ·
scissors
· · ·
dried lavender
· · ·
wide, flat basket, with handle
· · ·
glue gun and glue sticks
· · ·
blue paper ribbon
· · ·
blue twine

Because of its fresh scent, lavender is the perfect decoration for a basket that holds laundry or towels.

A traditional willow basket decorated with bunches of dried lavender makes an exquisitely pretty and scented storage place for linen. It could also be kept on the kitchen dresser, filled with freshly laundered tea towels (dish towels) ready on hand when you need them, or used to decorate a guest room. This display is very appealing because the final result is practical as well as pretty.

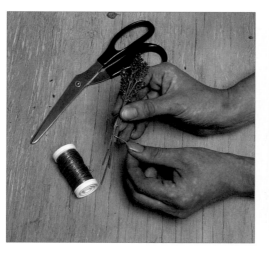

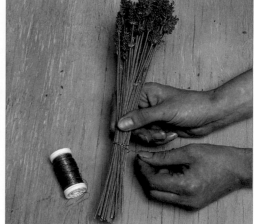

1 Using silver reel (rose) wire, wire small bundles of about six lavender heads (see Techniques). You will need enough to cover the rim of the basket generously. Arrange the lavender heads so they are staggered, to give fuller cover. Trim the stalks short.

2 Wire the remaining lavender into twelve large bunches of about twelve lavender heads, for the handle. Leave the stalks long.

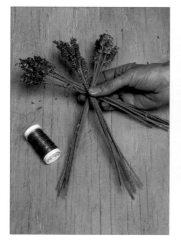

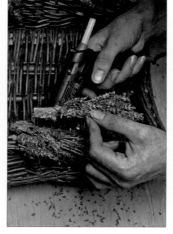

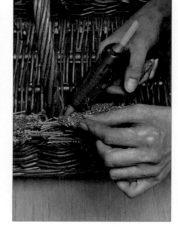

3 Wire three of the large bunches of lavender together as shown to make a fanned criss-cross shape. Repeat the process with the rest of the large lavender bunches.

4 Glue the small bunches to the rim of the basket, starting at one end and working towards the handle. Overlap the bunches to cover the width of the rim.

5 Add individual heads of lavender to cover any spaces, ugly wires or stalks that are still showing through. Pay particular attention to the area near the handle.

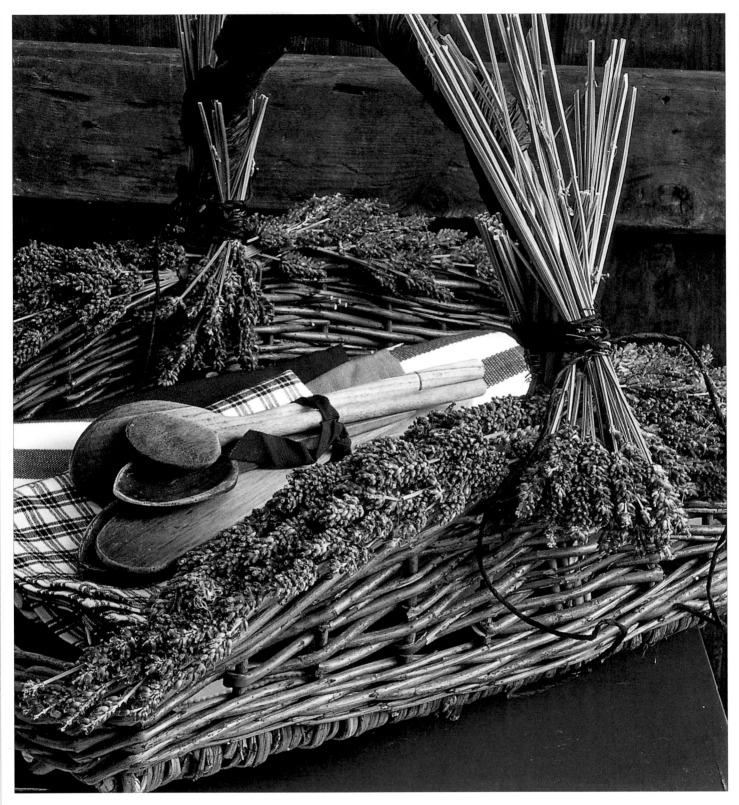

6 Wind paper ribbon around the handle. Wire the longer lavender bunches to the handle. Leave the stalks long but trim them to neaten. Cut the stalks on the inside of the handle shorter to fit. Bind the wired joints with twine.

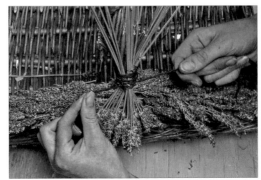

Criss-cross bunches of long lavender stalks make a bold, unusual decoration for a linen basket.

FLAT-BACKED TIERED BASKET

· · ·

MATERIALS

· · ·

knife

· · ·

*1 block plastic foam for
dried flowers*

· · ·

large rectangular basket

· · ·

scissors

· · ·

.91 wires

· · ·

dried wheat

· · ·

dried lavender

· · ·

dried roses

· · ·

fresh moss

· · ·

mossing (floral) pins (optional)

*The tall wheat is perfect at the
back of this basket. Because it
will shield the flowers from the
sun, the basket can be placed
on a windowsill.*

This formal design is one of the easiest for beginners to perfect. As long as you make sure that each layer is the correct height, you can create a dramatic display. Loose, flowing materials work well within the confines of a disciplined structure. Place it against a wall or to fill a fireplace during the summer months.

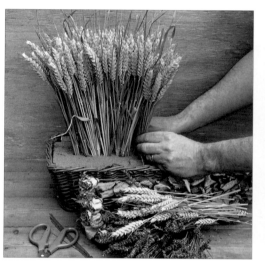

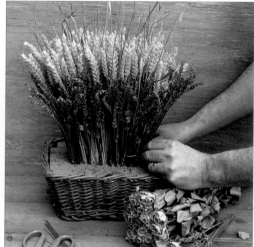

1 Cut the foam to fit the basket and press firmly in. Trim and wire the wheat into bunches of 8–10 stems (see Techniques). Starting in the centre of the foam, pack the stems closely together. Check that the height balances with the basket size.

2 Trim and wire the lavender into small bunches of 5–6 stems. Push them into the foam directly in front of the wheat, packing them close together. The lavender flowers should come just below the heads of wheat. Make sure the flowers are all facing the same way.

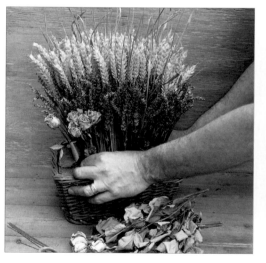

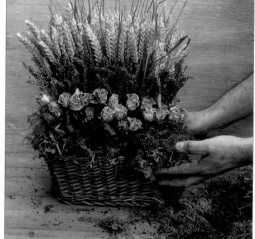

3 Add the roses individually, positioning them in front of the lavender. Keep as much foliage as possible to fill out the tier and give it shape. Place the roses at slightly varying heights so that each flowerhead is visible and evenly placed.

4 Cover the foam with generous handfuls of moss. Fix it in place with wires bent into U-shapes or mossing (floral) pins. Fresh moss shrinks when it dries, so allow it to overhang the sides of the basket.

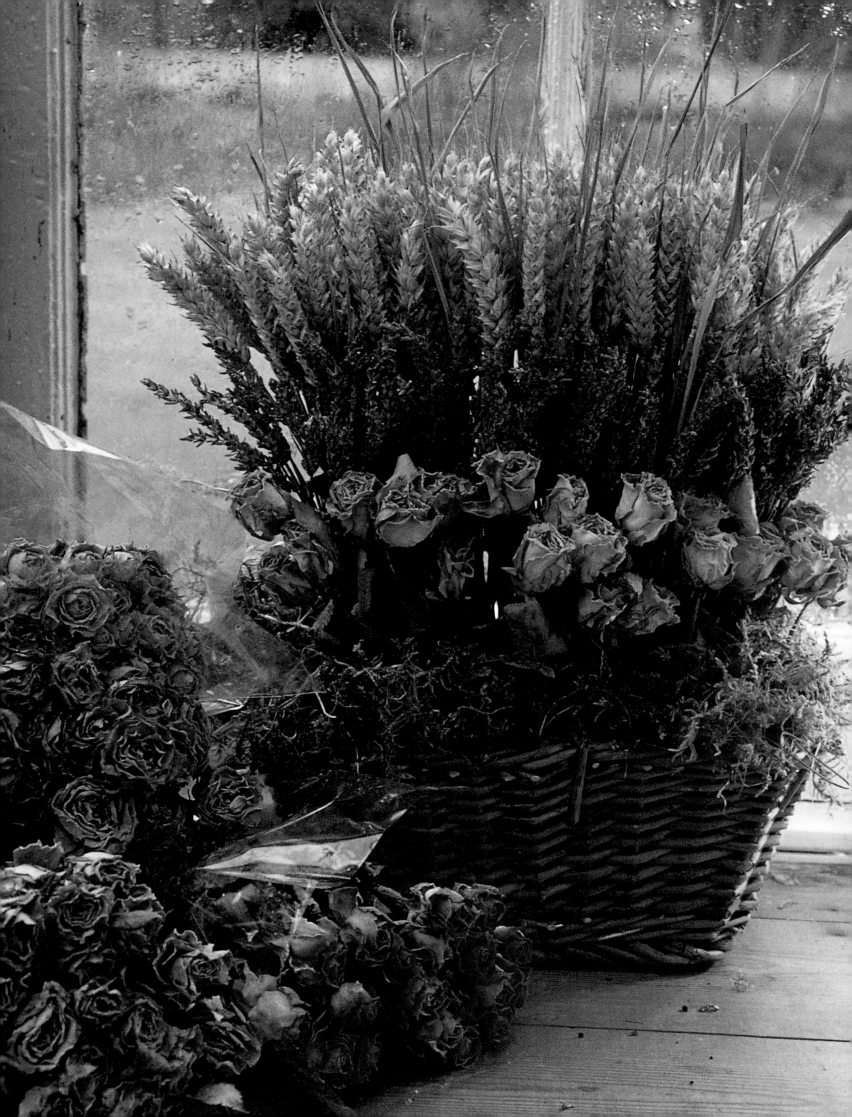

SMALL TIERED BASKET

· · ·

Using two garlands as a base helps to make this an unusual structured display.

This pretty tiered display is made with two favourite dried materials – red roses and lavender. The bottom tier is, in fact, the trimmed stalks from the lavender, their sculptural lines adding an extra dimension to the design. You can use a shallow basket instead of the two garlands.

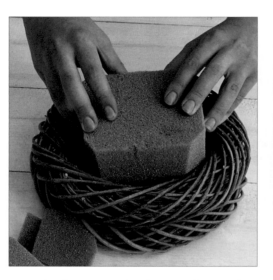

1 Join the two garlands securely together with wires. Cut a piece of the foam to fit snugly into the centre of the garlands and push in firmly.

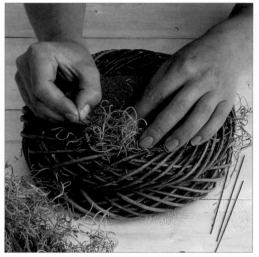

2 Attach hanks of moss to the edge of the foam, using wires bent into U-shaped staples. Allow the moss to hang over the edge of the top garland.

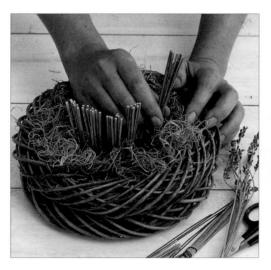

3 Trim about 12 cm (5 in) off all the lavender stalks. Wire the trimmed stalks at one end into even-sized bunches of about ten stalks (see Techniques). Insert the stalk bunches into the foam, just inside the moss.

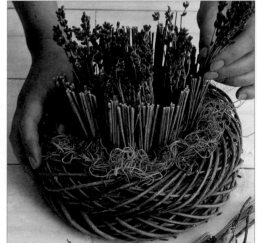

4 Trim the remaining lavender so the flowerheads are level and will stand just above the stalks. Wire them into even-sized bunches and insert in a circle just inside the trimmed stalks, leaving room for the roses. Trim the roses the same way, wire them into bunches of 2–3 flowers and insert in the centre, facing outwards at an attractive angle.

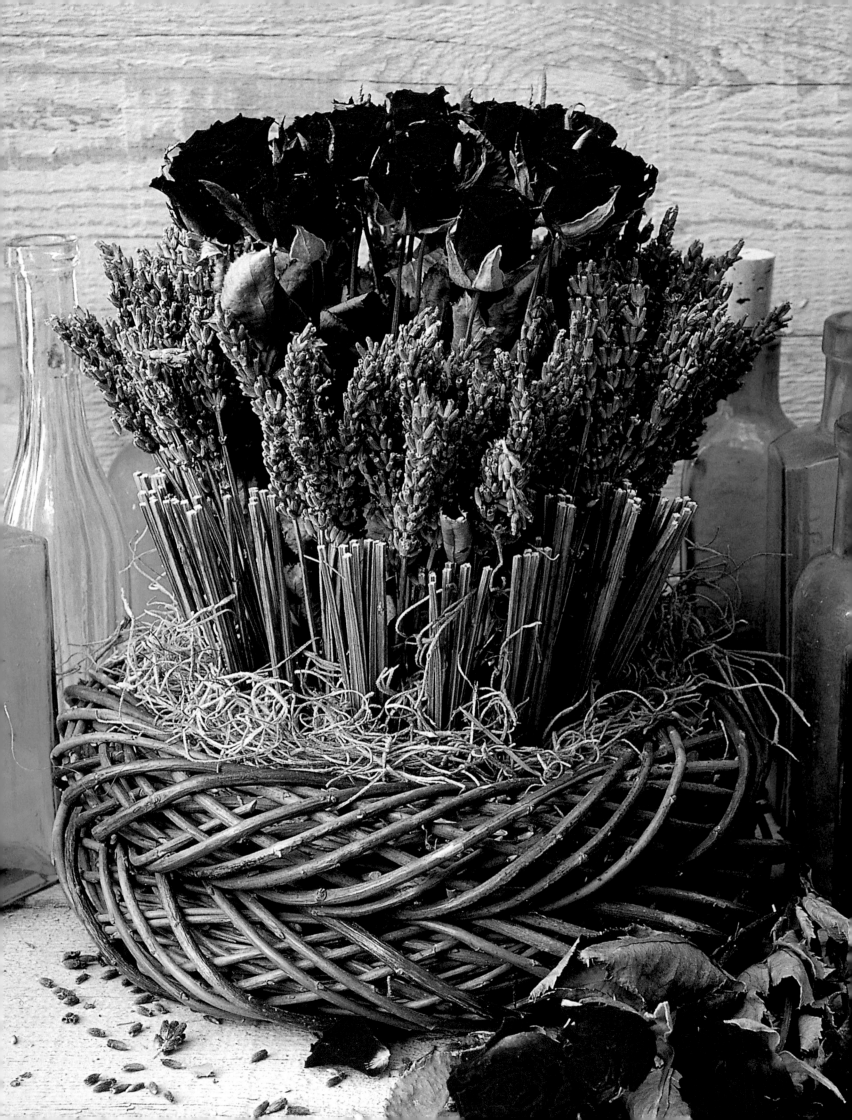

ROUND TIERED BASKET

· · ·

MATERIALS

· · ·

knife

· · ·

*1 block plastic foam for dried
flowers*

· · ·

round basket

· · ·

scissors

· · ·

dried deep blue larkspur

· · ·

.91 wires

· · ·

dried yellow roses

· · ·

dried hydrangea heads

· · ·

moss

· · ·

mossing (floral) pins (optional)

*The vibrant blue and bright
yellow of the larkspur and
the roses make for a very
cheerful display.*

This colourful basket is an informal round version of the traditional flat-backed tiered basket. The effect is simple to achieve as all you have to do is to keep each layer the same height. Insert the tallest flowers first then stand back to check that the height balances well with the size of the basket.

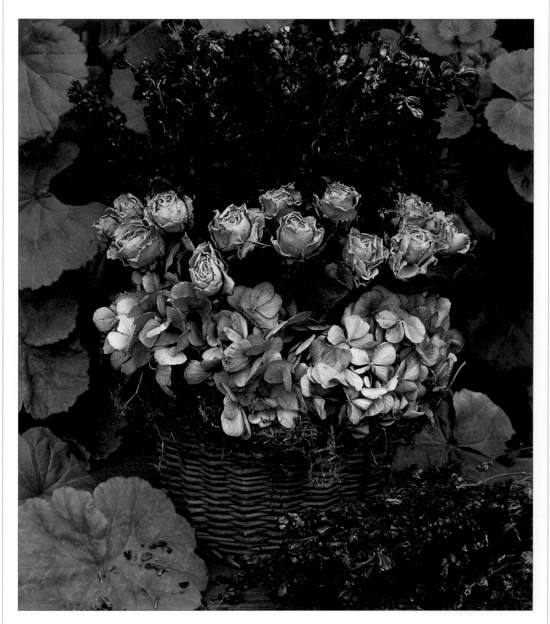

1 Cut the foam to fit the basket and press firmly in. Trim all the larkspur to the same length and wire into bunches of 8–10 stems (see Techniques). Insert the larkspur in the centre of the foam, packing the bunches closely together.

2 Trim and wire the roses, leaving as much green foliage as possible. Insert them individually in a circle around the larkspur, placing the rose heads at slightly varying angles to add interest, and so that each one is visible.

3 Trim the hydrangea heads, wire and insert around the bottom of the display. Cover the foam with moss, allowing it to trail over the edge of the basket, attaching it with mossing (floral) pins or wires bent into U-shapes.

SUMMER TIERED BASKET

· · ·

Flowering mint is an unusual material in a tiered basket, combined here with more traditional roses and lavender. Its delicious strong scent will last well, as will that of the lavender, reminding you of summer.

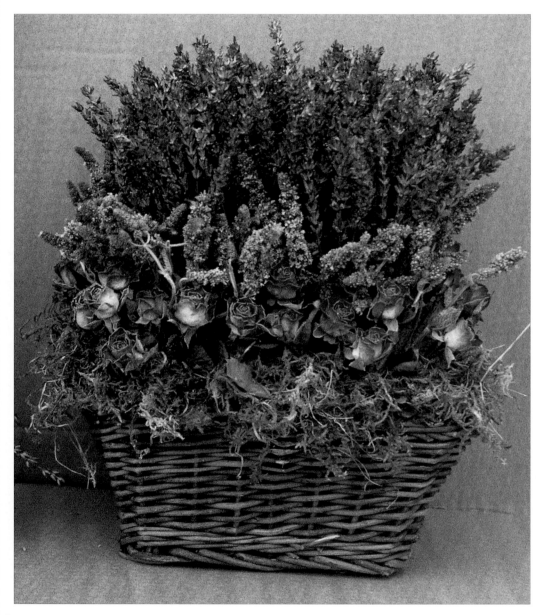

MATERIALS

· · ·

knife

· · ·

1 block plastic foam for dried flowers

· · ·

large basket

· · ·

scissors

· · ·

dried lavender

· · ·

.91 wires

· · ·

dried mint flowers

· · ·

dried deep pink roses

· · ·

fresh sphagnum moss

· · ·

mossing (floral) pins

When lavender is combined with mint a wonderful strong scent is created, while the roses help to accentuate the colour contrast in the design.

1 Cut the foam block to fit the basket and press firmly in. Trim all the lavender to the same length and wire into small bunches (see Techniques). Insert into the foam at the back of the basket, leaving space at either end for the other materials.

2 Trim the mint flowers so that they are shorter than the lavender. Insert them in front of the lavender and at the sides, allowing the row of flowerheads to create an informal, natural effect. Make sure that there is space for the row of roses.

3 Trim the roses so that they are shorter than the mint. Position them naturally in front of the mint and around the sides.

4 Cover the foam with handfuls of moss, attaching it with mossing (floral) pins.

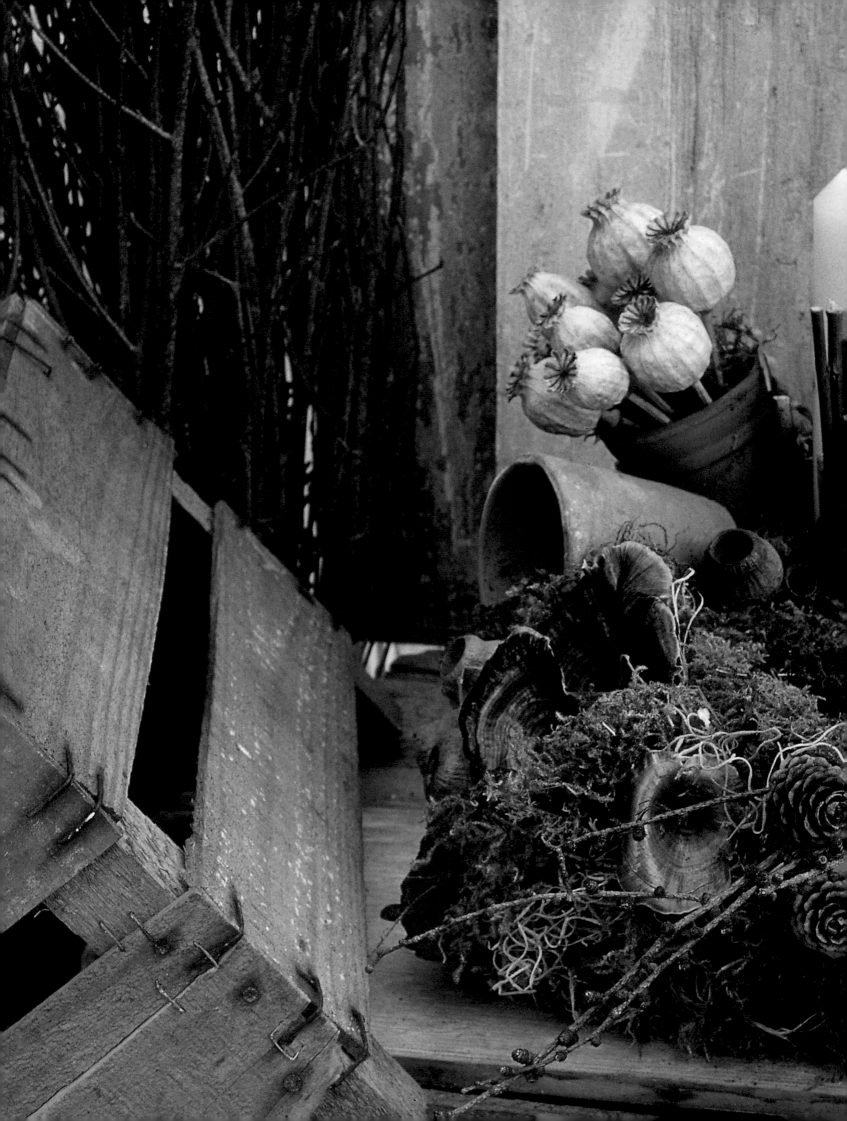

BOXES AND BUNDLES

• • •

Terracotta pots and baskets are only two of the many kinds of container that you can use for a dried flower display. Experiment with unusual boxes, or make your own base from a simple piece of cardboard. You can even dispense with a container altogether, and gather your dried materials together into a hay-covered bundle or a hand-tied posy.

INTRODUCTION

. . .

Above: Rose Bundle

Below: Quartered Box

Af/ter a while, you may find that working with conventional pots and baskets becomes a little predictable and that you want to try something different to expand your repertoire. This is an ideal chance to experiment, and to improvise by finding new bases for your displays.

A valued receptacle such as a glass bowl or antique pine tub may inspire a display specifically designed for that container. At the other end of the spectrum, recycled metal is now very fashionable in interior design and even a large tin looks effective when it is filled with a vivid display of flowers.

Other containers are not so attractive to look at and need to be disguised with paint or fabric. A basic wooden crate or humble cardboard box makes an excellent base for all kinds of displays, although you may need to reinforce the corners of a cardboard box so that it doesn't lose its shape under the weight of the dried materials. One of the simplest and most successful designs is a quartered box; this is a cardboard box sectioned with string or cord into four equal spaces, each of which is filled with a different-coloured material.

Another attractive option is to fill the top of a cardboard box with a still life composed of unrelated objects such as shells, fungi, sticks and flowers. You can also add a candle, depending on where you wish to place the finished display. This theme can be successfully repeated many times, using quite different objects. Yet another idea is to wrap an oval-shaped gift box with large preserved (dried) leaves,

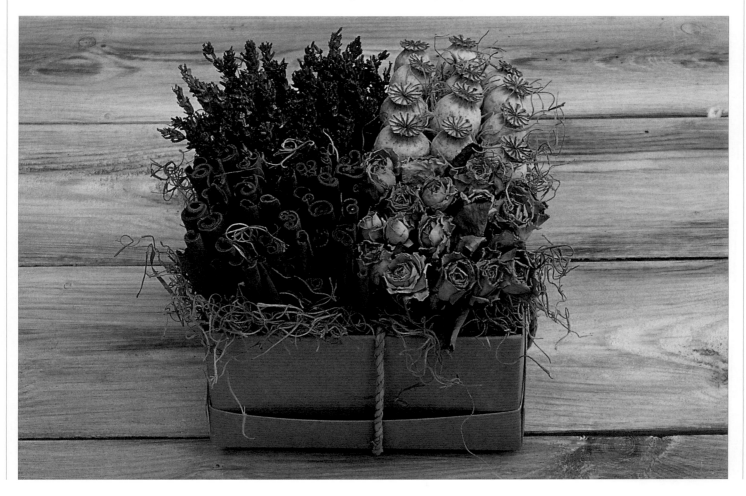

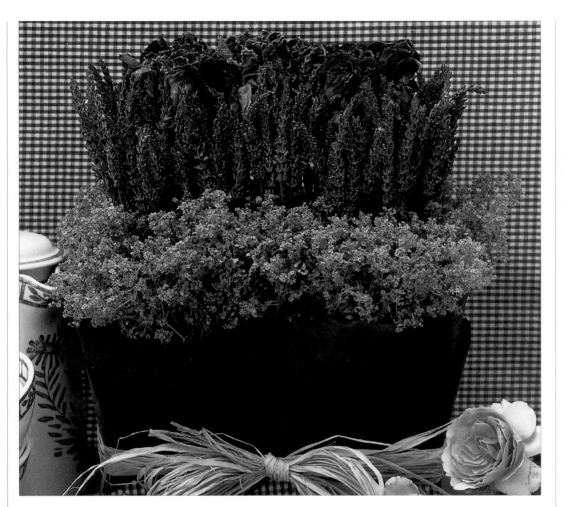

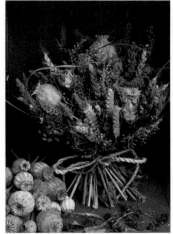

Above: Rope-tied Bunch

Left: Tiered Box

allowing the leaves to extend above the edge of the box and make an attractive border for the contents. And if you don't have a suitable box for a particular project, you can cut a piece of cardboard and wrap it around the base of plastic foam, disguising it with fabric or leaves.

To make a bundle arrangement of dried material, you need something like a small piece of foam covered with brown paper or fabric to structure the display. For a country look, attach hay to the outside so that the flowerheads appear above a rather unruly collar of hay. These displays often include dried grasses and ears of wheat, combined with colourful flowers.

Hand-tied bunches of dried flowers are completely self-supporting, with no base at all. Creating one is not as easy as it looks however; it takes a little practice to learn how to spiral the stems as you add them to the bunch, and to achieve the slightly domed shape.

Perfumed bunches of material are made quite differently. Flowers and herbs are arranged on top of long cinnamon sticks so that the flowerheads are at either end

Below: Spring Perfumed Bunch

of the sticks, then simply tied around the centre. These lovely designs use very little material and are quick and easy to make. To increase the perfume you can add a few drops of perfumed oil to the centre, avoiding the flowerheads themselves, which may go soft.

Many of these informal displays look best tied very simply with a large raffia bow, but for a more sophisticated look you can use an elaborate paper ribbon or fabric bow.

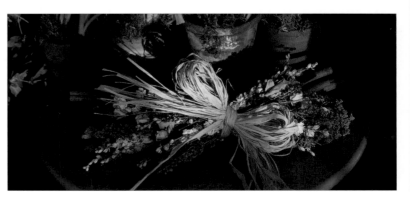

SIMPLE FLORAL BOX
. . .

MATERIALS
. . .
knife
. . .
*1 block plastic foam for dried
flowers*
. . .
small wooden crate
. . .
green moss
. . .
scissors or secateurs
. . .
dried Protea compacta
. . .
fresh bay leaves
. . .
mossing (floral) pins
. . .
rope

*Protea and bay leaves make
an unusual combination which
is very effective.*

This quick display can be made in a variety of boxes; even a cardboard box can look good if it is covered with spray paint or fabric. For a rustic feel, use a small wooden crate. Bay leaves are best used fresh from the bush as there is less risk of the leaves falling off the stems. When they are completely dry, their appearance will be improved with clear florist's lacquer.

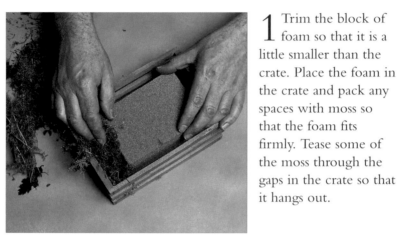

1 Trim the block of foam so that it is a little smaller than the crate. Place the foam in the crate and pack any spaces with moss so that the foam fits firmly. Tease some of the moss through the gaps in the crate so that it hangs out.

2 Trim the stems of the protea to the required height, allowing at least an extra 3 cm (1¼ in) of the stem to penetrate the foam. Starting slightly off–centre, insert a row of protea into the foam.

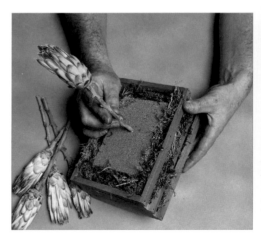

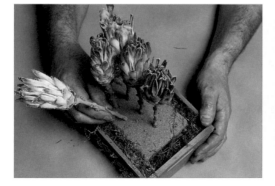

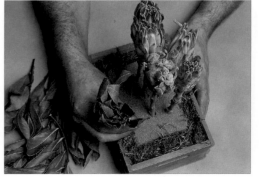

3 Add a second row of the protea stems to one side of the first, so that the two rows completely fill the centre of the display.

4 Trim the stems of the bay leaves and push them into the foam, so that the tops of the bay leaves are just below the bottom of the protea heads.

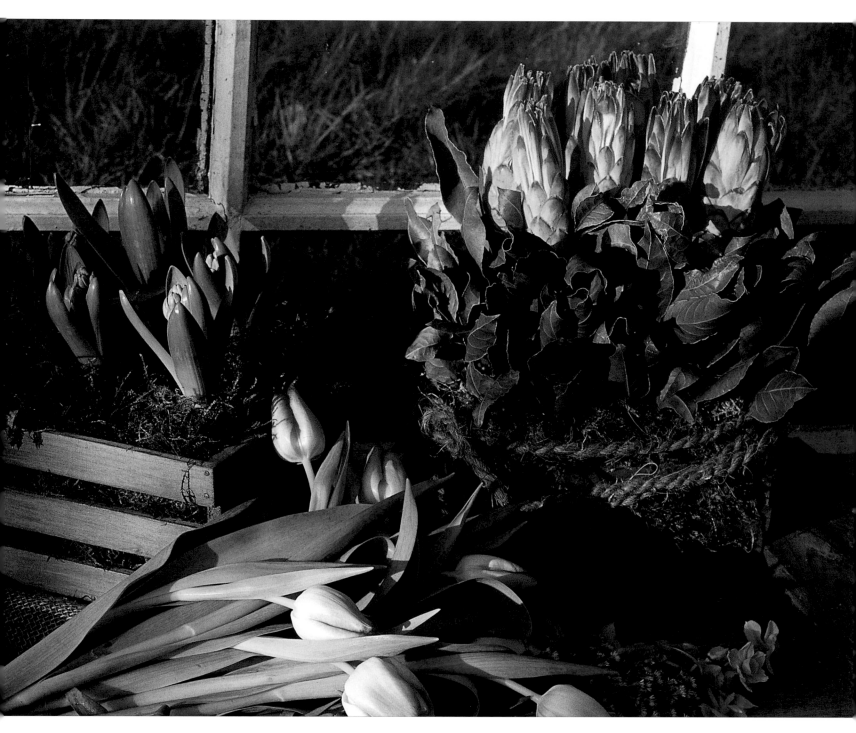

5 Add a collar of bay leaves all around the edge, completely covering the foam base. Add more moss, fixing it in place with mossing (floral) pins. Wrap the rope loosely around the crate a couple of times and tie in a knot or bow.

Place this arrangement in a prominent position so that the striking protea can be seen and admired.

LEAF-WRAPPED BOX

. . .

. . .

glue gun and glue sticks

. . .

large preserved (dried) leaves

. . .

cardboard box

. . .

knife

. . .

*1 block plastic foam for dried
flowers*

. . .

candle

. . .

scissors

. . .

dried miniature pink roses

. . .

moss

. . .

mossing (floral) pins

. . .

raffia

*A raffia bow gives a lovely
informal touch.*

This is a way of making use of gift boxes that are just too good to throw away. The candle is an option; a bigger box may need more than one candle to give the finished display a balanced look. Instead of raffia, you could use a wide ribbon tied in a bow for a softer look. Never leave a burning candle unattended.

1 Spread a little glue on the back of each leaf and press it firmly on to the side of the box. If the leaves are not large enough to cover the depth of the box, start the first row at the top then overlap the bottom row with next. The top row of leaves should extend above the lip of the box.

2 Trim the foam block to fit the box. Apply glue to the inside base of the box and push the foam block firmly in. Try to create a good, tight fit, to help ensure that the box keeps its shape.

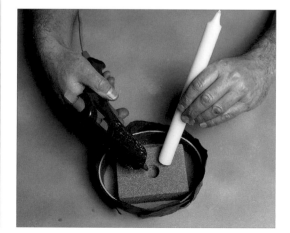

3 When the glue has set, push the candle into the foam in the centre of the box. Remove the candle and put a little glue into the hole then firmly replace the candle. This will ensure that the candle is safe.

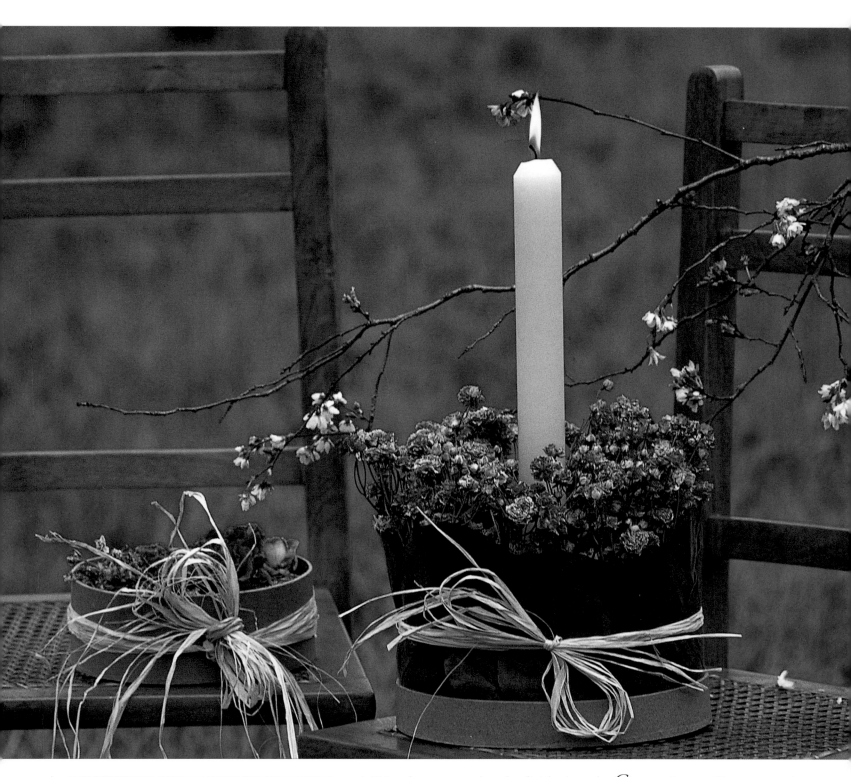

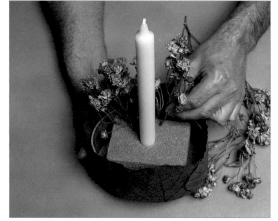

4 Trim the roses so that the finished length will allow about 3 cm (1¼ in) to be pushed into the foam, with about 5 cm (2 in) above the leaves. Insert them around the outside edge of the box. Leave a space around the candle so that there is no risk of the flowers burning. Fill spaces with moss, attached with mossing (floral) pins. Trim the moss around the candle. Tie raffia around the outside of the box, finishing in a bow.

Choose a long candle to create an attractive tall display and so that you do not have to change it too frequently.

BOXED TABLE CENTREPIECE

· · ·

MATERIALS

· · ·

knife

· · ·

*1 block plastic foam for dried
flowers*

· · ·

cardboard box

· · ·

glue gun and glue sticks

· · ·

large preserved (dried) leaves

· · ·

raffia

· · ·

scissors

· · ·

reindeer moss

· · ·

candle

· · ·

nuts and dried fruit

· · ·

.91 wires

· · ·

dried red chillies

*Nuts and dried fruit in a
table centrepiece continue the
"food" theme.*

This idea completely transforms a plain cardboard box into an unusual table centrepiece. The centre could be filled with sugared almonds or crystallized fruit surrounding the candle. Never leave a burning candle unattended.

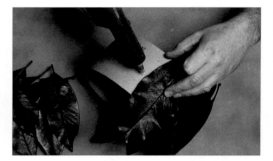

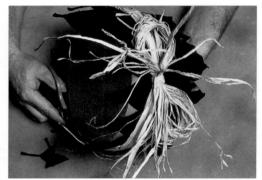

1 Trim the foam block to the shape of the box. Apply some glue to the base of the box and push the foam firmly into it. Try to create a good, tight fit, to ensure that the box keeps its shape.

2 Spread a little glue on the back of each leaf and press it firmly on to the side of the box. Position the leaves so that they extend well above the lip of the box. Make sure that they are evenly placed.

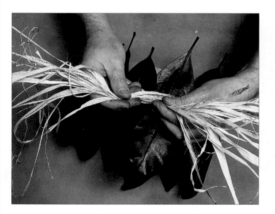

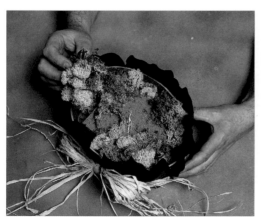

3 Wrap several strands of raffia around the leaf-covered box and tie in a bow.

4 Trim all the leaves that extend over the base of the box so that it will stand flat. Take care not to split the leaves.

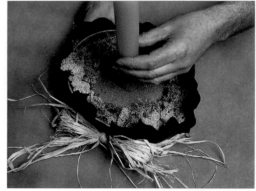

5 Arrange some reindeer moss inside the edge of the box, leaving the centre empty for the candle.

6 Take the candle and push it into the foam, in the centre of the box. Remove the candle and put a little glue into the hole then replace the candle.

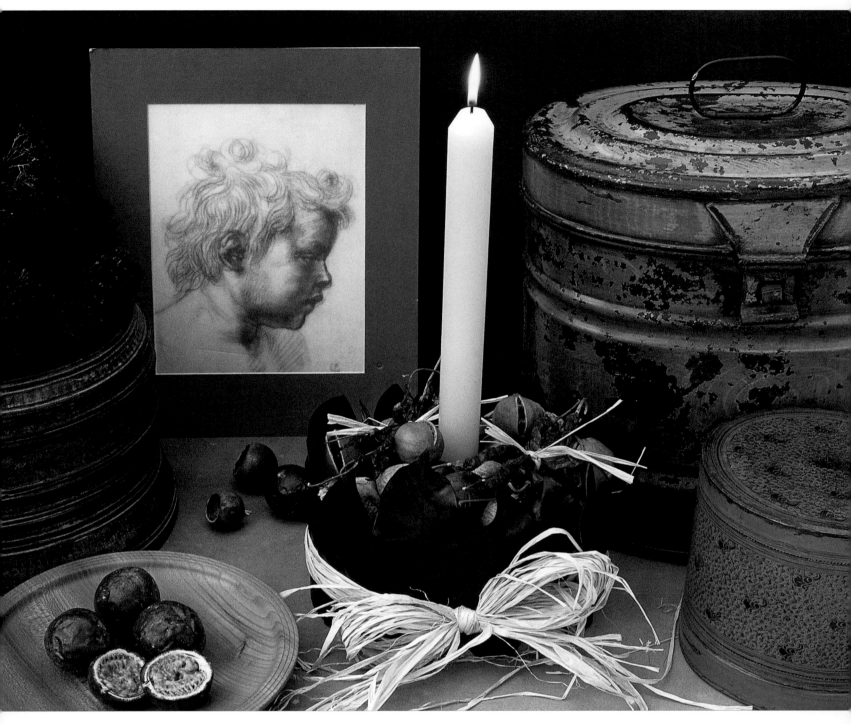

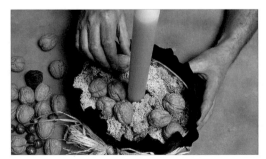

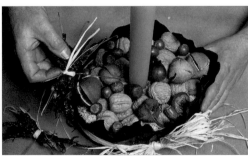

Autumn colours make a lovely table decoration, and the candle adds a magical touch.

7 Arrange the nuts and dried fruit in the box. Make sure that a varied selection is visible, keeping the best items, such as dried oranges, until last.

8 Bunch and centre-wire the chillies (see Techniques). Tie them with raffia to cover the wire then gently push the ends of the wire through the fruit into the foam.

STILL-LIFE BOX

· · ·

MATERIALS

· · ·

scissors

· · ·

hessian (burlap)

· · ·

rectangular cardboard box

· · ·

glue gun and glue sticks

· · ·

knife

· · ·

*1–2 blocks plastic foam for
dried flowers*

· · ·

secateurs

· · ·

willow sticks

· · ·

string

· · ·

shells

· · ·

dried fungi

· · ·

*other dried materials, e.g.
echinops, seed pods,
garlic cloves*

· · ·

reindeer moss

· · ·

candle (optional)

*Blue echinops always adds an
attractive and warm glow to
any display.*

Cover a box with hessian (burlap) to make a neutral base then fill it with a carefully arranged collection of shells, fungi and dried materials. Remember you should never leave a burning candle unattended.

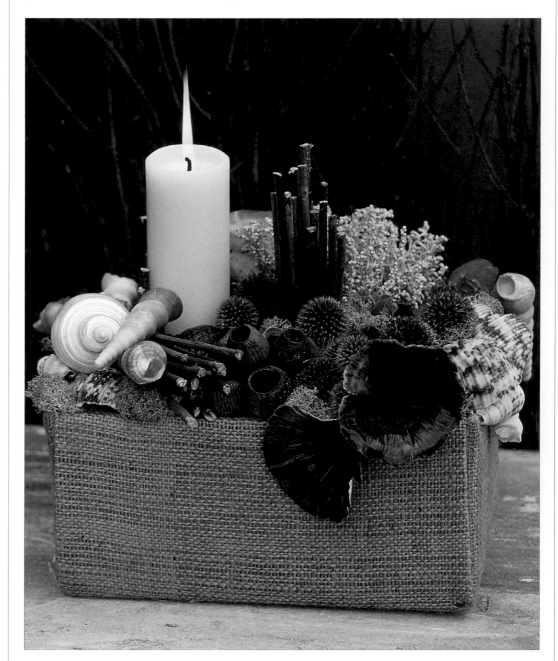

1 Cut a piece of hessian (burlap) to cover the outside of the box and extend about 5 cm (2 in) inside it. Glue it to the box, mitring the corners neatly. The raw edge inside will be hidden by the display.

2 Trim the foam blocks to fit into the box, slightly lower than the top edge. Cut the willow sticks to length and tie together in two bundles with string. Glue all the materials on to the foam, building up an attractive arrangement. Leave space for a candle if desired. Fill any gaps with reindeer moss, gluing it in place.

CINNAMON-WRAPPED TIERS

• • •

Cinnamon sticks are used here instead of leaves to cover the base of a tiered display. The tartan trim gives the impression of holding the cinnamon sticks in place but in fact is purely for decoration.

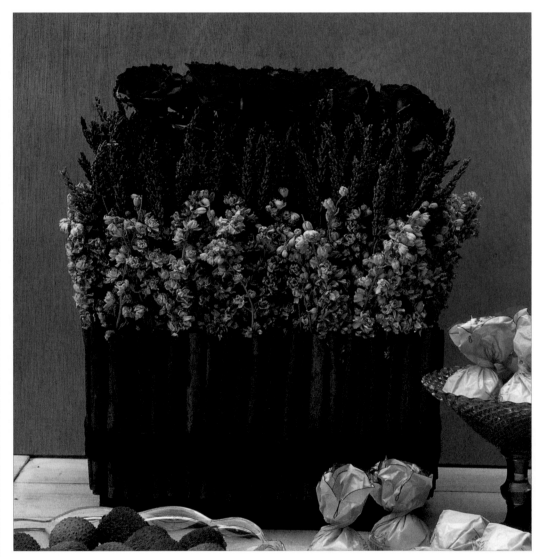

MATERIALS

• • •

craft knife

• • •

cardboard

• • •

1 block plastic foam for dried flowers

• • •

mossing (floral) pins

• • •

scissors

• • •

dried dark red roses

• • •

.91 wires

• • •

dried lavender

• • •

dried pink larkspur

• • •

glue gun and glue sticks

• • •

cinnamon sticks

• • •

tartan fabric

The delicate materials in this display will keep their colours for a long time, but they should be kept away from direct sunlight.

1 Cut a piece of cardboard to fit the bottom and about 5 cm (2 in) up the sides of the foam block. Fix it in place with mossing (floral) pins.

2 Trim the rose stems to the longest length required for the display. Push them into the foam in two rows, leaving space at either end and the front.

3 Wire the lavender into small bunches (see Techniques). Push into the foam along the front and sides of the roses so that the tops of the lavender are level with the bottoms of the roses. Repeat with the larkspur, so that their tops are level with the bottoms of the lavender.

4 Glue cinnamon sticks of equal length carefully around the front and sides of the cardboard collar, placing them close together like a fence.

5 Fold a strip of tartan fabric and glue around the base of the display. Make a fabric bow and glue in the centre of the display (see Techniques).

TIERED BOX

· · ·

MATERIALS

· · ·

craft knife

· · ·

cardboard

· · ·

*1 block plastic foam for dried
flowers*

· · ·

glue gun and glue sticks

· · ·

fabric

· · ·

mossing (floral) pins

· · ·

scissors

· · ·

dried peonies

· · ·

.91 wires

· · ·

dried lavender

· · ·

dried Alchemilla mollis

· · ·

*preserved (dried) leaves, e.g.
cobra leaves*

· · ·

raffia

· · ·

green moss

*The leaves cover the foam
block and make an innovative
container for an arrangement.*

This display has a flat back, so it can stand against a wall or in a small fireplace. If you want it to be viewed from all sides, the process is almost exactly the same but the first two rows of flowers need to start in the centre, and not at one edge. Then add the other flowers, working all the way around. For a larger display, simply glue several blocks of foam together.

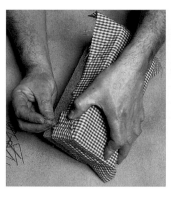

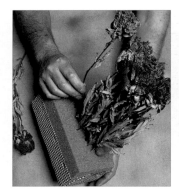

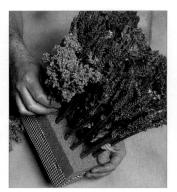

1 Cut a piece of cardboard to fit around the bottom of the foam block and glue it in place. Lay the foam block on the fabric and cut a piece large enough to cover the bottom and up the sides by about 5 cm (2 in). Hold the sides of the fabric in place with mossing (floral) pins, making sure that the base is crease-free.

2 Trim the peony stems to the desired length. Starting at the back of the display, push two rows into the foam block, leaving space at either end for the other materials. Make sure that at least 3 cm (1¼ in) of the stems penetrate the foam. Do not put material right at the edge of the foam as it will weaken the foam and break away.

3 Wire the lavender into medium-sized bunches (see Techniques). Push them into the foam block, along the front and sides of the peonies so that the tops of the lavender are level with the bottoms of the peonies. Repeat the same process for the alchemilla, so that their tops are level with the bottoms of the lavender bunches.

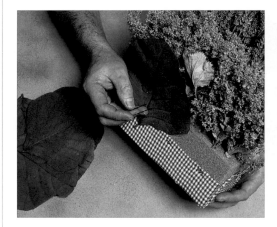

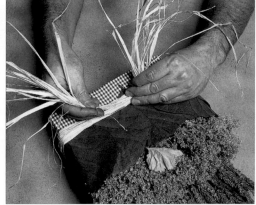

4 Fix the leaves along the front and the sides of the display, above the fabric, with mossing (floral) pins. Wrap at least one of the leaves around each back corner of the display.

5 Tie several strands of raffia around the arrangement, to cover the pins, and tie into a bow. Tuck green moss in the back of the display to cover any foam that may still be visible.

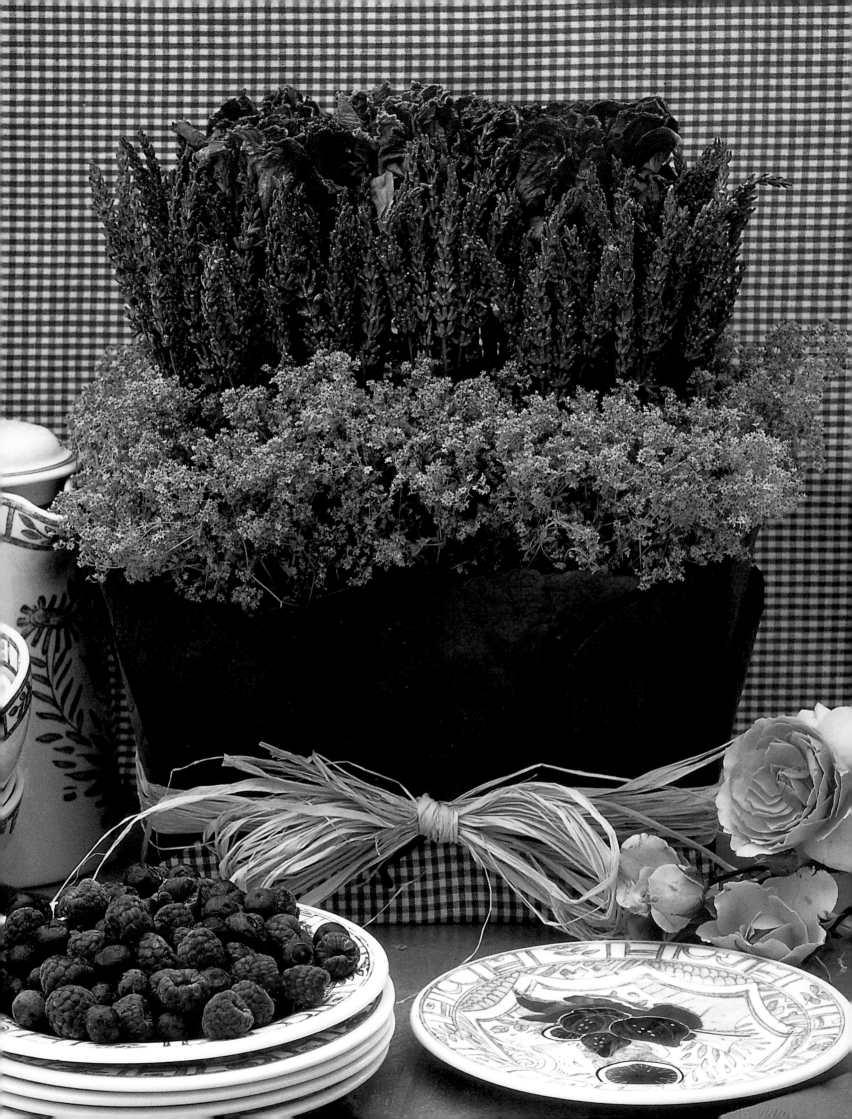

HARVEST DISPLAY

. . .

MATERIALS

. . .

knife

. . .

4 blocks plastic foam for dried flowers

. . .

large tin

. . .

dried wheat

. . .

dried lavender

. . .

dried poppy seed heads

. . .

reindeer moss

The lavender stalks look very impressive when massed together in a simple arrangement.

The soft blue shades of lavender have been teamed with golden wheat and poppy seed heads in a tin container whose gentle grey tones offset the blues, greens and golds perfectly. Here, a traditional tiered display has been given an effective modern treatment, using simple dried materials.

1 Trim the foam blocks and fit them into the container. If you are using a tall container, stand two foam blocks upright in the bottom to support two on top. It is important that the bricks on top fit the container tightly.

2 Insert the wheat, a few stalks at a time, into the centre of the foam. Discard any broken or imperfect stems.

3 Working in rows, insert the lavender stalks one by one around the wheat. Graduate the height of the lavender so that the front rows are slightly lower than the back ones.

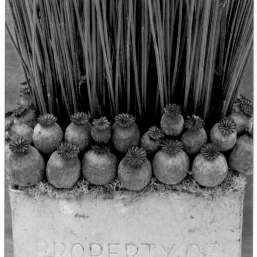

4 Trim the stalks of the poppy seed heads to about 5 cm (2 in). Insert a row all around the rim of the container. Place another row behind them so that it rests on top of the first. Tuck the reindeer moss carefully under the front row, lifting the seed heads a little if necessary.

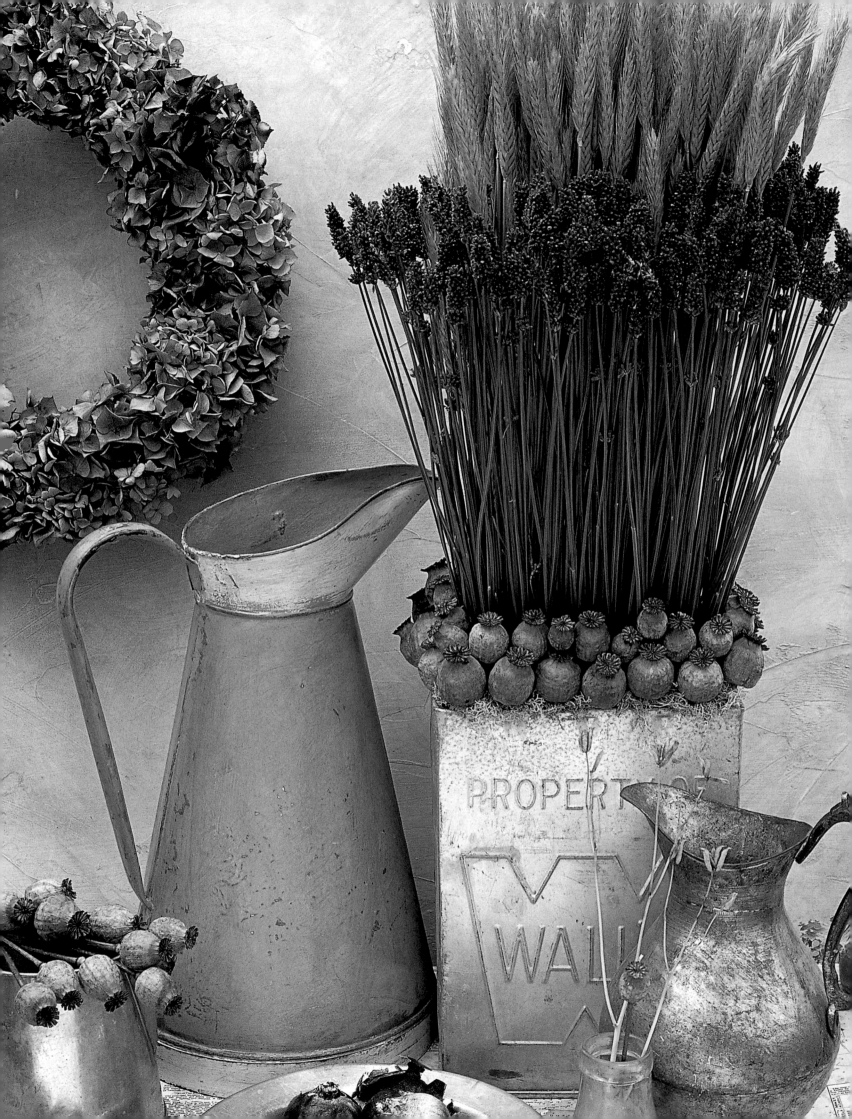

COUNTRY BUNDLE
· · ·

MATERIALS
· · ·
knife
· · ·
*1 block plastic foam for
dried flowers*
· · ·
pencil
· · ·
fairly thick cardboard
· · ·
craft knife
· · ·
glue gun and glue sticks
· · ·
fabric
· · ·
silver reel (rose) wire
· · ·
mossing (floral) pins
· · ·
hay
· · ·
scissors
· · ·
*dried materials, e.g.
Alchemilla mollis, pink
larkspur, marjoram, Nigella
orientalis, poppy seed heads,
pink roses, wheat*
· · ·
.91 wires
· · ·
raffia

*The combination of raffia
and grasses accentuates the
informal, country feel of
a display.*

This wonderful design requires more skill than you might expect to achieve its deliberately informal appearance, which creates a wonderful countryside look. If you plan to trim the hay at the bottom, choose fabric that will match your decor, otherwise any fabric can be used.

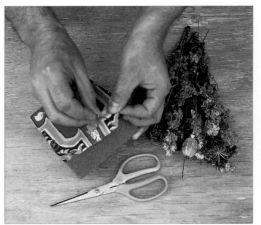

1 Cut the foam block in half. Take one piece and make sure it is square. Use the foam as a template to draw a square on the cardboard then cut it out with a craft knife. Glue it to the bottom of the block. Using the foam base as a guide, cut the fabric into a square about 5 cm (2 in) larger than the cardboard.

2 Fold the fabric up around the foam base. Use mossing (floral) pins to hold it in place, turning the corners and smoothing it so that there are no wrinkles.

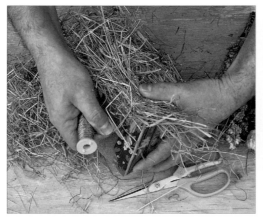

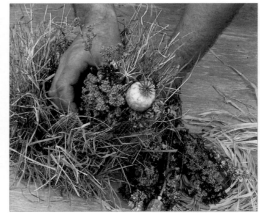

3 Wrap silver reel (rose) wire 3–4 times round the fabric-covered foam and add the hay to form a collar around the sides as you tightly wrap the wire. Cover the sides completely then secure the end of the wire by tying it to a mossing (floral) pin pushed into the base. Trim the hay at the base so that it is even and remove any straggly strands. If you want some of the fabric base to show, trim the hay about halfway up the sides of the block.

4 Trim the stems of the dried materials. They need to be long enough for about 5 cm (2 in) to be pushed into the foam, while allowing the flowerheads to show above the hay. Wire the flowers into small bunches of mixed or single varieties (see Techniques). Fill the space inside the hay collar, leaving no gaps. Make the centre a little higher and lean the bunches nearest the edge slightly outwards. Tie a raffia bow around the base.

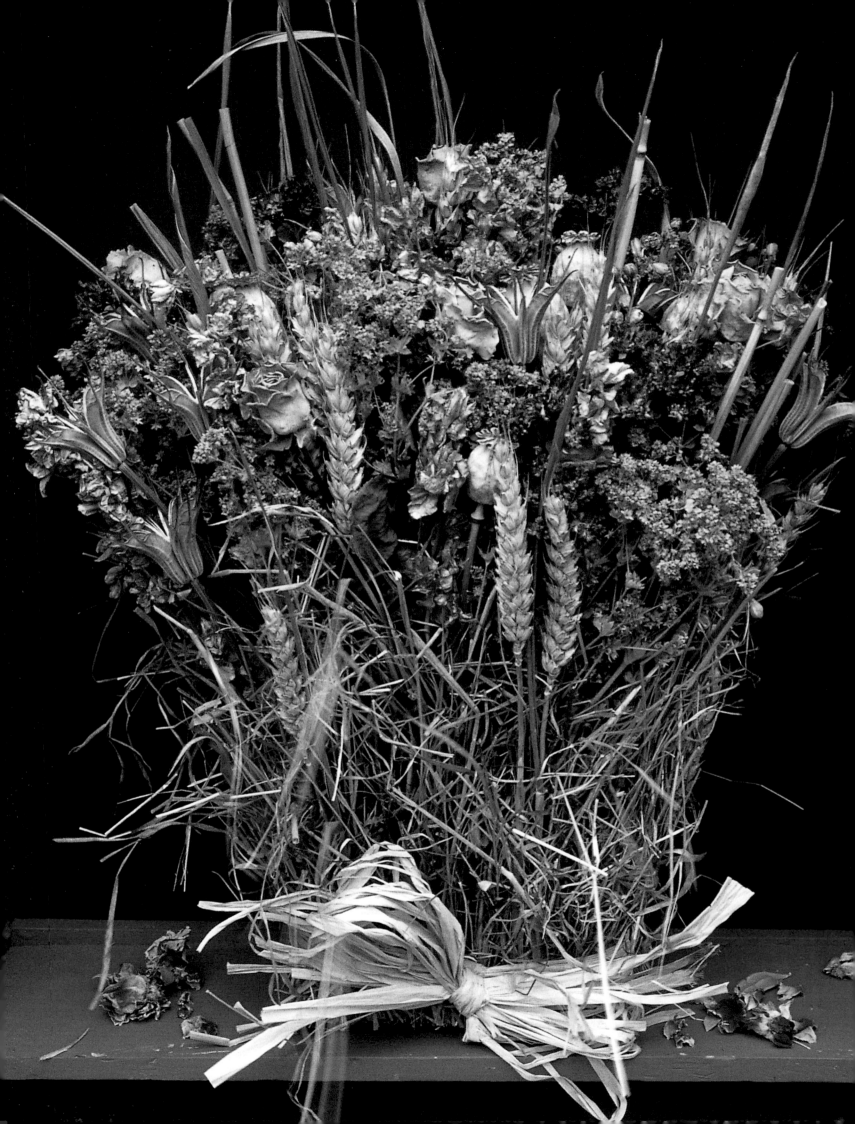

ROPE-TIED BUNCH
• • •

MATERIALS

• • •

dried materials, e.g. blue
larkspur, pink roses, poppy
seed heads, wheat

• • •

scissors

• • •

silver reel (rose) wire

• • •

sea-grass rope

Large poppy seed heads are
attractive when they protrude
from an arrangement of tall,
thin grasses.

Mix dried grasses and wheat with country cottage garden flowers to make this lovely tied display. Large poppy seed heads stand out against the smaller materials to help create a full and rounded effect. Complete the country look with an unusual bow of sea-grass rope or, if you prefer, raffia.

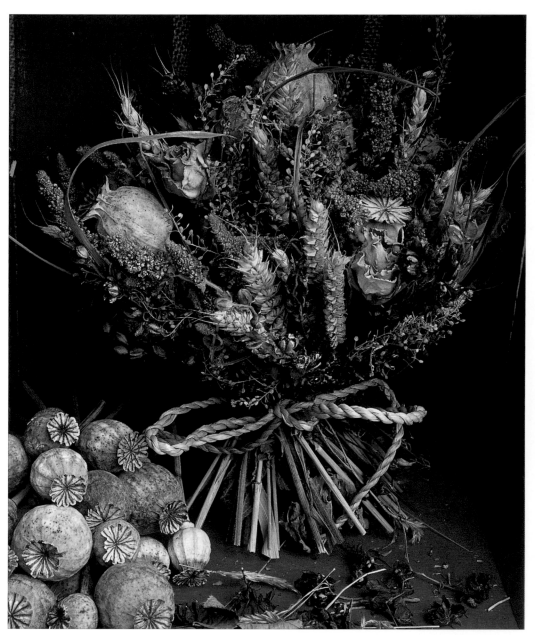

1 Separate the materials into piles. Trim any waste material from the stems. Select 2–3 stems of each variety and make a small bunch, holding them tightly in one hand with all the flower and seed heads level.

2 Add extra stems, changing the angle a little each time. As the display builds up, lower the flower and seed heads slightly to create a dome shape. When the bunch is complete, wind silver reel (rose) wire firmly around the stems 5–6 times. Trim the stems level. Tie the rope in a bow, to conceal the wire.

FRESH TUSSIE MUSSIE

• • •

In bygone days, ladies carried herbal tussie mussies with them as a form of personal perfume. They were usually made of several varieties of fresh herbs arranged in concentric circles. White lavender makes a delightful tussie mussie contrasted with the more conventional blue.

MATERIALS

• • •

deep blue lavender

• • •

white lavender

• • •

green raffia or twine

• • •

scissors

• • •

wide ribbon

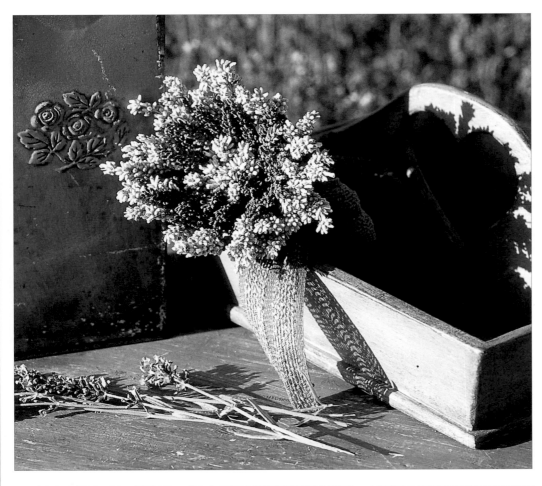

White and blue lavender look very pretty together and need no other decoration.

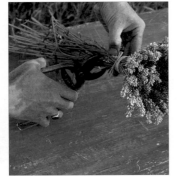

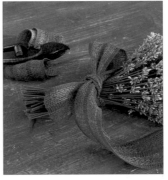

1 Arrange a circle of deep blue lavender stems around a small bunch of white lavender. Secure with a piece of raffia or twine.

2 Arrange the remaining white lavender around the blue. Secure the complete bunch with raffia or twine. Trim the stalks to an even length.

3 Cover the raffia with wide ribbon, tying the ends in a generous bow.

ROSE BUNDLE

• • •

MATERIALS

• • •

1 plastic foam round for dried flowers

• • •

brown paper

• • •

glue gun and glue sticks

• • •

craft knife

• • •

.91 wires

• • •

pliers

• • •

scissors

• • •

12 dried orange or yellow roses

• • •

moss

• • •

large preserved (dried) leaves, e.g. cobra leaves

• • •

mossing (floral) pins

• • •

raffia

Preserved (dried) leaves make an attractive wrapping for a dozen roses.

This little display is very easy to make, using a ready-made plastic foam circle covered with brown paper. Raffia gives the bundle a country feel; for a smarter look, tie the roses with a ribbon or paper bow.

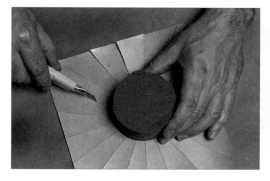

1 Place the foam round in the centre of the brown paper and glue it in position. Using a craft knife, cut from the edge of the foam to the outer edge of the paper, working all the way around at roughly 1 cm (½ in) intervals.

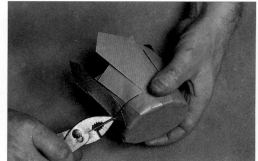

2 Fold the paper strips up to wrap the foam. Wrap a wire around the paper and the foam, making sure all the paper strips are straight and neat at the base, and twist the two ends of the wire tightly together with pliers.

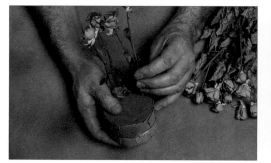

3 Trim the paper in line with the top of the foam. Trim the rose stems, retaining as many leaves as possible. Starting in the centre, push them carefully, one at a time, into the foam.

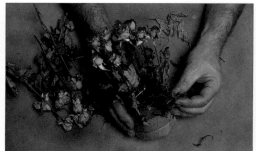

4 Cover the foam with roses and use moss in the gaps. About twelve roses should be enough. If more rose leaves are required, wire some together in bunches and add to the foam (see Techniques).

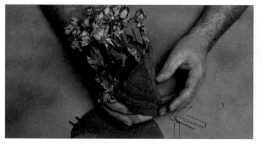

5 Wrap 3–4 leaves around the base, fixing each one in place with a mossing (floral) pin. Make sure you place each pin at the same height as the last.

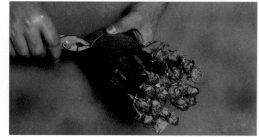

6 Wrap a wire around the leaves at the same level as the mossing (floral) pins and twist the ends together to make a tight fixing.

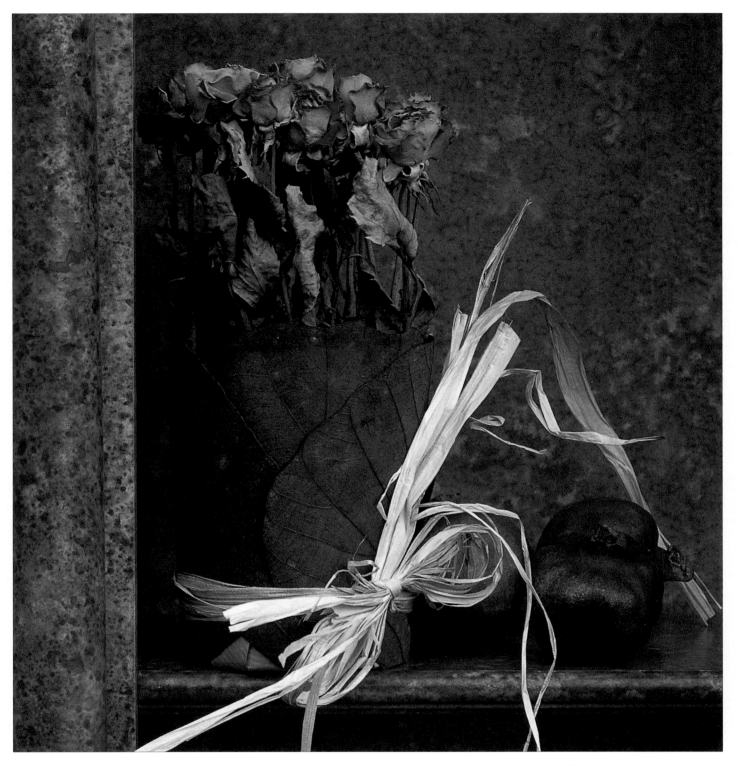

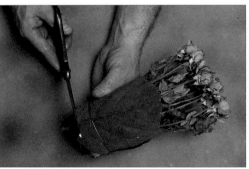

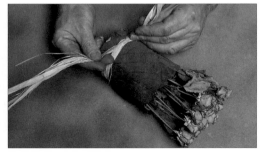

Orange and yellow roses keep their colour for a very long time, which makes them perfectly suited to the role of brightening a dark corner.

7 Trim the leaves at the base of the display so that it will stand evenly.

8 Tie raffia around the base to cover all the fixings, finishing with a bow. Fill any spaces with extra moss.

111

SUMMER FLOWER BUNDLE

· · ·

MATERIALS

· · ·

1 plastic foam round for dried flowers

· · ·

brown paper

· · ·

glue gun and glue sticks

· · ·

craft knife

· · ·

.91 wires

· · ·

pliers

· · ·

scissors

· · ·

dried pink larkspur

· · ·

dried pink roses

· · ·

moss

· · ·

large preserved (dried) leaves

· · ·

mossing (floral) pins

· · ·

raffia

Larkspur looks very summery against the dark leaves, and combines beautifully with pink roses.

This pretty arrangement would be a welcome gift for someone unwell at home or in hospital, with the advantage that it would take up very little precious bedside space. A dinner table with an individual small flower bundle for each place setting would also look very welcoming.

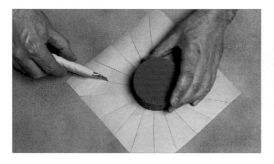

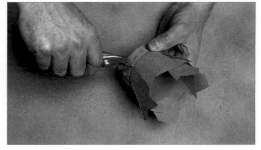

1 Place the foam round in the centre of the brown paper and glue it in place. Using a craft knife, make cuts from the edge of the foam to the outer edge of the paper, working all the way around at roughly 1 cm (½ in) intervals.

2 Fold up the paper strips to wrap the foam. Twist a wire around the paper and the foam. Make sure all the paper strips are straight and neat at the base then twist the ends of the wire together. Trim the paper in line with the foam.

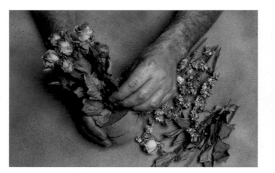

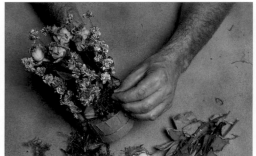

3 Trim the larkspur and rose stems, retaining as many of the leaves as possible. Starting in the centre, push them one at a time into the foam.

4 Cover the foam with flowers using moss to fill the gaps. If you want more leaves, add some wired bunches of rose leaves (see Techniques).

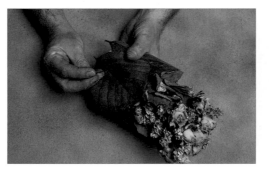

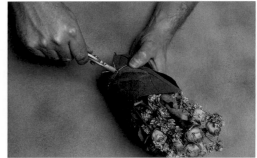

5 Wrap 3 or 4 leaves around the base, fixing each one in place with a mossing (floral) pin. Make sure each pin is placed at the same height as the last.

6 Using pliers, neatly wrap a wire around the leaves at the same level as the pins. Twist the ends together to make a tight fixing.

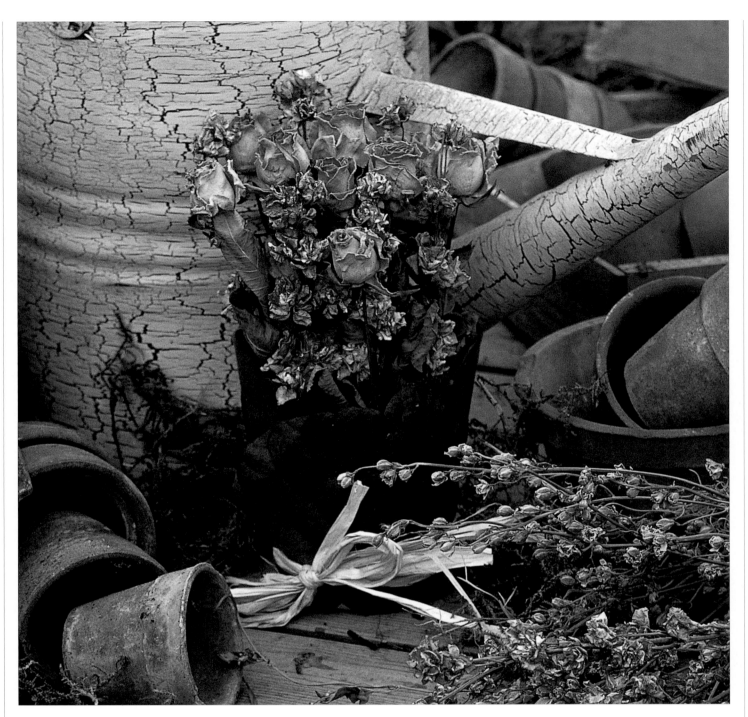

This arrangement is bright and compact, making it a perfect gift as well as an attractive decoration.

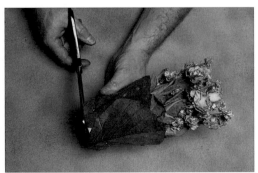

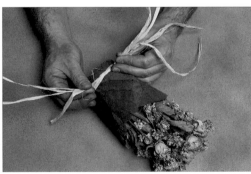

7 Trim the leaves at the base of the display with scissors, so that the display will stand evenly without wobbling.

8 Tie raffia around the base, covering all the fixings. Finish with a bow or a simple knot. If the roses had a limited number of leaves, fill the spaces around the stems with extra moss.

113

HAND-TIED POSY

· · ·

MATERIALS

· · ·

dried hydrangeas

· · ·

dried red roses

· · ·

dried red amaranthus

· · ·

dried oregano

· · ·

scissors

· · ·

raffia

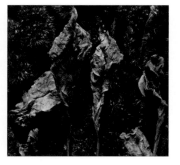

The mixture of flowers and herbs makes a beautiful posy, and the draping red amaranthus creates a unique effect.

Hand-tied posies have a fresh, simple, just-picked look about them, but it takes time and practice to perfect the technique of spiralling the stems to create a free-standing bouquet. The long trailing strands of rich, red amaranthus add more interest to this neat, round arrangement.

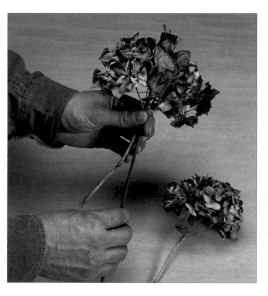

1 Select your first stem of hydrangea and thread a single rose through the centre. The two stems should cross one another diagonally.

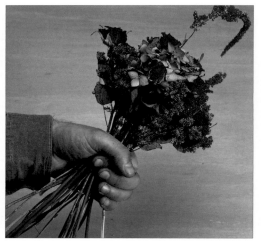

2 Begin to add the amaranthus and oregano stems symmetrically to the core, angling the stems at diagonals. This is very important to achieve the dome shape and to allow the posy to stand by itself once finished.

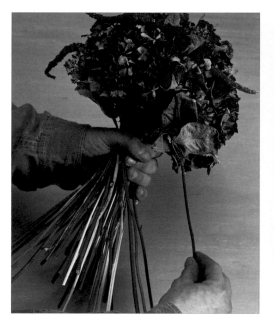

3 With one hand, continue to add further stems of each material diagonally to the bunch. Hold the bunch securely in the other hand, creating a spiralled effect as you add more material.

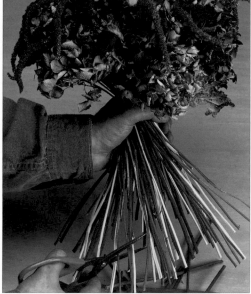

4 Build up the posy until you can no longer hold the stems comfortably in your hand. Trim the stems to an even length – the length of the stems should be in proportion to the size of the posy.

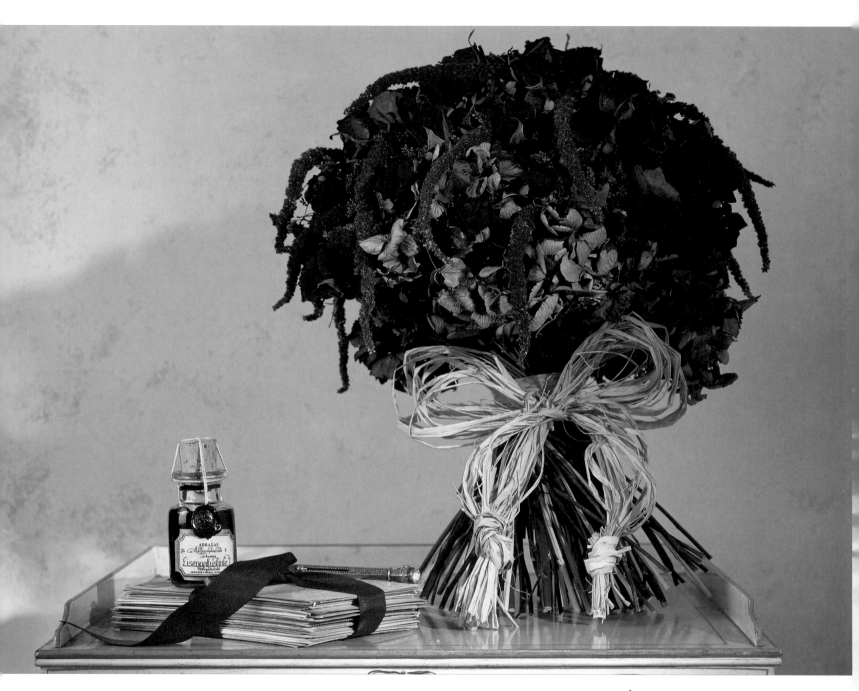

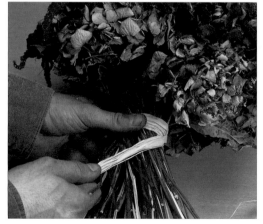

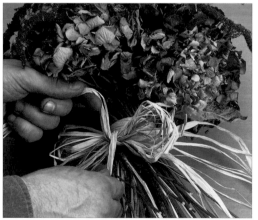

A free-standing posy makes an impressive display.

5 Tie the bunch tightly with raffia at the narrowest part of the spiral. If the bunch is correctly made, the posy should stand by itself without support.

6 Make a loose bow out of several lengths of raffia and tie round the binding point. Trim and knot or bind the ends for a neat finish.

115

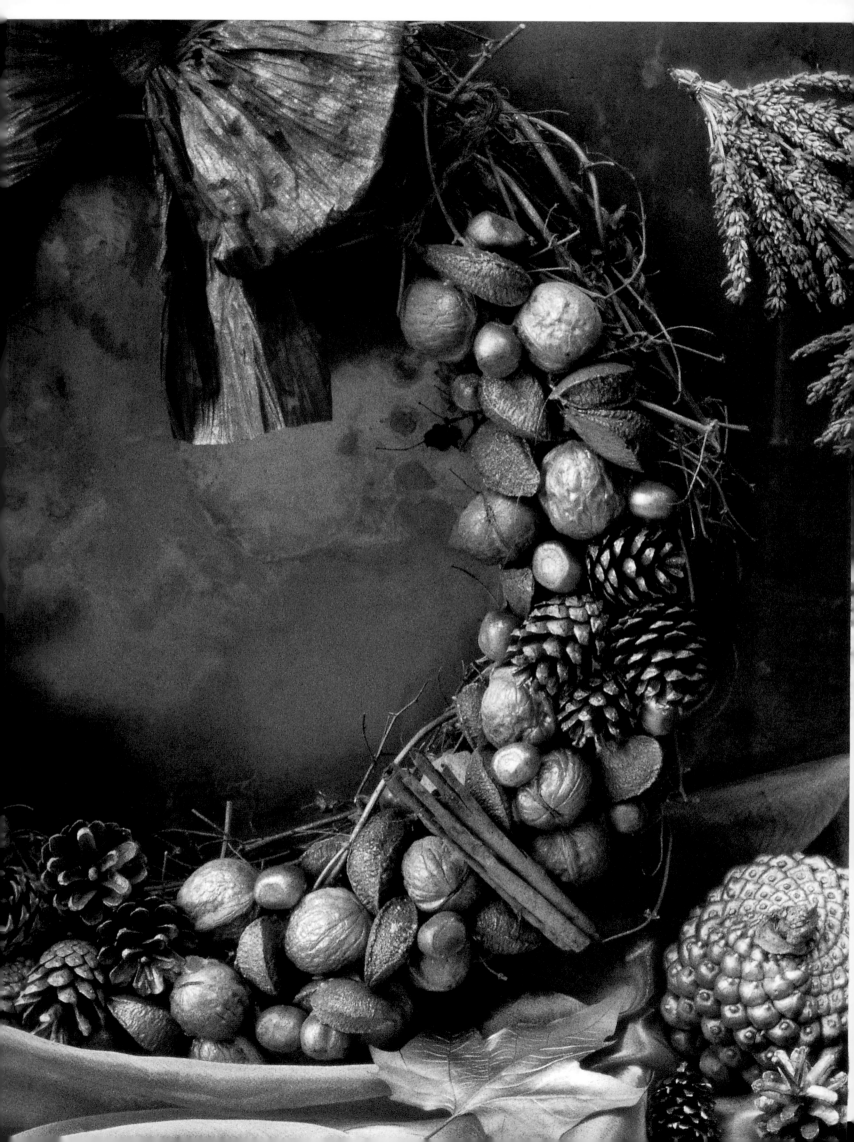

GARLANDS
AND SWAGS

. . .

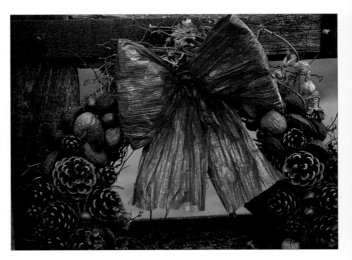

Decorate your home with these traditional
symbols of hospitality and welcome. They can
be a simple mixture of flowers and herbs, or an
impressive display for a special occasion. Hang a
garland on a wall or place it flat on a table as an
attractive centrepiece. For a grand effect, drape a
swag along a mantelpiece, fireplace surround or
down the centre of a party table.

INTRODUCTION
· · ·

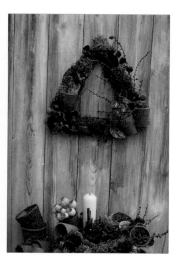

*Above: A Geometric Garland
above a bundle display*

Below: Mixed Swag

Dried flower garlands and wreaths are always popular throughout the year. A beautifully scented blue pine (spruce) wreath decorated with fir cones, red roses and cinnamon sticks is a traditional welcome to hang on the front door at Christmas. Simple garlands decorated with dried roses, pot-pourri, lavender and herbs will bring the colours and scents of summer into your home, even in winter. More unusual garlands can be made using a single dramatic dried material such as massed dahlia heads or giant sunflowers, to create a very modern look.

Whatever the finished design, all garlands are built on a base, which you can buy from a florist's or make yourself. Ready-made rings woven from natural materials such as hop vine or willow are available from florists in many different sizes. If you like the idea of weaving your own ring, use vines or twigs cut when they are green so that they are pliable. Leave the ring to dry out naturally before adding the decoration. You can also make your own hay ring by simply binding the hay with silver reel (rose) wire. Another, more expensive base is a copper or steel ring, which consists of two wire circles. This can be covered with hay or moss, or in some garland designs one of the wire circles is used on its own. You can even construct unusual shapes such as triangles or squares, using sticks or canes bound together at the corners.

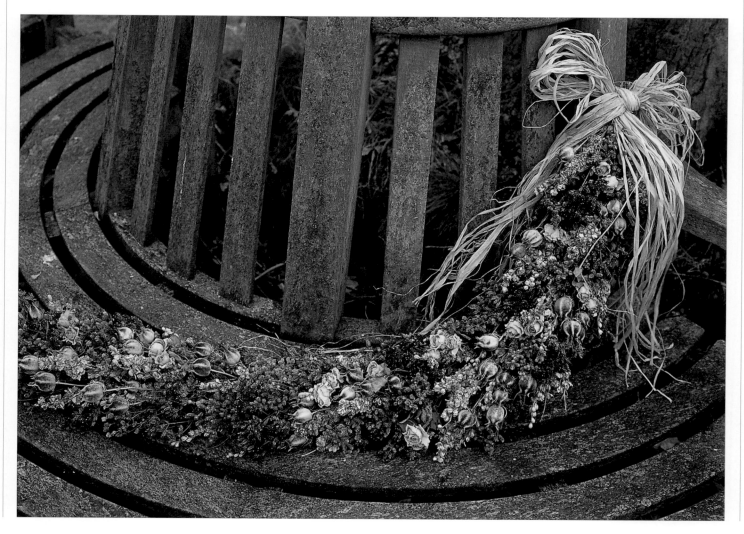

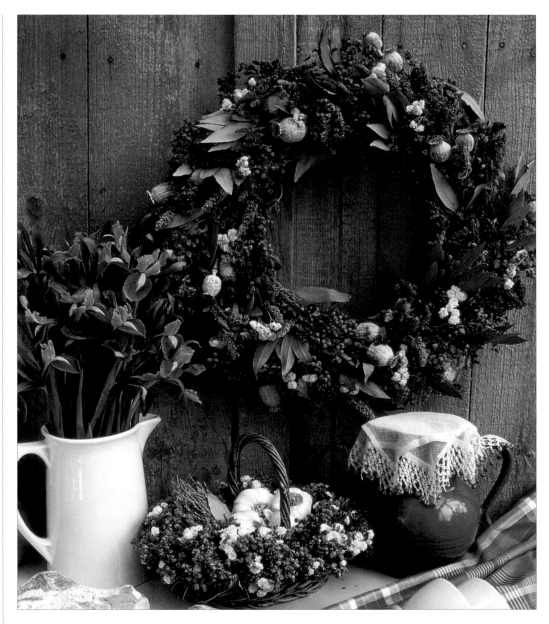

Above: Fabric-decorated Swag

Left: Romantic Herb Garland

Below: Christmas Garland

Swags are also built on to a base, which can be a length of rope (or even string), a hay rope or a sausage of chicken wire stuffed with hay or moss. They are technically quite straightforward to create but their sheer size often makes them a challenge. The most important thing is to have plenty of space and to lay all the dried materials out in a very orderly fashion. Work along the whole length of the swag, or around the circle of a garland, to keep an even balance of materials and so that they appear to flow together. Stand back frequently to check the design as it progresses and add delicate flowers such as roses and peonies at the end. Large swags are often made in two or more sections, making them much easier to transport to their finished location. If you are making a single length, work from either end towards the centre; if necessary, you can disguise the point where they meet with a ribbon or raffia bow.

Traditional swags made of winter foliage look wonderful at Christmas, displayed along the length of a fireplace, table or mantelpiece. Mixed summer swags made of flowers and herbs are ideal for summer parties and weddings. More unusual designs featured here include a hanging swag incorporating fabric to match your decor, and an outdoor swag studded with shells and starfish. Swags do not have to be large and impressive; a small swag makes a very attractive, novel feature and is much quicker to make.

HEART OF WHEAT

. . .

MATERIALS

. . .

scissors

. . .

heavy-gauge garden wire

. . .

florist's tape (stem-wrap tape)

. . .

silver reel (rose) wire

. . .

large bundle of wheat

Fashioning simple decorations out of wheat is a traditional country custom, and very satisfying to do.

M̲ake this endearing "token of affection" at harvest-time, perhaps for a delightful decoration to place on a kitchen wall or dresser. It is quite robust and should last for many years. You can make the base any size you wish.

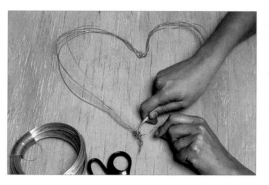

1 Cut three long lengths of wire and bend them into a heart shape. Twist the ends together at the bottom.

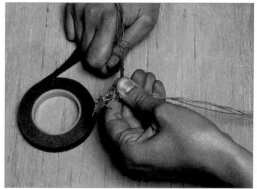

2 Use florist's tape (stem-wrap tape) to cover the wire.

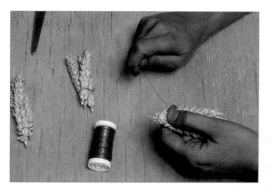

3 Using silver reel (rose) wire, bind together enough small bunches of wheat to cover the wire heart densely. Leave a short length of wire at each end.

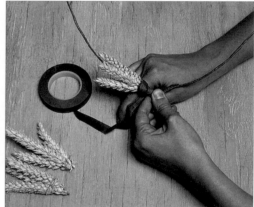

4 Starting at the bottom, tape the first bunch of wheat stalks to the heart.

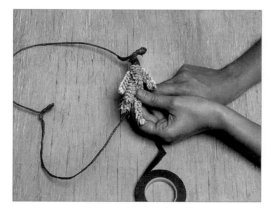

5 Tape the second bunch further up the heart shape, behind the first. Continue to tape the bunches until the whole heart is covered.

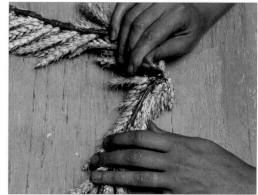

6 For the bottom, wire together about six bunches of wheat stalks, twist the wires together and wire them to the heart. Neaten with florist's tape (stem-wrap tape).

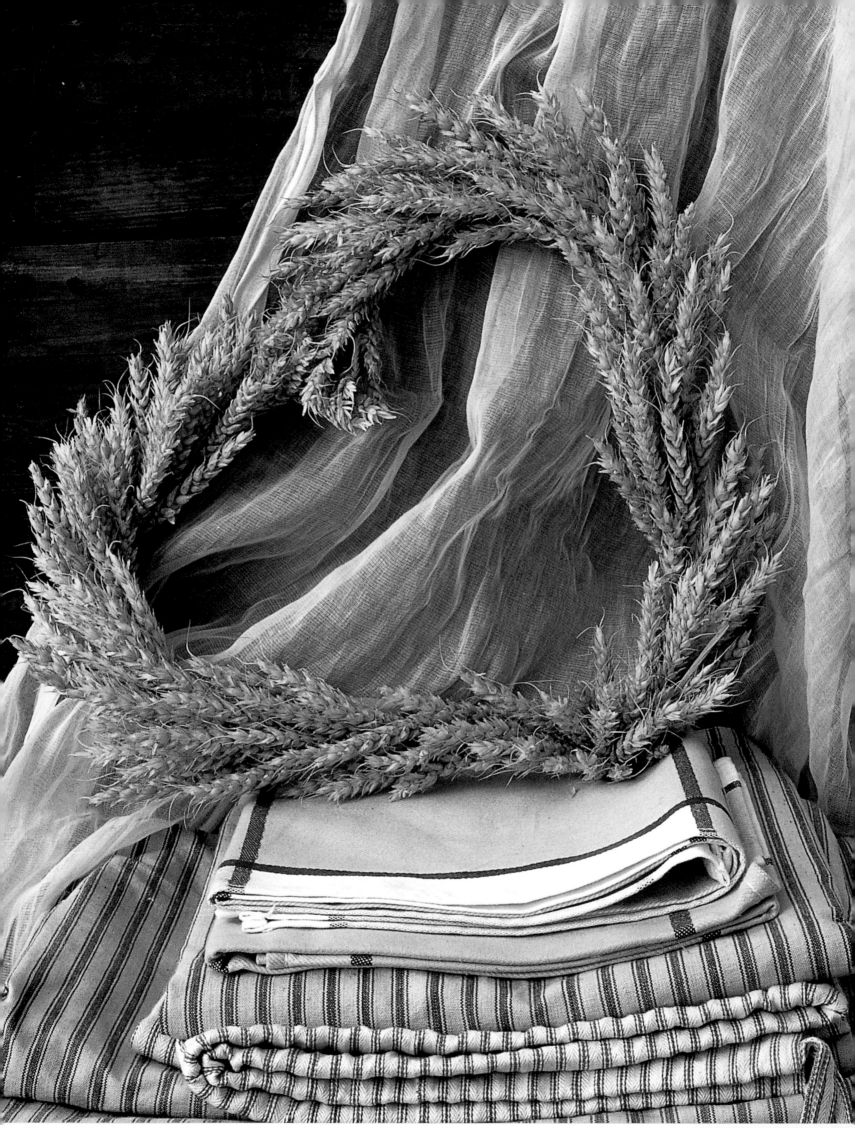

LAVENDER AND HERB GARLAND

· · ·

MATERIALS

· · ·

scissors

· · ·

.91 wires

· · ·

dried lavender

· · ·

dried artemisia

· · ·

dried lovage

· · ·

dried tarragon

· · ·

glue gun and glue sticks

· · ·

small wicker garland base

· · ·

dried French lavender

Sweet-smelling herbs and flowers are always a delight to work with, and they make the finished garland very fresh and summery.

This pretty garland is composed of mixed herbs and two kinds of lavender, all of which are highly scented. French lavender has large flowerheads, so place these individually at the end to stand out against the smaller-flowered materials.

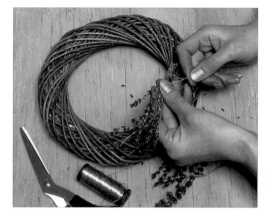

1 Trim and wire all the dried herbs and flowers, except the French lavender, into small bunches (see Techniques).

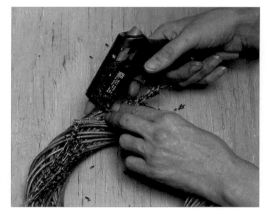

2 Using a glue gun, glue the first bunch of the dried lavender neatly on to the garland base.

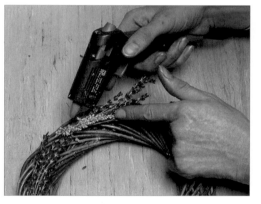

3 Next glue a bunch of artemisia to the garland base between the lavender.

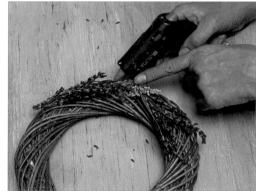

4 Work around the garland, adding a bunch of lovage.

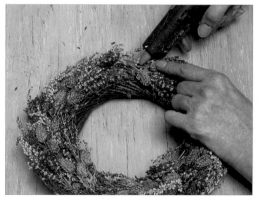

5 Continue all round the garland, interspersing the different bunches of herbs to cover it completely.

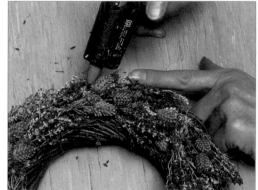

6 Finally, add the individual French lavender flowerheads, positioning them regularly around the garland.

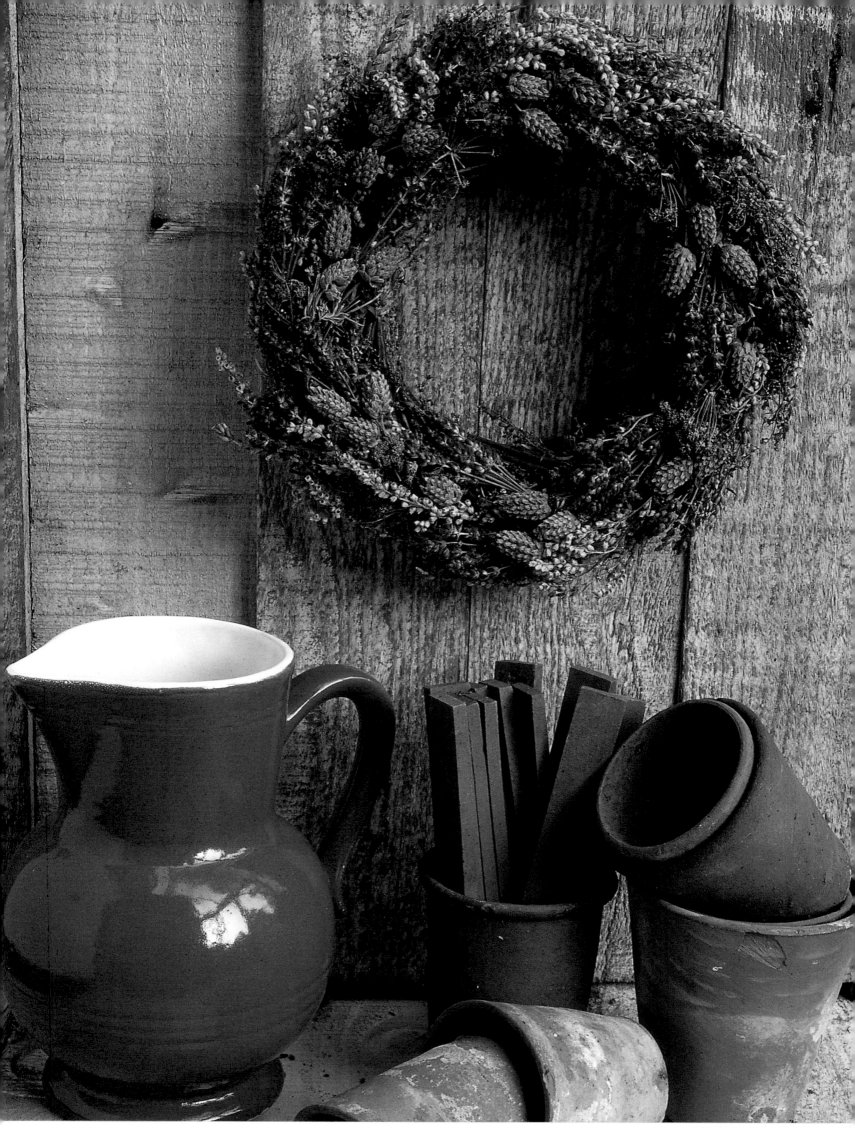

GEOMETRIC GARLAND

· · ·

MATERIALS

· · ·

strong canes or sticks

· · ·

strong florist's wires

· · ·

pliers

· · ·

glue gun and glue sticks

· · ·

moss

· · ·

silver reel (rose) wire

· · ·

twigs

· · ·

.91 wires

· · ·

dried fungi

· · ·

fir cones

If you make a triangular frame, the resulting garland is even more unusual.

Most garlands are round, but they can also be square or triangular. Experiment with different shapes created with canes or sticks – they do not have to be completely straight to create an interesting variation.

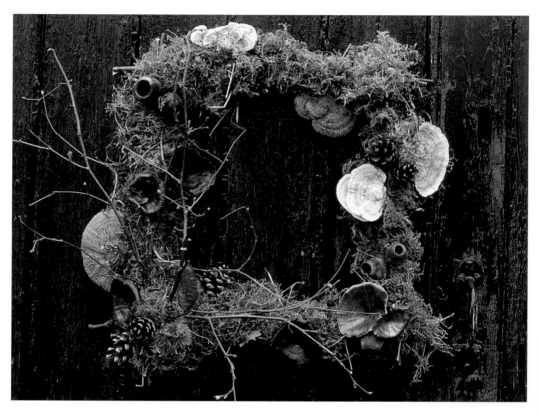

1 If the canes or sticks are thin, wire 5–8 together to make one stronger length for each side of the frame. Use pliers to twist the wire around the ends. Make a square frame, tying the canes or sticks in each corner with a wire. Add a dab of glue to the wires to fix them firmly.

2 Cover the frame with moss, holding it in place with silver reel (rose) wire. Try to keep an even amount of moss on all sides and avoid leaving any gaps. Make the base secure, as this is what the remaining material will be attached to.

3 When the frame is completely covered with moss, tie the twigs on to it with wire. Add as many as you think look good, remembering what materials you have to come. Then glue the fungi and fir cones in position, placing them in small groups. Hide any wires that show with extra moss.

FROSTED WINTER GARLAND

. . .

This design is very simple and quick to make as you can use a glue gun to attach all the materials to a ready-made base. Leave the garland in its natural state or spray it with a light coat of silver, white or gold paint for a festive effect.

MATERIALS
. . .
glue gun and glue sticks
. . .
fir cones
. . .
hop vine or twig ring
. . .
assorted nuts, e.g. brazil nuts, hazelnuts (filberts), walnuts
. . .
cinnamon sticks
. . .
wide red paper ribbon
. . .
silver, white or gold spray paint

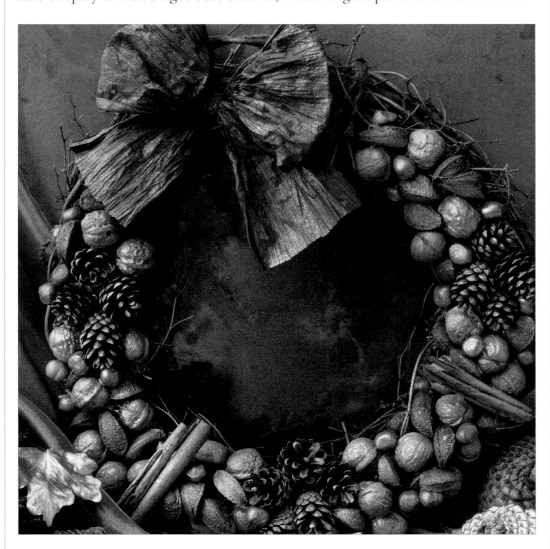

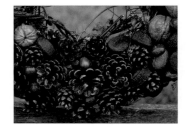

Graduate the fir cones and nuts from a thin layer at the top of the ring to a thicker layer at the bottom.

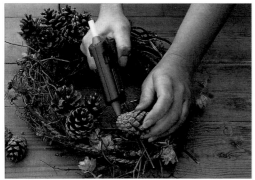

1 Glue the fir cones to the ring in groups of 4–5, leaving a large space between each group. Attach the larger fir cones at the bottom of the ring.

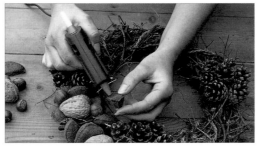

2 Glue the nuts and cinnamon sticks between the fir cones, individually or in groups, again with the larger nuts at the bottom. Tie the ribbon in a large bow and glue to the top of the ring. Spray the whole design lightly with paint.

CHRISTMAS GARLAND

· · ·

· · ·

copper or steel ring

· · ·

moss

· · ·

silver reel (rose) wire

· · ·

secateurs

· · ·

blue pine (spruce)

· · ·

dried amaranthus, dyed red

· · ·

.91 wires

· · ·

dried red roses

· · ·

dried lavender

· · ·

raffia

· · ·

twigs

· · ·

sweet chestnuts

· · ·

fir cones

· · ·

dried fungi

· · ·

strong florist's wire

Blue pine (spruce) instantly evokes Christmas spirit.

I n this garland, blue pine (spruce) is used fresh and left to dry out later. It releases a glorious fresh scent as you work with it and makes a magnificent Christmas decoration. Here it is used with red roses and amaranthus for a traditional look. You could also add fresh apples or tangerines for a lively, if less long-lasting, arrangement – pierce each fruit with a wire to fix it in place.

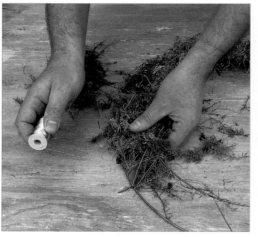

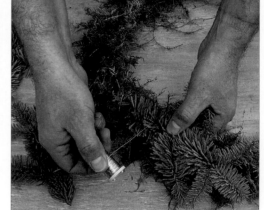

1 Cover the ring very roughly on both sides with moss – this need not be thick but should be fairly even. Secure in place by winding with silver reel (rose) wire, leaving a space of about 5 cm (2 in) between each loop.

2 Trim the blue pine (spruce) to lengths of about 15–20 cm (6–8 in). Divide into four piles and begin to tie each stem to the ring with wire, using one pile for each quarter of the ring. Work outward from the inner edge in a zigzag fashion.

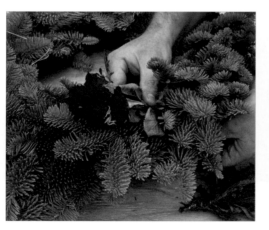

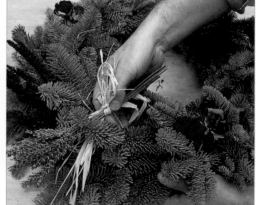

3 Trim the amaranthus stems to 20 cm (8 in) and wire into four small bunches (see Techniques), leaving the wires untrimmed. Treat the roses in the same way, but cut the stems to 10 cm (4 in). In each quarter of the ring, push a bunch of roses and a bunch of amaranthus, tying the wires into the back of the ring.

4 Trim the lavender to 20 cm (8 in) and wire into four bunches. Keep a long length of wire hanging from each bunch and wind a bow of raffia around the stems. Push each wire through the blue pine (spruce) and tie to the back of the ring.

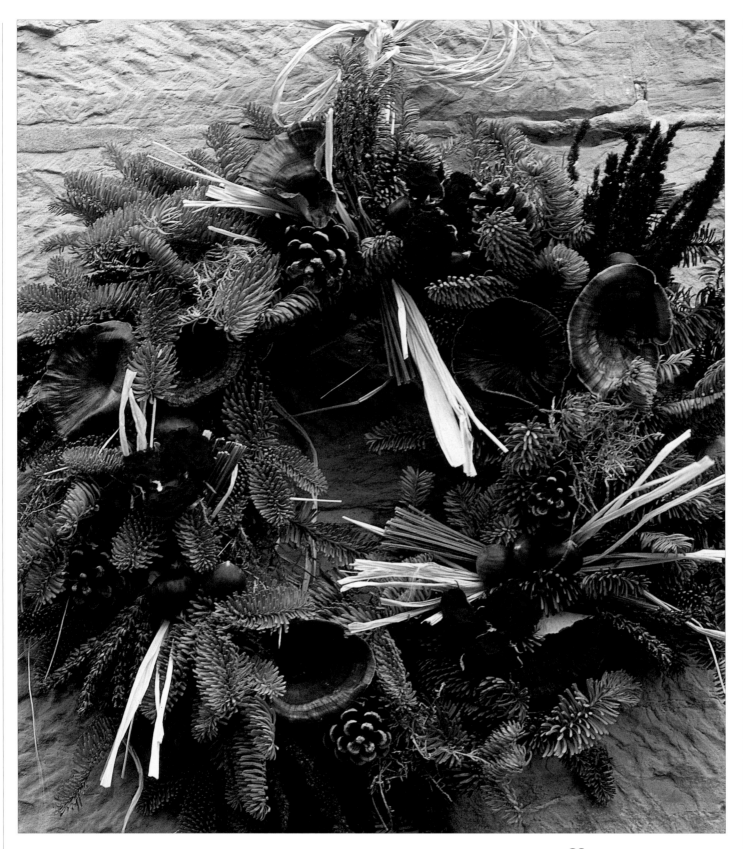

5 Wire bunches of twigs, chestnuts, fir cones and fungi. Tie bows of raffia around the bunches of twigs. Add these materials in small mixed groups, linking each group around the ring. Add a loop of strong wire to the back of the garland for hanging and tie a raffia bow at the top.

Hung outside the front door, a Christmas garland provides a festive welcome for visitors.

FLOWERPOT SWAG
· · ·

MATERIALS
· · ·
wire cutters
· · ·
chicken wire
· · ·
sphagnum moss
· · ·
.91 wires
· · ·
small terracotta pots
· · ·
scissors
· · ·
dried pink and blue larkspur
· · ·
dried blue larkspur
· · ·
dried Achillea ptarmica
· · ·
dried oregano
· · ·
dried Amaranthus caudatus
· · ·
dried yellow roses
· · ·
glue gun and glue sticks
· · ·
dried peonies
· · ·
mossing (floral) pins
· · ·
green moss
· · ·
raffia

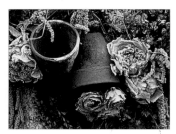

Trailing amaranthus flowers work very well in this swag, giving it a natural country feel.

This lovely design has a chicken wire swag, filled with moss, for its base. Tiny terracotta pots are suspended along its length, blending well with the colour-ful selection of flowers. Add the large peony heads at the end, using them to adjust the balance of the design and also to cover any wires.

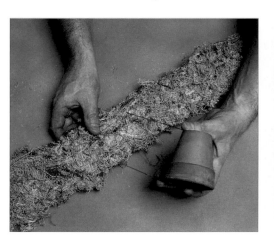 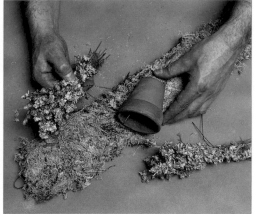

1 Make a chicken wire swag about 1.2 m (4 ft) long (see Techniques). Attach the terracotta pots by passing a wire through the drainage hole in the base and over the rim. Pass the two ends through the swag and twist them firmly together. Push the twisted ends of wire back into the swag.

2 Trim and centre-wire the larkspur, *Achillea ptarmica* and oregano (see Techniques). Starting with the pink larkspur, push the ends of the wires firmly into the swag base. Work the whole length of the swag, adding one variety at a time and criss-crossing the materials to create a balanced look.

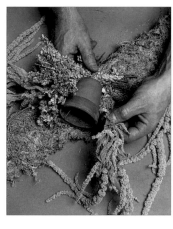 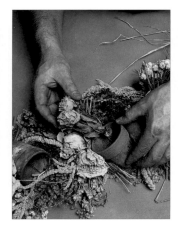 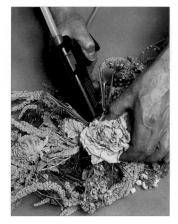

3 Trim the amaranthus, leaving only 5 cm (2 in) of stem, and wire it into bunches (see Techniques). Add them along each edge of the swag, plus a few bunches along the centre between the other materials.

4 Wire small bunches of yellow roses. Put a little glue on the stems and push them into some of the terracotta pots.

5 Cut the peony heads from the stems directly under the flowers. Glue in groups of 2–3, to cover any stems or wires. Using mossing (floral) pins, attach the moss in any gaps. Tie a raffia bow and glue it to one end of the swag.

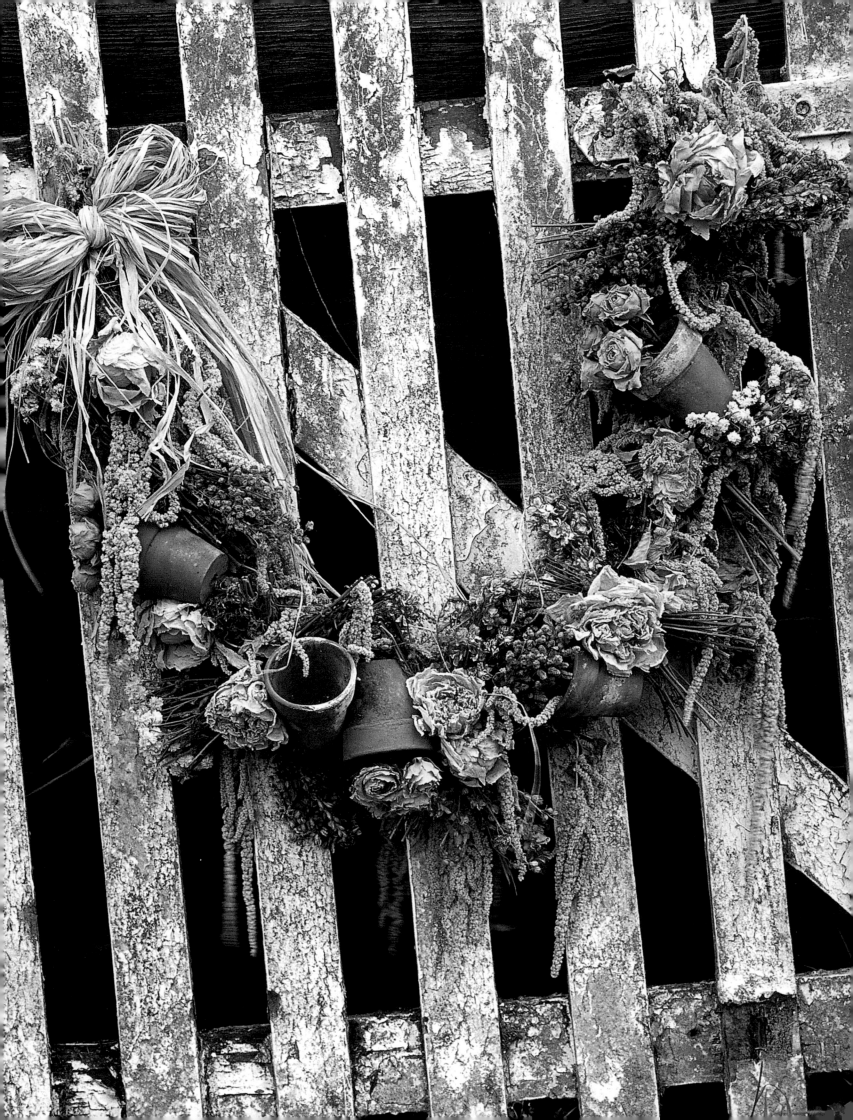

SEASIDE SWAG

· · ·

MATERIALS

· · ·

wire cutters

· · ·

chicken wire

· · ·

sphagnum moss

· · ·

.91 wires

· · ·

small terracotta pots

· · ·

dried Eryngium alpinum

· · ·

glue gun and glue sticks

· · ·

dried echinops

· · ·

dried Eucalyptus spiralus

· · ·

shells

· · ·

starfish

· · ·

mossing (floral) pins

· · ·

reindeer moss

· · ·

dried yellow roses

· · ·

raffia

The materials used in this swag make it ideal for damp conditions.

This large swag is made from a wide collection of materials, combining dried flowers and leaves with seashells, starfish and small flowerpots. It makes an exuberant summer decoration to display outdoors.

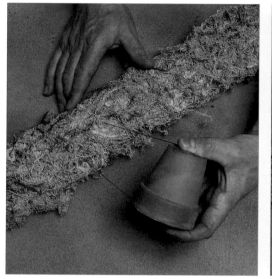

1 Make a chicken wire swag about 1.2 m (4 ft) long (see Techniques). Fix several pots along its length, by passing a wire through the drainage hole in the base and over the rim. Pass the ends of the wire through the swag, then twist firmly together and push back into the swag.

2 Centre-wire the eryngium (see Techniques). Push the ends of the wire firmly into the swag. Work gradually along the whole length, criss-crossing the bunches of eryngium.

3 Glue small bunches of echinops on to the swag. Space them along the whole length of the swag, covering both the sides and the top. Wire the eucalyptus (see Techniques) and place in bunches along the swag and around the pots.

4 Attach the shells and starfish, making sure that the glue comes into contact with the chicken wire frame, the stems and the wires.

5 Using mossing (floral) pins, fix reindeer moss into any gaps. Finally, bunch the roses and push 4–5 into some of the pots. Tie the raffia into a large bow and glue it to one end of the swag.

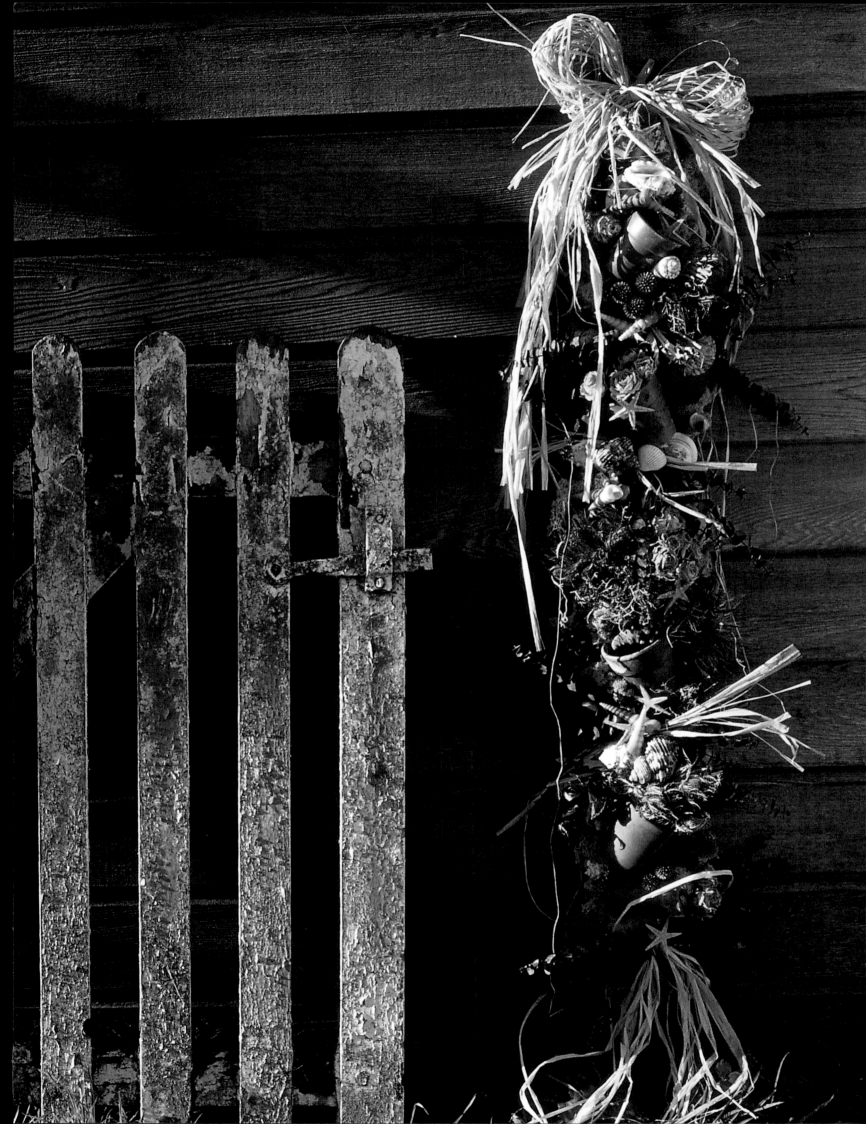

STARFISH SWAG

· · ·

MATERIALS

· · ·

scissors

· · ·

rope

· · ·

glue gun and glue sticks

· · ·

starfish

· · ·

tillandsia moss

· · ·

dried eucalyptus

· · ·

.91 wires

· · ·

shells

· · ·

lichen moss

· · ·

small branches

The distinctive shapes of starfish make this swag very appealing.

This small swag is full of character, with an unusual and interesting mix of materials. It can be viewed from both sides, making it ideal for placing against a window or mirror. The starfish swag would be ideal for a bathroom, where dried flowers and herbs are less suitable.

1 Cut a length of rope 1–1.2 m (3–4 ft) long. Randomly tie knots along its length and make a loop at one end.

2 Place a blob of glue on one side of a starfish and lay the rope across it, between two knots.

3 Glue a second starfish over the top of the first, trapping the rope between the two. Tuck some tillandsia moss around the edges of the two starfish, so that some of it hangs out of the sides. Repeat at several points along the rope.

4 Trim the eucalyptus to 20 cm (8 in) lengths. Using wires, fix several pieces to the rope in one place. Repeat along the rope about every 25 cm (10 in).

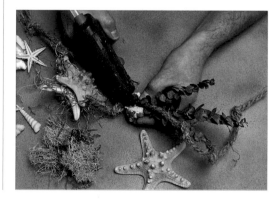

5 Glue a shell at the base of the eucalyptus bunches. Work around the rope until the bases of the stems and the wires are covered. Attach a little lichen moss and add occasional pieces of branch. Repeat along the whole length of the rope at varying intervals.

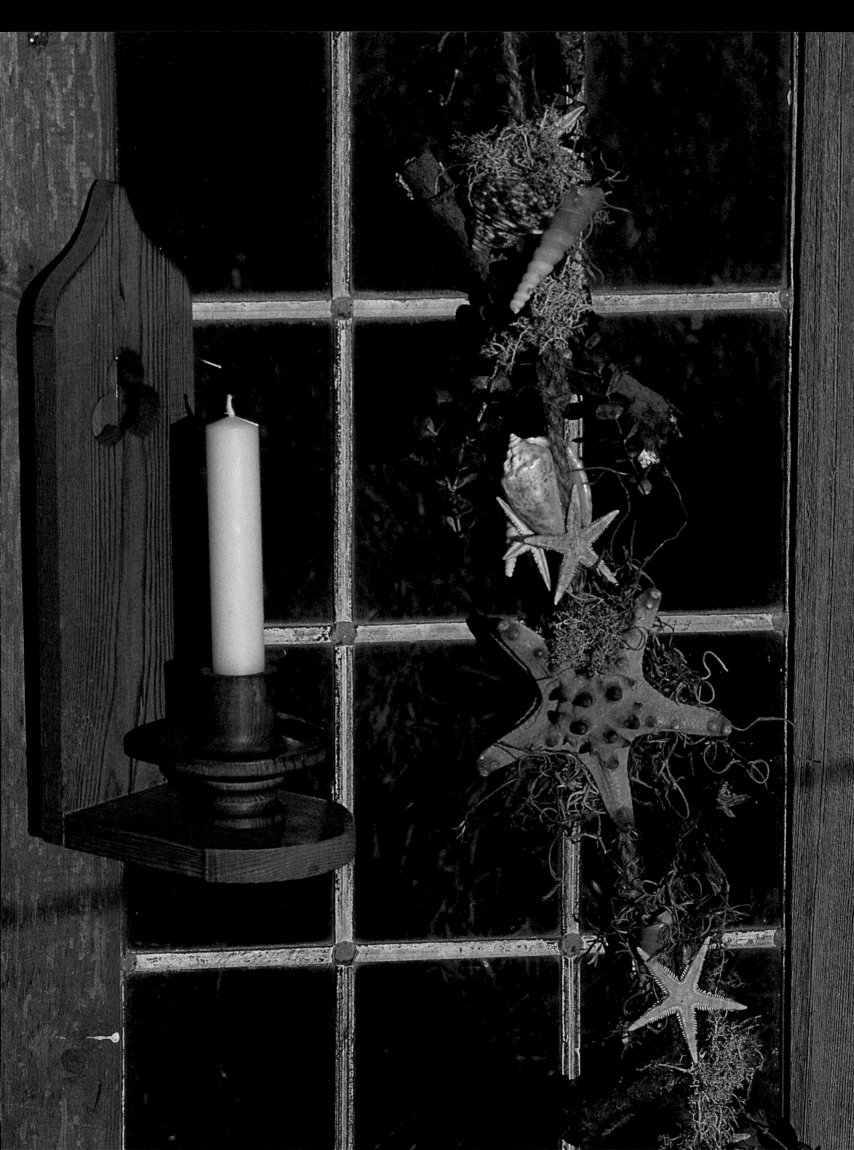

MANTELPIECE SWAG
· · ·

MATERIALS
· · ·
string
· · ·
silver reel (rose) wire
· · ·
scissors
· · ·
secateurs
· · ·
blue pine (spruce)
· · ·
wire cutters
· · ·
.91 wires
· · ·
freeze-dried artichokes
· · ·
dried pomegranates
· · ·
fir cones
· · ·
dried red chillies
· · ·
thick rope or wide ribbon

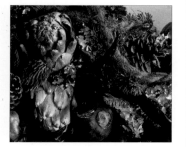

Artichokes, pomegranates, red chillies and fir cones add extra texture and depth to the blue pine (spruce).

This grand swag is very simply created, using string and sprigs of fresh, supple blue pine (spruce) as a base for the other decorative materials. Drape it along a mantelpiece, or wind it around banisters in a hallway for an impressive welcome to your guests. The dried artichokes can be substituted if they are too hard to find.

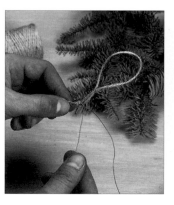
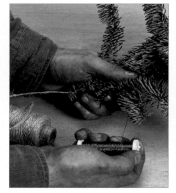
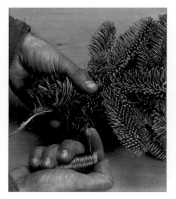

1 Make a loop of string and attach the silver reel (rose) wire to its base, twisting it around several times to secure. Measure the string to the desired length of the swag and cut. Cut sprigs of blue pine (spruce) of roughly equal length.

2 Place a sprig of blue pine (spruce) over the loop then wind the wire around both as tightly as possible. Continue to add a few sprigs at a time along the string.

3 Alternate sides and rotate the swag to achieve a full-rounded effect. The string should be wound into the centre of the swag to act as a core and to ensure flexibility. When you reach the end, make another loop, tie with the wire and cut.

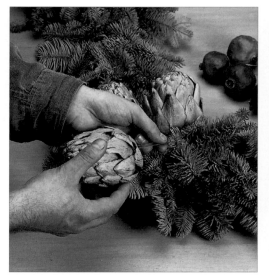
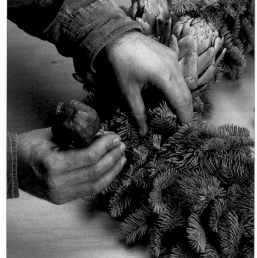

4 Wire the artichokes and pomegranates individually (see Techniques). Insert them into the body of the swag in clusters of three, starting with the artichokes and wire in position. Space each group evenly along the whole length of the swag.

5 Push the wires firmly through the body of the swag at a diagonal, then wind the prongs tightly round one another to secure. Place groups of pomegranates at regular intervals between the artichoke clusters.

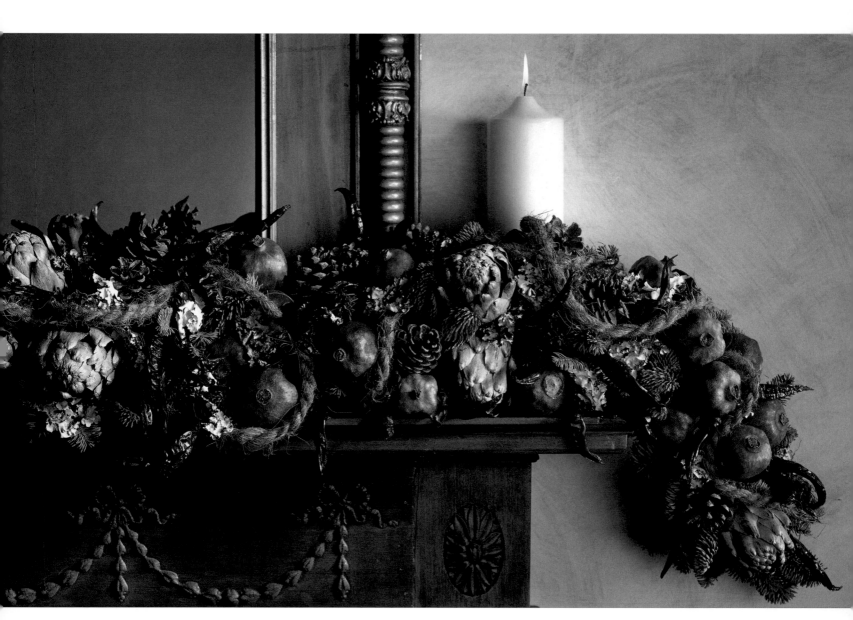

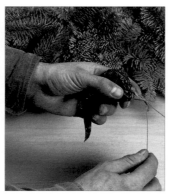

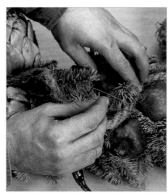

String makes an unusual base for such an impressive swag, and also makes it very flexible.

6 Wire the fir cones between the natural "teeth" of the cone, as close to the base as possible. Add the fir cones in groups of three at regular intervals.

7 To prepare the chillies, take three at a time and wire the stalks together. Introduce these into the swag in large clusters between the other main groups of materials.

8 To finish, feed rope or ribbon between the various groups. Secure it to the swag at strategic points with pins made of short lengths of bent wire. Do not pull the rope or ribbon too tightly – just a little slack will look far more natural.

WINTER FIREPLACE SWAG

· · ·

MATERIALS

· · ·

knife

· · ·

thick rope

· · ·

secateurs

· · ·

dried red amaranthus

· · ·

dried marjoram

· · ·

dried holly oak

· · ·

fresh blue pine (spruce)

· · ·

silver reel (rose) wire

· · ·

.91 wires

· · ·

dried red roses

· · ·

dried lavender

· · ·

dried red chillies

· · ·

dried kutchi fruit

· · ·

glue gun and glue sticks

· · ·

fir cones

· · ·

dried oranges

· · ·

green moss

· · ·

raffia

When you are working with a large number of materials it is easy to forget one or two, so check the design frequently.

This attractive swag is created from a rich mixture of many different materials. The blue pine (spruce) is used fresh, providing a soft base for the other dried materials. The swag will look good throughout the winter, and for Christmas you can add dark red ribbons and gold-sprayed fir cones. Remember to position the swag on the fireplace but well away from an open fire.

1 Cut the rope to the required length. Trim the amaranthus, marjoram, holly oak and blue pine (spruce) and make a pile of each. Using silver reel (rose) wire, tie small bunches to the rope, alternating the materials. Work in a zigzag fashion, leaving no spaces along the bottom, until the rope is covered.

2 Wire the roses and lavender, and centre-wire the chillies and kutchi fruit, both in small bunches (see Techniques). Attach these to the swag, to create a pleasing design. Glue the fir cones and oranges at intervals. Fill small gaps with moss, using glue. Tie a large raffia bow and glue to the centre of the swag.

TRAY DECORATION

· · ·

This pretty little garland was specially designed to decorate a tray, to cheer up an invalid confined to bed. Use small flowers so that you can keep the depth of the garland fairly low, otherwise it might get in the way. A copper or steel ring is made up of two separate rings, only one of which you need for this project.

MATERIALS

· · ·

copper or steel garland ring

· · ·

hay or moss

· · ·

silver reel (rose) wire

· · ·

dried miniature pink roses

· · ·

scissors

· · ·

small dried flowers, e.g.
Achillea ptarmica,
bupleurum, hydrangea,
marjoram

· · ·

glue gun and glue sticks

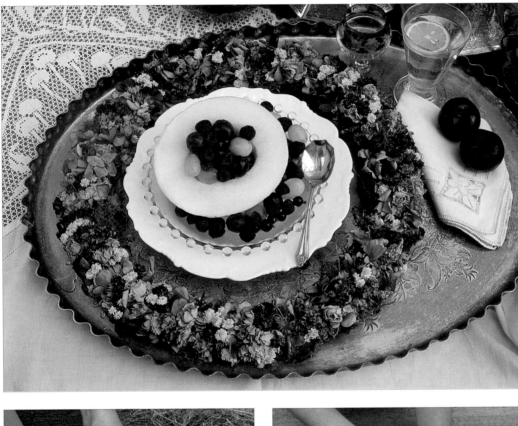

On a small garland such as this, the best effect is created by mixing the different varieties of dried flowers all over the ring.

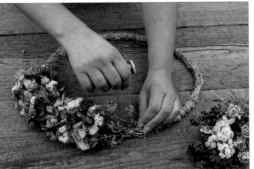

1 Cut off the cross-wires between the two rings and retain one circle for this project. Cover it with hay or moss, attaching it by winding around silver reel (rose) wire. Leave gaps of about 2.5 cm (1 in) between each turn of the wire.

2 Steam the roses if necessary and set aside (see Techniques). Trim the other flower stems to about 5 cm (2 in).

3 Tie silver reel (rose) wire to the covered ring and begin to wind it around the stems, working from the inside outwards. The flowers should hang down to touch the work surface.

4 Trim the rose stems close to the flowerheads and glue them to the garland, together with extra material if necessary to fill any gaps.

153

EVERGREEN TABLE SWAG

. . .

MATERIALS

. . .

knife

. . .

rope

. . .

secateurs

. . .

fresh blue pine (spruce)

. . .

silver reel (rose) wire

. . .

fir cones

. . .

.91 wires

. . .

dried red chillies

. . .

glue gun and glue sticks

. . .

dried fungi

. . .

dried pomegranates

. . .

reindeer moss

. . .

dried lavender

. . .

dried red roses

Decorate the blue pine (spruce) swag with crossed bunches of red roses and lavender.

This seasonal table decoration is made in two halves so it is easier to handle. Conceal the join with large dried materials such as extra pomegranates and fir cones. Use the blue pine (spruce) fresh; it will dry out naturally without losing its colour or needles, and has a wonderful scent. Take great care when using the hot glue gun; any glue that gets on to the display by accident can be covered with the addition of a little moss. If you want to place your swag above an open fire, make sure it is well away from the heat.

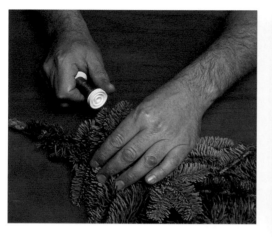

1 Cut two lengths of rope; their combined length should be the length you want the swag to be. Cut the blue pine (spruce) stems to about 20 cm (8 in) long. Using silver reel (rose) wire, bind the stems to the rope.

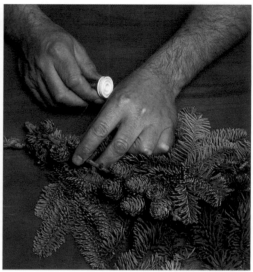

2 If some of the cones are still attached to the stems, bind them to the rope with wire as well.

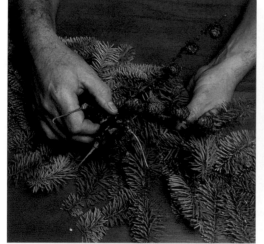

3 Continue the process until the whole length of both ropes has been well covered. Do not leave any gaps along the edges. Centre-wire the chillies (see Techniques), and fix them along the length of the swag.

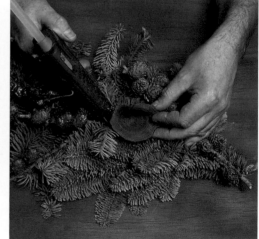

4 Using a glue gun, glue the fungi, extra fir cones and pomegranates in place, at well-balanced intervals and to create an attractive design. Then add the reindeer moss to fill any spaces and to create extra colour and interest.

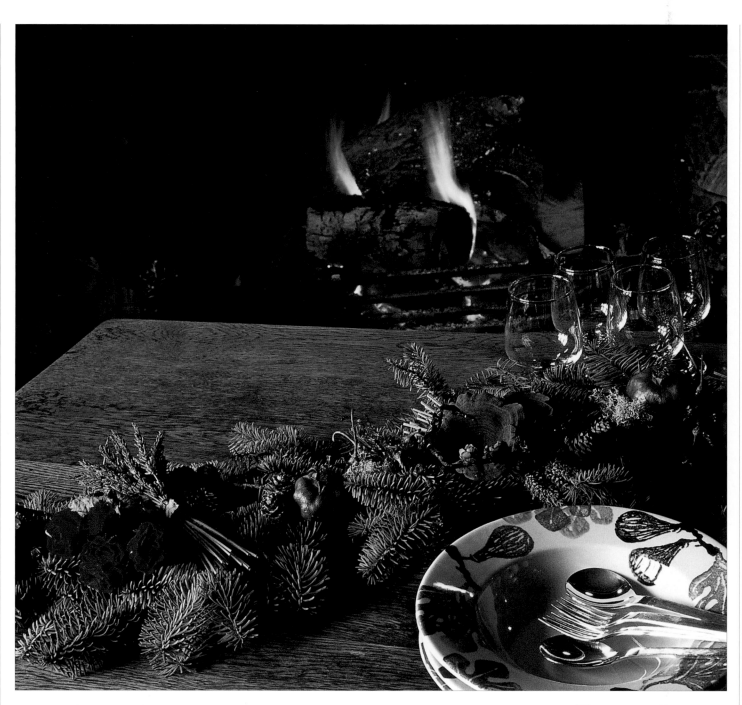

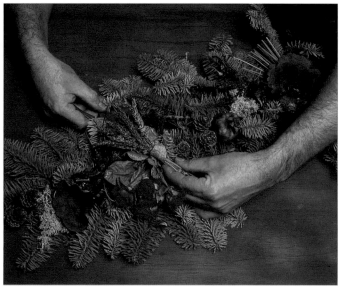

5 Centre-wire the lavender and roses. Fix them in groups, crossing a bunch of roses with a bunch of lavender. Twist the wire ends under the swag and tuck the sharp ends back into the bottom. You can decorate the point where the ends of the swag meet, if you like, by placing candles in terracotta pots in the centre of the display.

This festive swag will look wonderful decorating the table for a simple meal for two, or as the feature of a traditional Christmas feast.

157

CHRISTMAS WREATH

· · ·

MATERIALS

· · ·

ball of string

· · ·

copper or steel garland ring

· · ·

sphagnum moss

· · ·

scissors

· · ·

silver reel (rose) wire

· · ·

secateurs

· · ·

blue pine (spruce)

· · ·

birch twigs

· · ·

.91 wires

· · ·

freeze-dried artichokes

· · ·

dried red chillies

· · ·

dried pomegranates

· · ·

fir cones

· · ·

glue gun and glue sticks

· · ·

dried lichen

· · ·

rope or ribbon

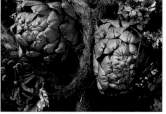

The artichokes provide dramatic shapes and texture, but you can use another dried material if they are not readily available.

This luxurious Christmas wreath combines the rich colours and textures of pomegranates, artichokes and chillies with traditional evergreen foliage and fir cones. It can be hung on a door or placed in the centre of the dining table.

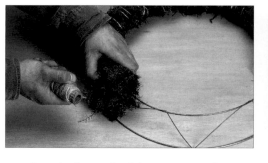

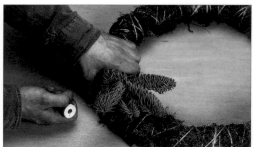

1 Attach the end of the string to the larger of the two rings. Attach the moss to both sides evenly, winding the string tightly around the ring. Continue until the whole ring is covered, then tie the string firmly and trim the ends.

2 Tie the end of the silver reel (rose) wire to the ring. Snip off several sprigs of blue pine (spruce) and build up a thick garland by staggering them evenly around the ring. Secure each sprig in place by winding the wire tightly around the stem.

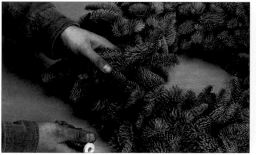

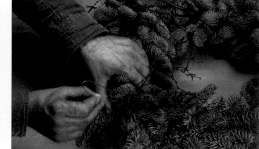

3 Continue to build up the blue pine (spruce) base until the whole ring is covered. Cut off the wire and twist it around itself several times on the underside of the wreath.

4 Make large loops out of birch twigs and place diagonally at intervals around the wreath. Secure with lengths of wire bent into U-shaped pins pushed firmly through the middle of the wreath.

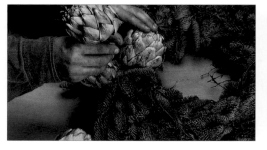

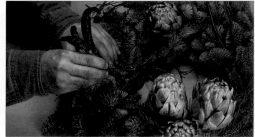

5 Wire the larger dried materials individually (see Techniques). Begin with a group of artichokes. Push the wired stems firmly through the body of the wreath.

6 Wire the chillies in threes (see Techniques). Group them together between the artichokes in large clusters.

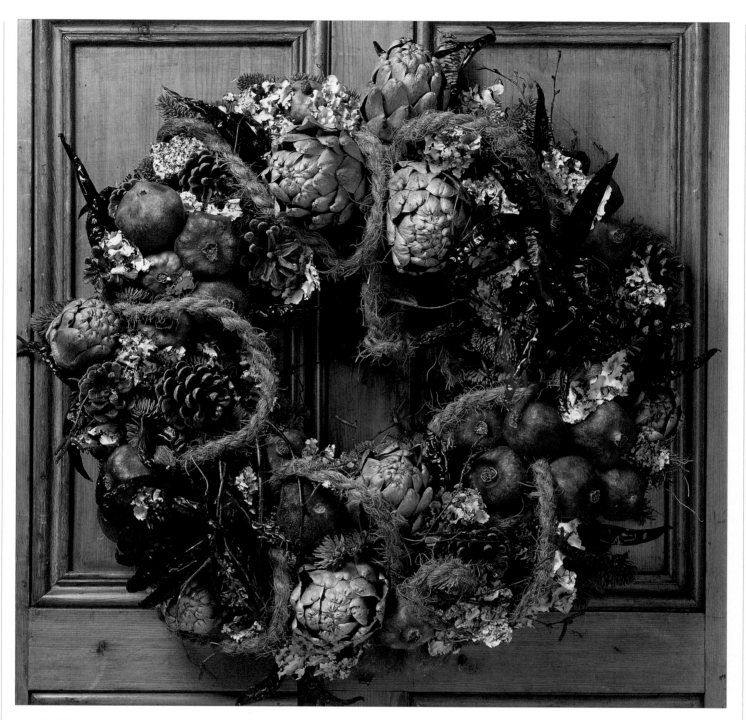

This full-bodied wreath makes a perfect decoration for the festive season.

7 Insert the pomegranates in clusters of at least five to balance the artichoke and chilli groups. Fill in the gaps with smaller clusters of fir cones.

8 Glue the lichen to the wreath. It is very delicate and cannot be wired. Intertwine rope or ribbon between the dried materials. Anchor it with wires folded in half to form U-shaped pins.

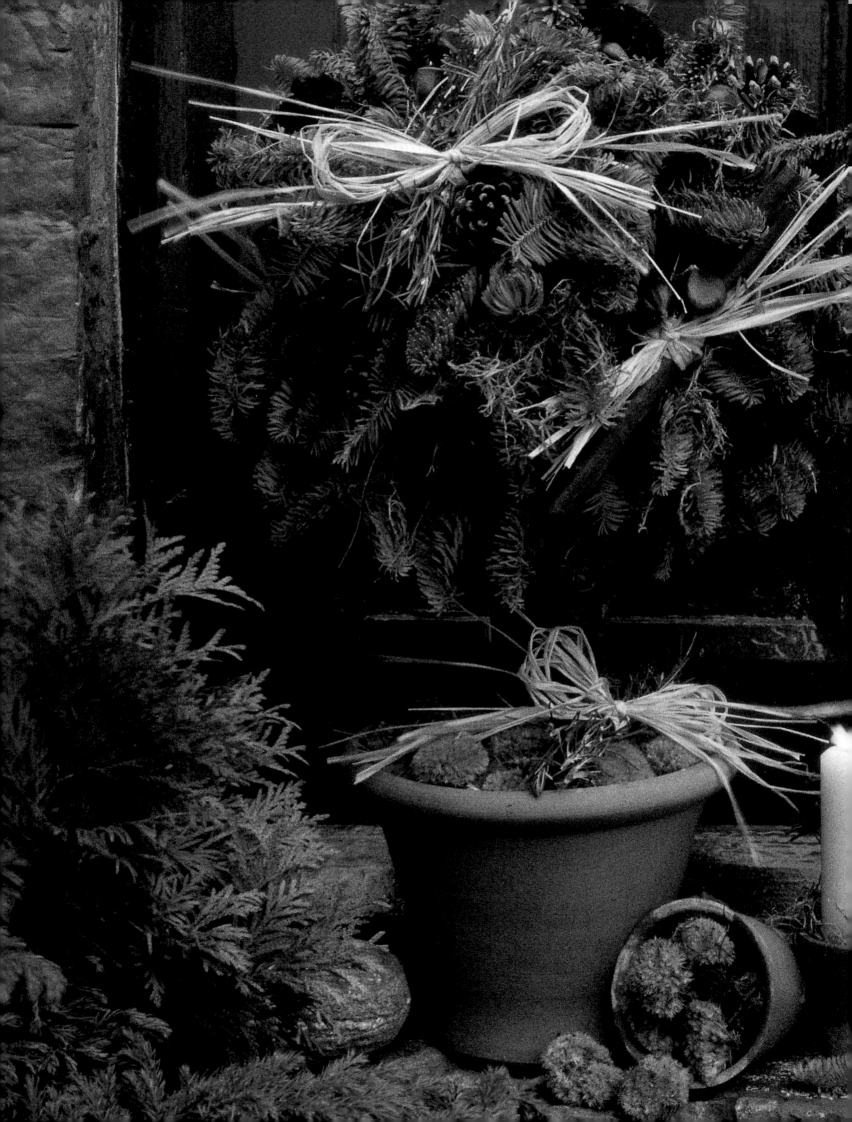

...

TOPIARY
DISPLAYS

...

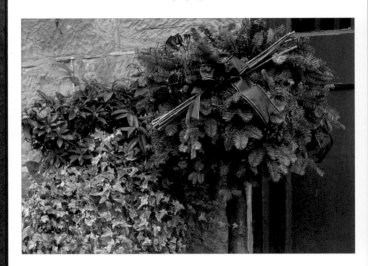

Creating a perfect topiary tree or ball is quite a challenge but very rewarding and fun to do. Your efforts will certainly be noticed and admired, and should last a long time. The classic image of topiary is a sculptural shape in green foliage, but there are many variations on this theme. Experiment with different dried materials to achieve some spectacular results.

INTRODUCTION

· · ·

A topiary display is the ideal solution if you do not have space for a traditional arrangement which would take up a lot of room on a flat surface. A tall topiary tree will fill an awkward space, and a tree decorated with flowers will give colour and interest to a dark corner. For a really elegant effect, place a matching pair of topiary trees either side of a doorway or on a mantelpiece.

The other most popular topiary design is a hanging ball, which is simply a round tree shape without the trunk. Often decorated with sweet-smelling roses, small flowers or herbs, these look very attractive suspended by a ribbon from a beam across a ceiling or in an alcove, again in positions where other dried arrangements would not be suitable.

The base of any topiary arrangement is a geometric shape, usually a ball or cone. For a less formal finish, you can make a ball yourself out of chicken wire filled with plastic foam offcuts and dried moss. Always make sure that the moss is fully dried out, especially if you intend to add flowers to the design, as fresh moss contains thousands of tiny mould spores which would ruin your display. To save time and effort, and for a perfect shape, ready-made plastic foam balls and cones are available from florists' suppliers in a wide range of sizes. The foam can be trimmed with a knife to fit into the pot you are using, or to create an unusual shape for a particular project.

Above: Frosted Rose Tree

Below: Fir Cone Trees

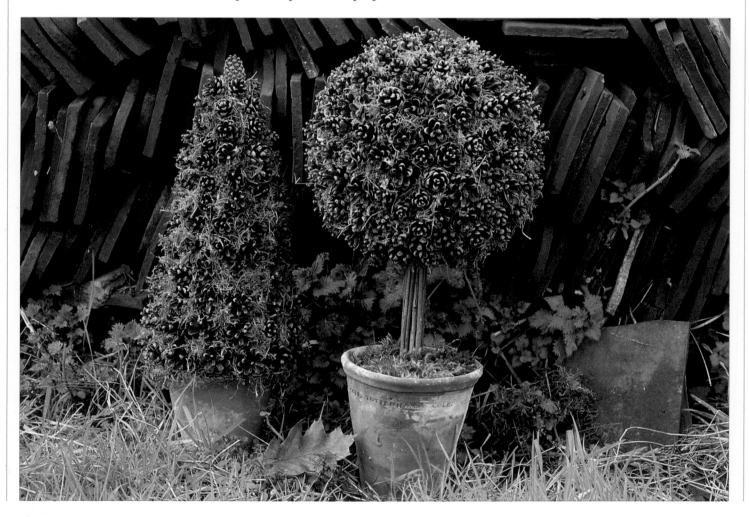

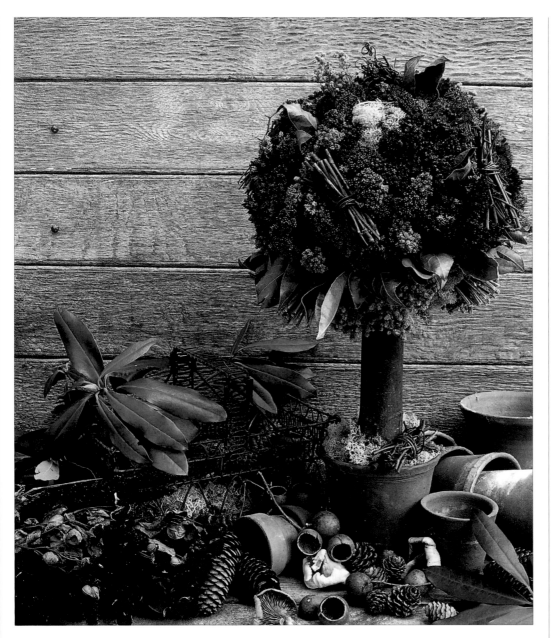

Above: Rose Tree

Left: Marjoram and Bay Tree

If you are making a topiary tree, the first stage is to fix the pot, the trunk and the ball or cone firmly together to make a solid base to work on. The trunk is often a branch or a group of canes tied together; in some designs, a twisted trunk of contorted willow may add to the overall sculptural effect. A common fault is to make the trunk too thin – a short, thick trunk is preferable to one that is long and thin, which could look unbalanced. Always keep the size and height of the finished tree in proportion to the pot, standing back frequently as you work to check the shape.

If you do not want to display a topiary tree in a terracotta pot, it is still a good idea to have a pot as the base. Use a plastic pot and conceal it inside a decorative container; if the container is made of clear glass, surround the pot with pot-pourri to complement the colours in the topiary.

To create a more adventurous topiary design, experiment with unusual dried materials such as preserved (dried) leaves or ferns, eucalyptus, blue pine (spruce), poppy seed heads, spices, protea flowers or ata fruit. Often a single material looks most dramatic on its own, without any other decoration. The main requirement is that the material you choose should be long-lasting, so that you can create a permanent display to be proud of.

Below: Protea Tree

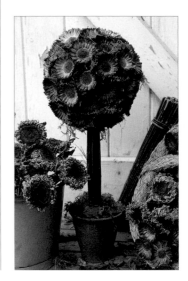

163

ROSE TREE

. . .

MATERIALS

· · ·

silver reel (rose) wire

· · ·

*plastic foam ball, with trunk
and pot attached
(see Techniques)*

· · ·

scissors

· · ·

.91 wires

· · ·

dried roses

· · ·

dried oregano

· · ·

moss

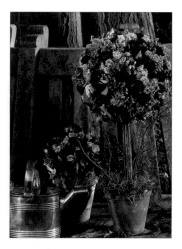

*You can use any colour
combination you like for the
rose tree, such as red and
pink roses, and herbs, as
shown here.*

Dried roses make stunning topiary trees but you always need more flowers than you think. To create a perfectly round shape, it is important to wire the roses to the same height and balance them evenly with the other materials. You can add a few drops of perfumed rose oil to the moss, but don't put it directly on to dried flowers or this will make the petals soft and they will become mouldy.

1 Tie the end of the silver reel (rose) wire to the tree trunk then wind it around both the trunk and the ball to hold them together. Secure the end with a wire bent in half and inserted into the foam.

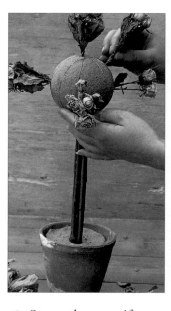

2 Steam the roses if necessary (see Techniques). Trim the stems about 8–10 cm (3–4 in) from the base of each rose head. Wire small bunches of 3–4 roses, with the leaves attached (see Techniques). Attach extra leaves from the discarded stems if necessary. Wire the oregano into small bunches (see Techniques). Begin to push the rose bunches into the foam ball.

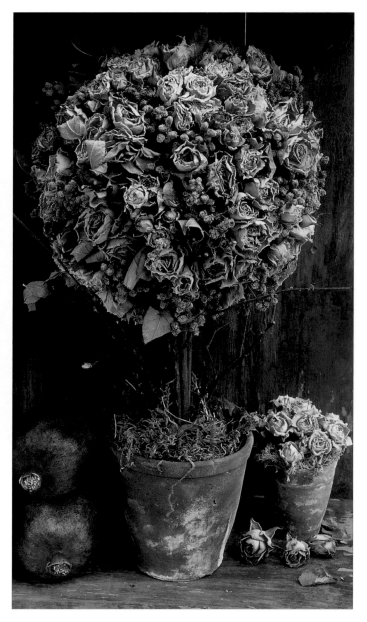

3 Use the rose bunches to create the basic shape of the tree. When you have added 10–12 bunches, start to fill in the spaces with the oregano. Support the foam with your other hand on the opposite side of the ball, but don't hold the trunk. Complete the design then fill any small spaces with moss. Finally, cover the base of the trunk and the clay in the pot with generous handfuls of extra moss.

FROSTED ROSE TREE

· · ·

After a couple of years the colours of a rose tree will inevitably fade. Instead of discarding the display, give it a new lease of life by spraying it with a fine dusting of white paint, to make an enchanting winter decoration.

MATERIALS

· · ·

faded rose tree

· · ·

hair-dryer

· · ·

6 mm (¹/₄ in) wide paintbrush

· · ·

white spray paint

To accentuate the winter theme, spray paint a few fir cones and add them around the base of the tree.

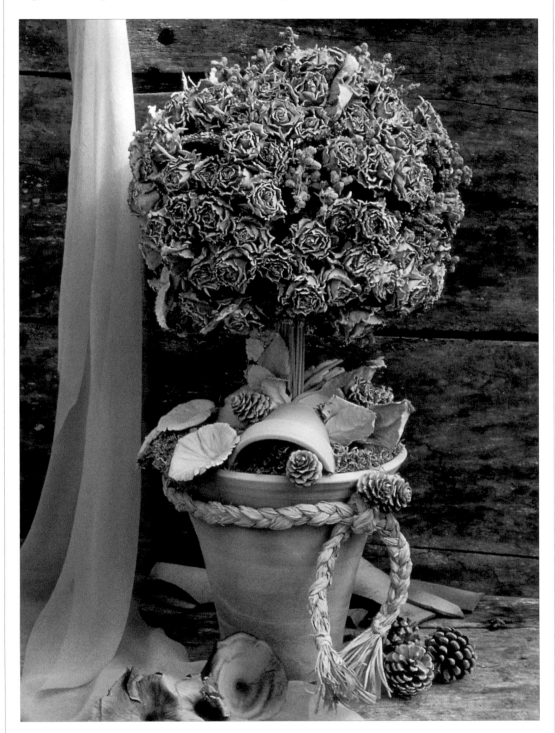

1 First clean the dust carefully off the old display, using a hair-dryer (set on cold) and a paintbrush. Take care not to break any materials in the display.

2 Spray the whole display, including the pot, with a fine coat of white paint. Keep the paint can moving while spraying so that the layer of paint is even.

MARJORAM AND BAY TREE

· · ·

MATERIALS

· · ·

terracotta pot

· · ·

setting clay

· · ·

*piece of tree trunk or branch,
for the trunk*

· · ·

reindeer moss

· · ·

mossing (floral) pins

· · ·

plastic foam ball

· · ·

silver reel (rose) wire

· · ·

scissors or secateurs

· · ·

dried marjoram

· · ·

.91 wires

· · ·

fresh bay stems

· · ·

dried oregano

· · ·

twigs

*When this display looks a
little tired, you can spray it
with clear florist's lacquer to
bring back some of the colour
and the natural glossy shine of
the bay leaves.*

Herbs make excellent topiary trees. If you have access to fresh bay leaves, add them straight from the bay tree and they will slowly dry out in the display. Most of the materials are added in blocks, but a few pieces of each are mixed with the bulk, to tie the whole design together.

1 Fill the pot with setting clay. Push the trunk into the centre, through to the bottom of the pot. Fix reindeer moss around the base of the trunk, using mossing (floral) pins. Leave the clay to set until rock-hard then push the foam ball on top of the trunk. Tie silver reel (rose) wire to the trunk then wind it around the ball to attach it securely.

2 Trim and wire the marjoram in bunches, with stems about 10 cm (4 in) (see Techniques). Push the bunches one at a time into the foam ball, holding the opposite side of the foam to which the flowers are being added, to ensure that you don't push the ball off the top of the trunk. Stand back from the display so that you can check the shape.

3 Keep adding bunches of marjoram until the whole ball is covered.

4 Cut the bay stems vertically to separate sprays of 1–2 leaves. Wire in bunches or leave individually; also wire the oregano (see Techniques).

5 Turn the whole display upside-down and push the bay stems and oregano into the foam, all around the base of the trunk. There should be no bay stalks showing. Centre-wire the twigs into bundles (see Techniques) and place through the arrangement.

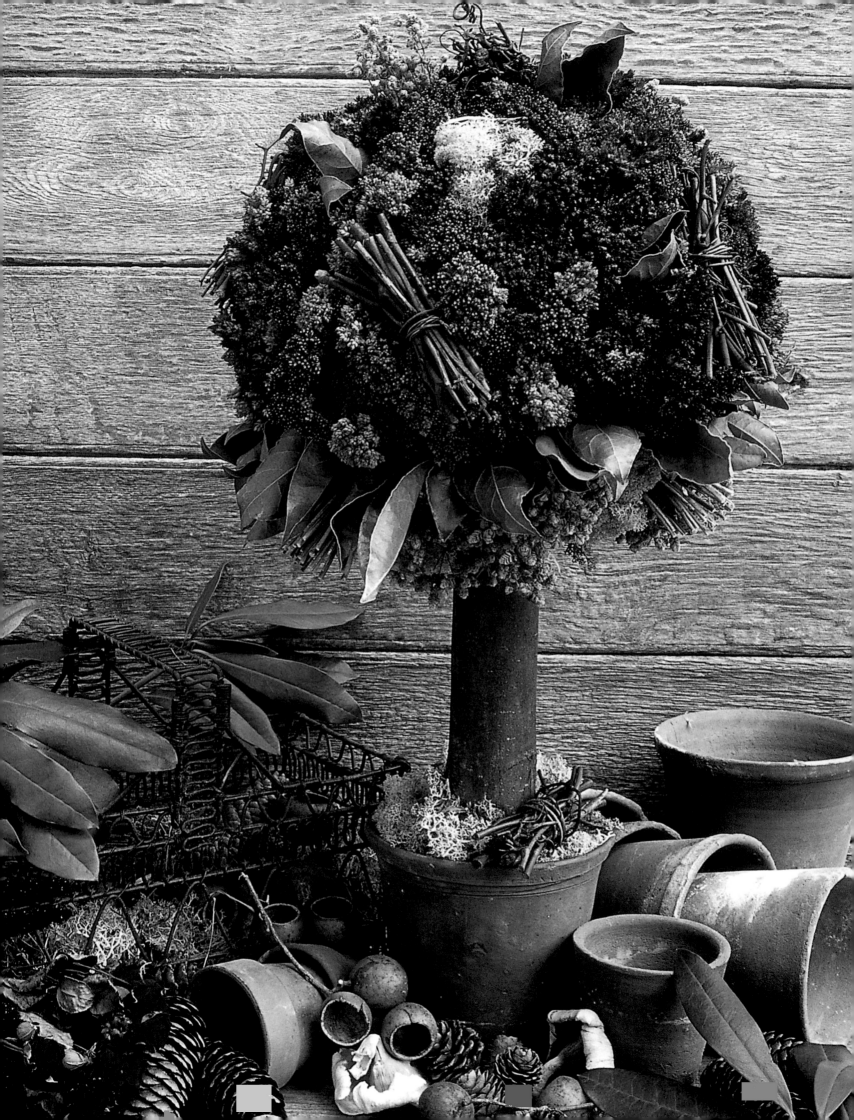

LAVENDER TREE
· · ·

MATERIALS
· · ·

knife

· · ·

*2 plastic foam balls, about
20 cm (8 in) diameter*

· · ·

*container, same diameter as the
foam balls*

· · ·

secateurs

· · ·

contorted willow

· · ·

scissors

· · ·

dried lavender

· · ·

.91 wires

· · ·

reindeer moss

*Contorted willow makes an
unusual and very attractive
trunk for a topiary tree.*

Make a beautiful, scented dried lavender tree with a contorted willow trunk. You could even make a pair of trees and place them on either side of your mantelpiece mirror or fireplace for an elegant architectural effect.

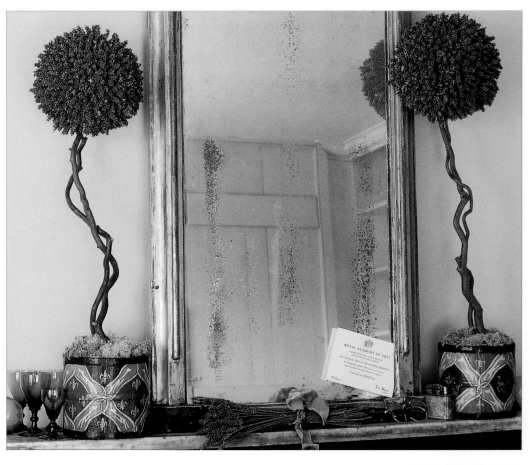

1 Cut one of the foam balls in half and place in the container. Use extra foam if necessary to fill the container. Cut two 50 cm (20 in) lengths of contorted willow and insert into the foam.

2 Push the other foam ball on to the top of the willow. Trim the lavender stalks to 2.5 cm (1 in). Insert a ring of lavender around the foam ball then repeat in the opposite direction.

3 Fill in each section with lavender, working evenly in rows until full. Bend wires into U-shapes and use to pin reindeer moss at the base of the tree in the container, to conceal the foam.

OAK-LEAF TOPIARY
· · ·

Preserved (dried) foliage is an excellent display material in its own right, as well as a useful filler with other materials. By experimenting with different leaves you can create unusual designs with great impact. Oak, copper and beech leaves are the most common type of preserved (dried) leaf.

MATERIALS
· · ·
silver reel (rose) wire
· · ·
plastic foam cone, with trunk
and pot attached
(see Techniques)
· · ·
moss
· · ·
secateurs
· · ·
.91 wires
· · ·
preserved (dried) oak leaves

You could also try pinning individual oak leaves to a foam ball or cone with mossing (floral) pins. Work from the top downwards, placing the next leaf to hide the previous pin. Alternatively, you can use a glue gun to attach the leaves.

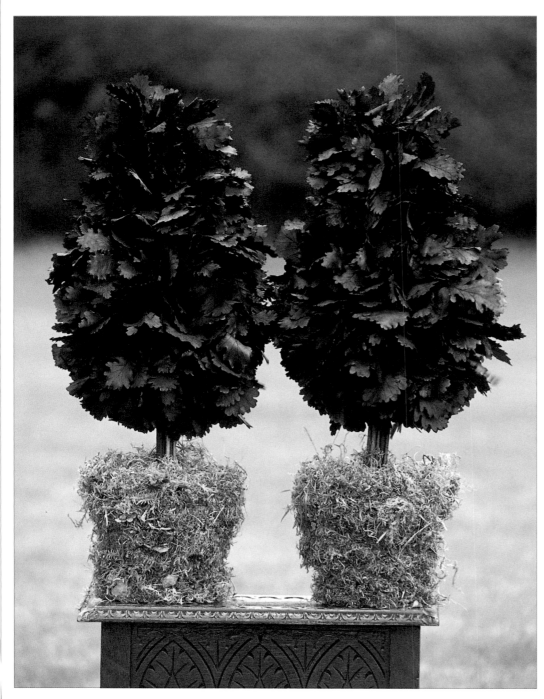

1 Wind silver reel (rose) wire 2-3 times around the pot to secure. Continue to wind from the bottom of the pot upwards, trapping hanks of moss under the wire as you work.

2 Trim and wire small bunches of 6-8 oak leaves (see Techniques). Push them into the foam cone at random, so that they fan out. Use smaller bunches of 2-3 leaves to fill the gaps.

SPICE CONE

· · ·

MATERIALS

· · ·

knife

· · ·

cinnamon sticks

· · ·

small terracotta pot

· · ·

glue gun and glue sticks

· · ·

*2 small plastic foam cones, 1 to
fit the pot, 1 slightly larger*

· · ·

.91 wires

· · ·

whole star anise

· · ·

scissors

· · ·

cloves

*Star anise, together with the
other spices, look as delicious as
their wonderful rich scent.*

Ideal for Christmas, this unusual little cone is studded with cloves and star anise,
both of which are highly aromatic. A cinnamon stick cross completes the design
and the pot is also decorated with cinnamon sticks. Place it near the entrance to
your home so that the scent will welcome you on arrival.

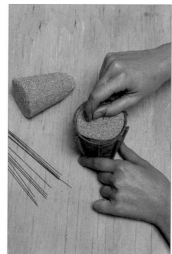

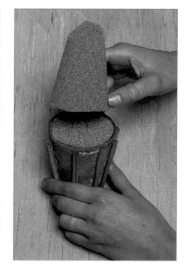

1 Cut the cinnamon
sticks carefully to the
height of the pot. Glue
them at regular intervals
around the pot.

2 Trim off the top of the
larger cone and work it
into a less regimented
shape. Cut the smaller cone
to fit the pot.

3 Put four wires upright
into the pot so they
project above the foam. Fix
the sculpted cone on top of
the pot.

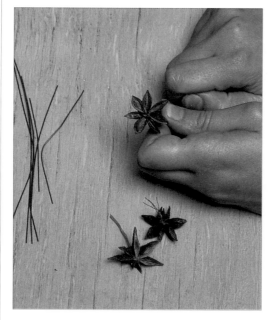

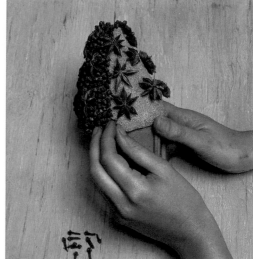

4 Pass a wire over the front of the first
star anise, in one direction then in
another direction to make a cross. Twist
the wires together at the back and trim to
about 1 cm (½ in).

5 Arrange the star anise in rows down
the cone, to quarter it. Add two more
vertically between each line. Fill the
remaining area of cone with cloves,
packing them tightly. Glue two short
pieces of cinnamon stick into a cross.
Wire and place on top of the spice cone.

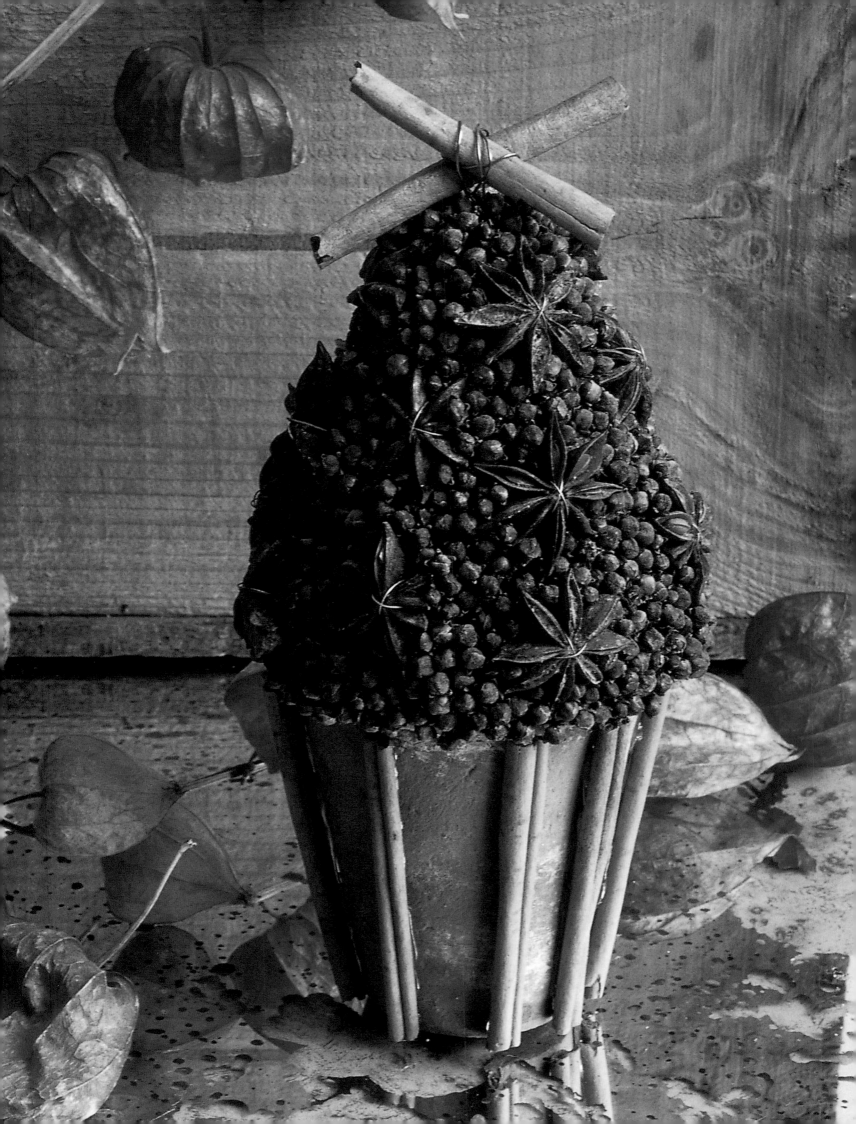

SPICED POMANDER

. . .

MATERIALS

. . .

cloves

. . .

*plastic foam ball, about 8 cm
(3 in) diameter*

. . .

glue gun and glue sticks

. . .

green cardamom pods

. . .

raffia

. . .

.91 wire

*Cloves and cardamom smell
delicious and look
very decorative.*

Pomanders are Nature's own air fresheners. The traditional orange pomanders are fairly tricky to make because the critical drying process can easily go wrong, leading to mouldy oranges. A foam ball, decorated with spices such as cloves and cardamom pods in soft, muted colours, makes a refreshing change.

1 Press in a single line of cloves all around the circumference of the ball. Make another line in the other direction, to divide the ball into quarters.

2 Following the same pattern, press in a line of cloves on both sides of the original lines to make broad bands of cloves quartering the ball.

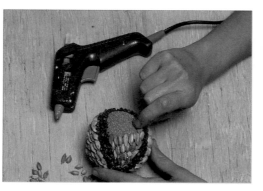

3 Starting at the top of the first quarter, glue cardamom pods over the foam, working in rows to create a neat effect. Repeat on the other three quarters.

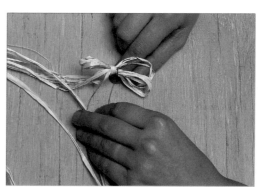

4 Tie a bow in the centre of a length of raffia. Pass a wire through the knot then twist the ends together, leaving them to stick out.

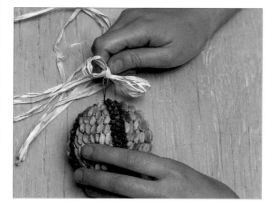

5 Attach the bow to the top of the pomander ball, using the wire.

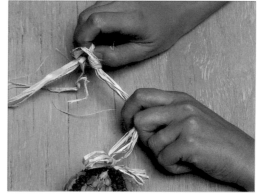

6 Join the two loose ends in a knot, for hanging the pomander.

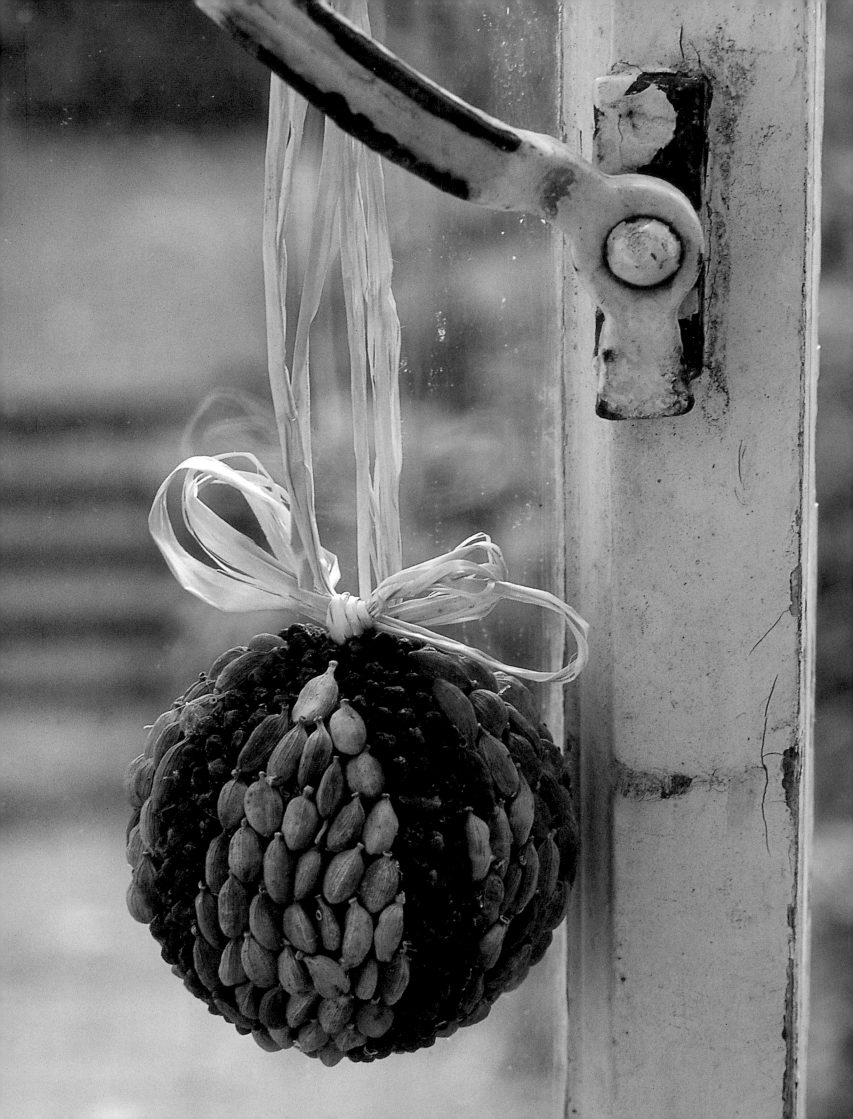

DRIED FRUIT TOPIARY URN

· · ·

MATERIALS

· · ·

glue gun and glue sticks

· · ·

antique metal urn

· · ·

plastic foam ball

· · ·

moss

· · ·

.91 wires

· · ·

dried ata fruit, with stalks

Ata fruit is quite an unusual material to use, which makes it all the more satisfying.

This elegant urn is simply filled with a foam ball then decorated with ata fruit to create an effect similar to a giant pineapple. Like fir cones, this fruit comes with stalks ready for arranging. You could use dried limes and small dried oranges instead, but they would need to be wired first.

1 Using a glue gun, inject a generous line of glue all around the inside edge of the antique metal urn.

2 Place the foam ball over the urn and press down firmly. Hold for at least 30 seconds to allow the glue to set.

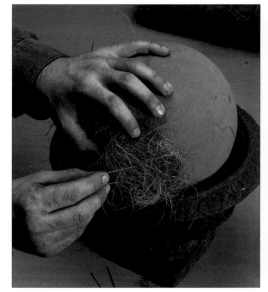

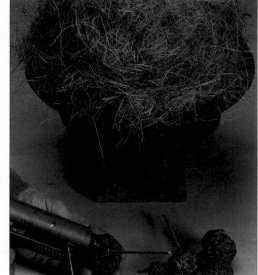

3 Cover the surface of the foam with a good layer of moss. Pin it securely in place with pins made from wires bent in half. This will hide the foam and help to position the ata fruit.

4 Begin to add the ata fruit to the moss-covered foam. For added anchorage, squeeze a few drops of glue on to the base of each ata fruit before inserting the stalk firmly into the foam.

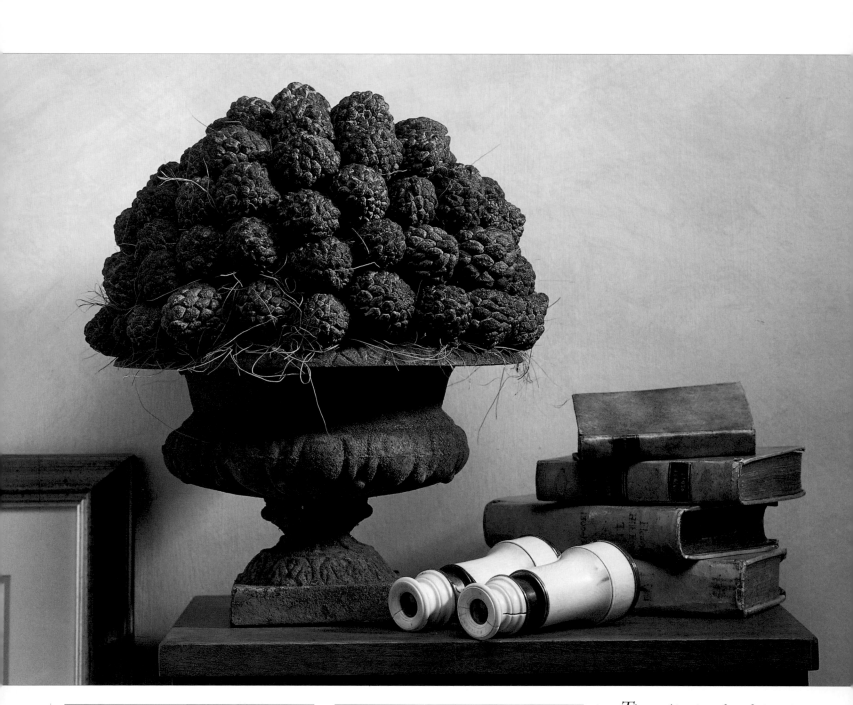

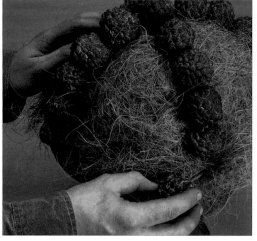

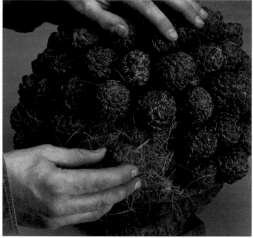

The combination of ata fruit and an antique urn makes a striking display.

5 Place two lines of fruit in the shape of a cross on the foam. Ensure that the heads are level with one another and that the cross shape is even.

6 Fill in each quarter with more fruit. Look at the size of each ata fruit to decide where it will be best placed, as some are smaller than others.

ORNAMENTAL DESIGNS

. . .

Special occasions such as weddings and dinner parties call for special displays. You can still use simple materials, to give a country effect, or you can indulge in grand theatrical gestures. Chandeliers, candle pillars, unusual place settings and dramatic table centrepieces are just some of the ornamental designs you can create to delight your guests.

INTRODUCTION

· · ·

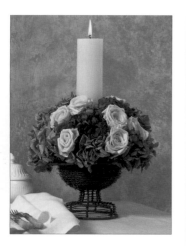

Above: Formal Table Centrepiece

Below: Candle Rings

D ried materials are ideal for special occasions because the displays can be made ahead, leaving you free to attend to other, pressing matters. They are also often dismantled afterwards, so this is an excuse to create something extravagant and spontaneous instead of a display which needs to be long-lasting. Several of the table centrepieces in this chapter are designed to be taken apart and reassembled on another occasion, each time adding to or adjusting the arrangement to keep it interesting. They incorporate numerous candle pots and a wealth of different dried materials to create large, exuberant displays which are still essentially based on simple techniques.

Candle pillars, however, are definitely intended for grand occasions. They always look elegantly stunning, and are ideal for a wedding reception or formal evening party. Place a single large candle pillar on the floor, or make a matching pair for either end of a mantelpiece or a long dinner table. The success of the design rests on getting the right balance between the candle and the base. They are more vulnerable to accidents than short, fat candles in pots, so do position them very carefully and never leave them unattended when the candle is burning.

Another very effective way to mix candles and dried materials is in a chandelier. These are quite easy to make, using a garland ring as a base and decorating it with

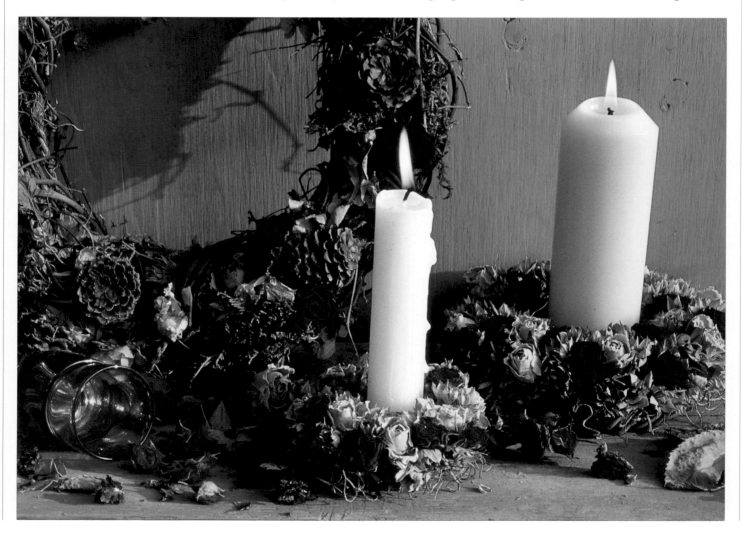

Above: Summer Candle Sack

Left: Floral Chair-back

summer flowers or gilded fruits according to the season. They never fail to enchant with their fragile, magical candlelight.

A wedding is the ultimate opportunity to use your skills with dried flowers. Simple designs for the wedding ceremony itself include delicate posies and circlets for the bridesmaids, and candle decorations for the pew ends in the church. There may already be a fixing on the pew ends for this kind of display, but it is always a good idea to check first. At the wedding reception, you can cover not only the table but also the chair-backs with lavish displays of flowers. Another lovely wedding or party decoration is to loop flower-decked swags along the edge of the table; in this case, fresh green conifer can be used for the base of the swag because the display is not intended to last.

Many ornamental designs are, by their very nature, extra-large and extravagant in their use of materials. Try to find plenty of space in which to work, so that you can spread the various materials out around you, separating them into different varieties and colours. When you are fixing or hanging heavy objects, such as a richly decorated mirror, use solid metal fixings and wire or rope to support the weight. If the display uses fresh moss, it is advisable to leave it somewhere cool to dry out before hanging it on a wall as the fresh moss will add to the weight.

Below: Leaf Napkin Rings

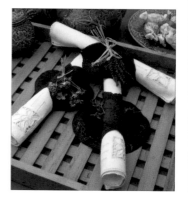

CANDLE PILLAR
. . .

MATERIALS
. . .

medium terracotta pot

. . .

setting clay

. . .

tree trunk

. . .

glue gun and glue sticks

. . .

small terracotta pot

. . .

green moss

. . .

silver reel (rose) wire

. . .

dried yellow roses

. . .

scissors

. . .

dried echinops

. . .

mossing (floral) pins (optional)

. . .

tall candle

The yellow flowerheads contrast well with the blue, to make a bold, modern design.

Covered in dark green moss, this pillar looks stunning, an ideal decoration for a grand dinner party. A pair of these above the fireplace or on the dinner table would add atmosphere to any occasion. Choose a candle that balances the thickness of the floral base. Because of its height, a candle pillar is much more vulnerable to accidents, so make sure you place it in a secure position and never leave it unattended when the candle is lit.

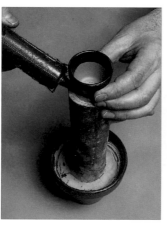
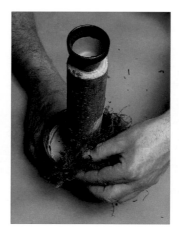
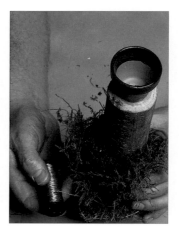

1 Make a topiary base using the medium terracotta pot (see Techniques). Glue the small pot to the top of the trunk, making sure that it is completely straight.

2 Tuck moss into the base of the larger pot and wrap it around the trunk, tying it in place with silver reel (rose) wire. Keep the moss as even as possible and not too thick.

3 Continue to add the moss until the whole trunk has been covered, and so that the area around the small pot at the top of the trunk also has a good layer of moss.

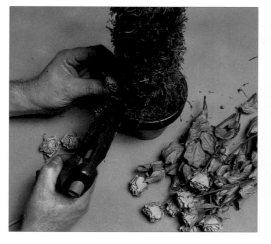
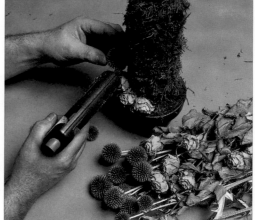

4 If the roses are small, steam them (see Techniques). Trim the stems off the rose heads then glue the heads in small groups on to the moss, in various positions around the trunk.

5 Repeat with the echinops until the whole of the moss is covered. Fill any small gaps with moss, fixing it in place with a glue gun or mossing (floral) pins. Fix the candle in the small pot, either by gluing or by packing the pot tightly with moss.

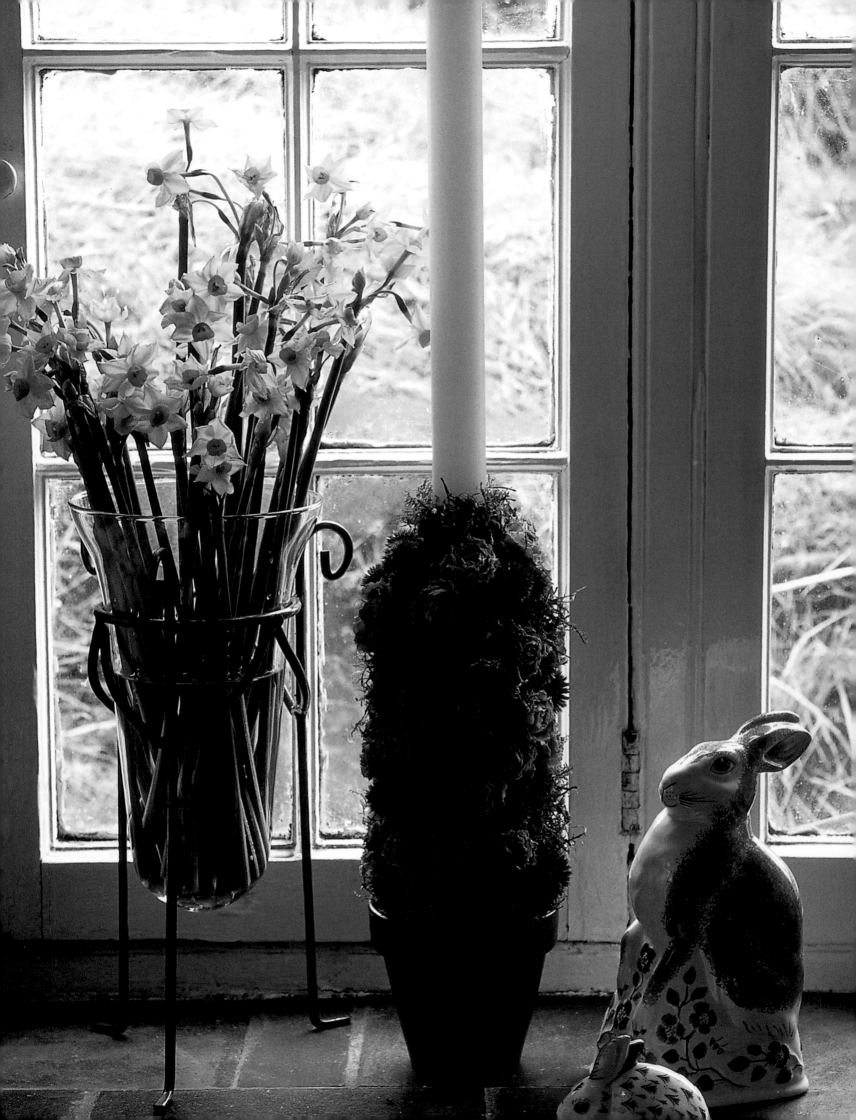

FLORAL CHANDELIER

· · ·

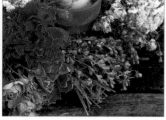

This mix of flowers will keep its colour for a long time, but you may need to replace the moss after a few months.

This unusual chandelier is designed to hang fairly low, so no flowers are added to the base. Hold it up every so often while you are making it to see how it looks from that angle. The flowers look enchanting in the candlelight; remember never to leave the chandelier unattended when lit.

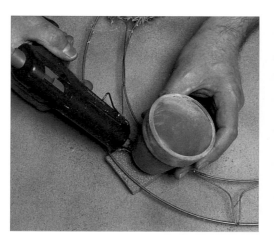

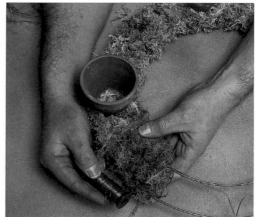

1 Flatten the garland ring by pushing or pulling the triangular wires towards each other. Glue a small piece of foam under the ring and to one of the pots, so that at least one of the wires crosses the centre of the foam; change the angle of the wire if necessary. Attach all four pots in the same way, spacing them evenly around the ring.

2 Wrap sphagnum moss around the ring, holding it in place with silver reel (rose) wire. The moss needs to be about 2.5 cm (1 in) thick. Pay particular attention to the base of the ring, making sure that the foam base and the area around the pots are covered.

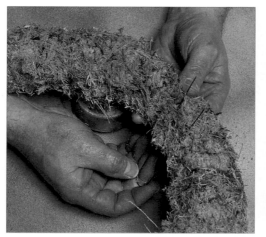

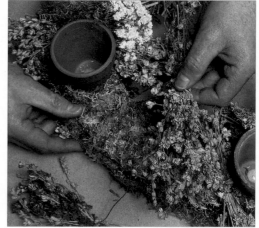

3 To create a hanging loop, push both ends of a strong wire through the ring, between two pots on the inner edge. Make sure that it crosses the ring frame under the moss. Twist the ends together and tuck into the moss. Repeat at even intervals to make four loops for hanging.

4 Centre-wire bunches of larkspur, roses and achillea (see Techniques). Push the wire into the moss frame. Angle the flowers so that they are pointing from the inside of the frame to the outside.

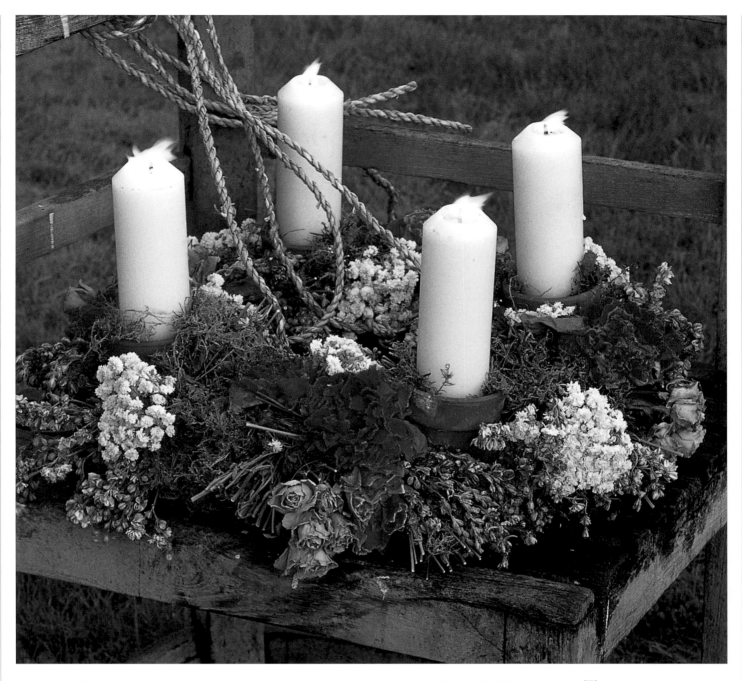

The chandelier will look dramatic when lit, and should last a fair while with such thick candles.

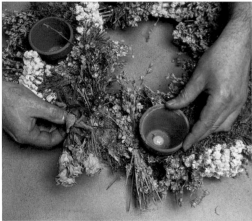

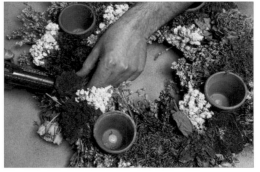

5 Continue to add these three materials, criss-crossing them. Place them in the same order in each quarter of the ring, to give balance to the design.

6 Cut the stems off the peonies and glue the heads in place. Using mossing (floral) pins, attach the dark green moss to the ring, filling any gaps. Attach four hanging ropes to the wire loops. Fit the candles into the pots, wedging them in place with foam and moss.

201

PINK LARKSPUR PILLAR

. . .

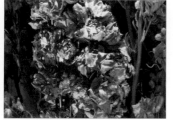

Pink larkspur is the dominant flower in this candle pillar, blending nicely with the other materials.

This lovely display is fairly easy to make, but only add as much material as you can comfortably hold in one hand, fixing it in place with the silver reel (rose) wire before trying to add more. Experimentation will tell you the best position to hold the pillar – you may find it easier to lay it down while you add the materials. When the display is finished, go back to the top and if there are any gaps push a few stems between those already in place.

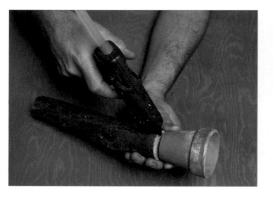

1 Glue the small pot to the top of the trunk, making sure that it is completely level. Set the trunk in the medium pot, using setting clay.

2 Tuck moss into the base of the medium pot and wrap it around the trunk, tying it in place with silver reel (rose) wire. Keep the moss even.

3 Continue until the whole trunk is covered with moss. Make sure that the area around the pot at the top of the trunk also has a good layer.

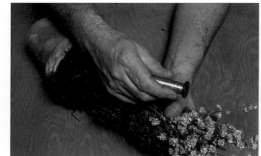

4 Trim the flower stems to about 13 cm (5 in). Starting at the top of the trunk, tie the larkspur in place with silver reel (rose) wire.

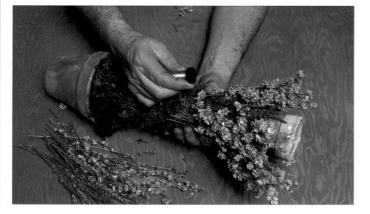

5 Add the lavender, working down the whole length of the trunk. Each layer should cover the workings of the last. Wrap green moss around the stems and wire of the final layer, and fix in place with mossing (floral) pins. Glue the candle into the small pot.

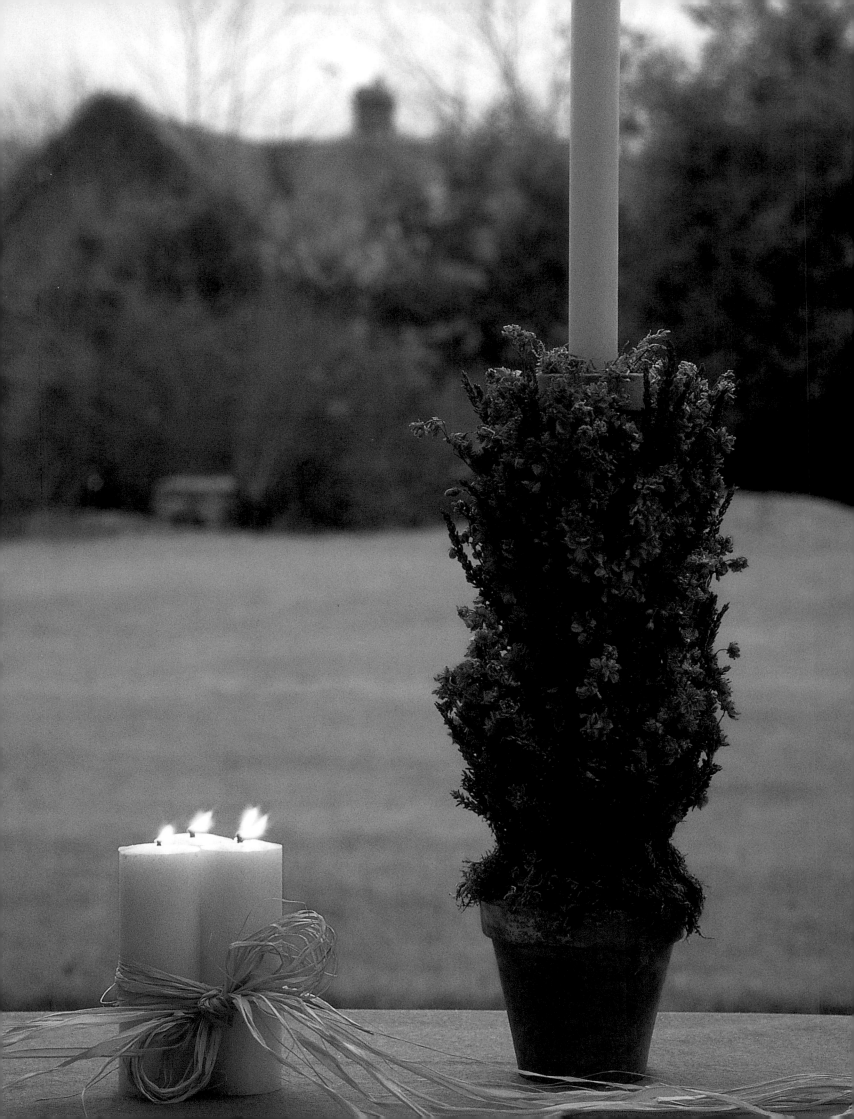

ARTICHOKE CANDLEHOLDER

· · ·

MATERIALS

· · ·

large dried globe artichoke

· · ·

gold spray paint

· · ·

glue gun and glue sticks

· · ·

plastic candleholder

· · ·

dark green moss

· · ·

mossing (floral) pins

· · ·

fir cones

· · ·

.91 wires

· · ·

twigs or cinnamon sticks

· · ·

candle

· · ·

gold cord

Dried artichokes have a stunning impact, but you can use dried fruit if they are too hard to find.

Sprayed gold, the distinctive shape of the artichoke makes an exotic table decoration. Choose artichokes with a flat bottom so that the candle will stand safely. Make sure that you never leave a burning candle unattended.

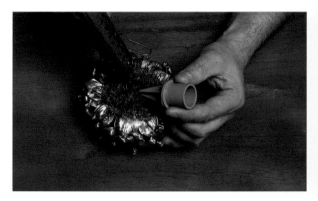

1 Spray the artichoke with gold paint and leave to dry for a few minutes. Put some glue in the centre of the artichoke and push the candleholder into the soft glue.

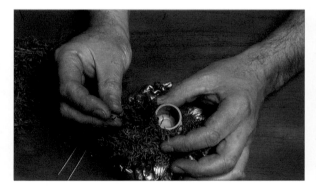

2 Cover the top of the artichoke with moss, fixing it in place with mossing (floral) pins. Make sure the moss covers the sides of the candleholder, but leave the hole at the top clear.

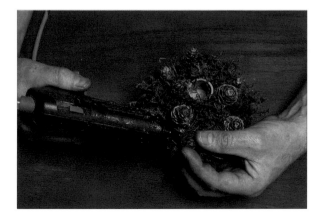

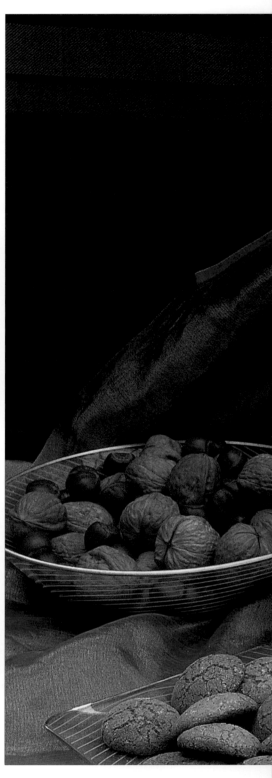

3 Using a glue gun, glue the fir cones firmly on top of the moss. Try to create a pleasing, balanced arrangement as a base for the other materials.

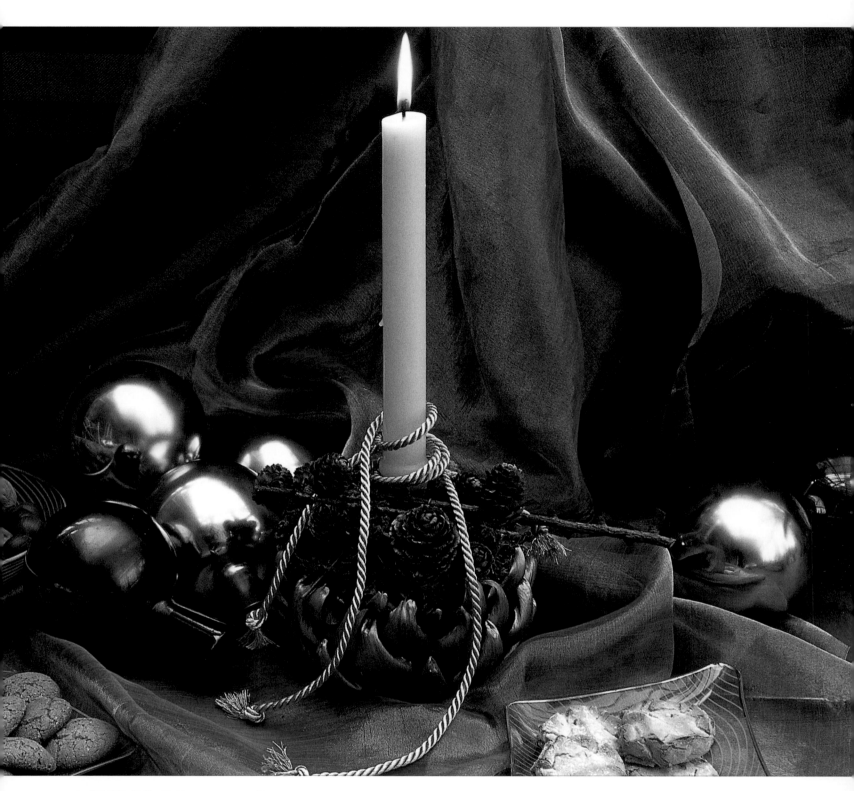

4 Decorate with wired bunches of twigs or cinnamon sticks or, as shown here, fir cones on a twig. Fit the candle into the candleholder and arrange the cord.

This display makes a perfect Christmas table decoration.

LEAF-WRAPPED CANDLES

· · ·

MATERIALS

· · ·

glue gun and gun sticks

· · ·

*large preserved (dried) leaves,
e.g. magnolia leaves*

· · ·

candle

· · ·

scissors

· · ·

raffia

*These naturally dark magnolia
leaves are very attractive in a
display, but can also be bought
dyed a beautiful rich burgundy
colour, as for this project.*

These handsome candles are simple to make yet sophisticated enough for a grand occasion. Thin candles will burn too quickly so make sure that you choose ones that are at least 8 cm (3 in) in diameter and about 15 cm (6 in) tall. Remember never to leave burning candles unattended.

1 Place a little glue on the back of a leaf, near the base. Press the leaf firmly on to the side of the candle. Repeat all round the candle.

2 Trim the base of the leaves, so that the candle stands straight. Tie a few strands of raffia tightly around the bottom of the leaf-wrapped candle.

CANDLE RINGS

· · ·

Any small-headed flowers would be suitable for these attractive decorations but dried miniature roses are perfect. If you are using more than one shade of rose on a candle ring, glue them in pairs of different colours and position the heads so that they are facing outwards. Small leaves discarded with the unwanted rose stems make useful fillers, but take care that they are not too tall and may become a fire hazard. Never leave lighted candles unattended.

MATERIALS

· · ·

glue gun and glue sticks

· · ·

moss

· · ·

small cane ring

· · ·

scissors

· · ·

dried flowers, e.g. miniature roses, bupleurum

· · ·

candle

· · ·

moss

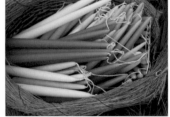

Make the candle ring any size, depending on the width of your candle.

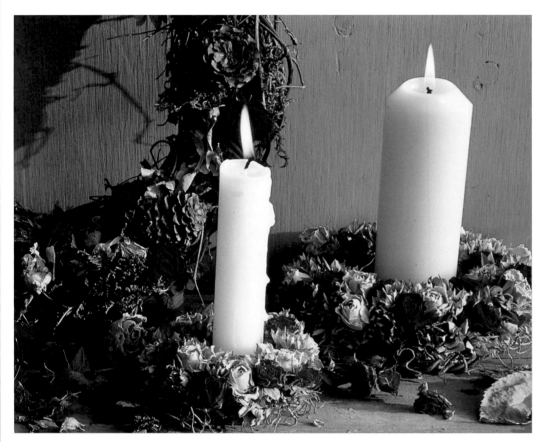

1 Glue a light covering of moss to the cane ring. Try to make sure that no glue is visible.

2 Trim the rose heads from their stems, leaving as little stalk as possible. Glue them in place in a balanced and symmetrical design.

3 Fill the spaces between the roses with other flowers or foliage, leaving enough room for the candle. Fill any remaining gaps with moss.

WINTER CHANDELIER
. . .

MATERIALS
. . .
dried oranges
. . .
gold spray paint
. . .
knife
. . .
small screwdriver
. . .
.91 wires
. . .
glue gun and glue sticks
. . .
moss
. . .
starfish
. . .
rope
. . .
ready-made hop vine or twig garland
. . .
green moss
. . .
4 florist's candleholders
. . .
4 candles

Starfish, dried oranges and moss make very unusual decorations.

This quirky chandelier consists of a moss-covered ring, from which hang gold-sprayed dried oranges decorated with gold starfish. To dry the oranges, place them on a wire rack over a stove or in an airing cupboard for several weeks until they are very hard. Remember to never leave a burning candle unattended.

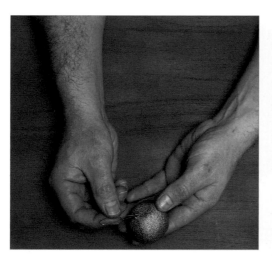

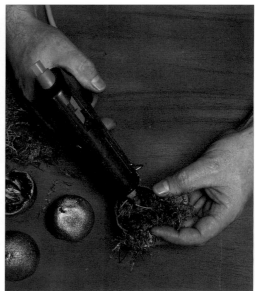

1 Spray the oranges with gold paint. Cut them in half and make a hole in each half with a screwdriver. Push the two ends of a bent wire through the hole, to make a hanging loop. Turn the orange over and bend the ends of the wire up, to prevent the loop from falling out.

2 Using a glue gun, coat the inside of the orange with glue and push moss into the open space, until you have completely filled it up.

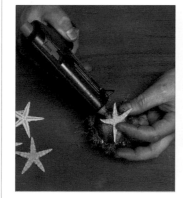

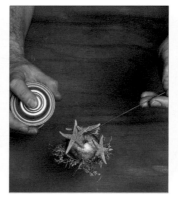

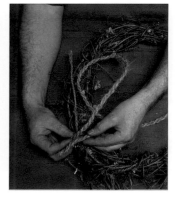

3 Take a starfish. Place glue on the moss and around the edge of the orange, where the starfish touches it. Hold in place until the glue sets. Dab a little glue on two or three more starfish and place them on the top and sides of the orange.

4 Bend the top and bottom of a long wire and hang the orange on one end. Spray it gently and carefully with gold paint, so that it provides a frosting rather than solid colour, allowing a little of the orange colour to show through.

5 Tie four lengths of rope firmly to the ring, so that the chandelier hangs horizontally. At this stage, keep the ropes fairly long so that you can adjust them afterwards.

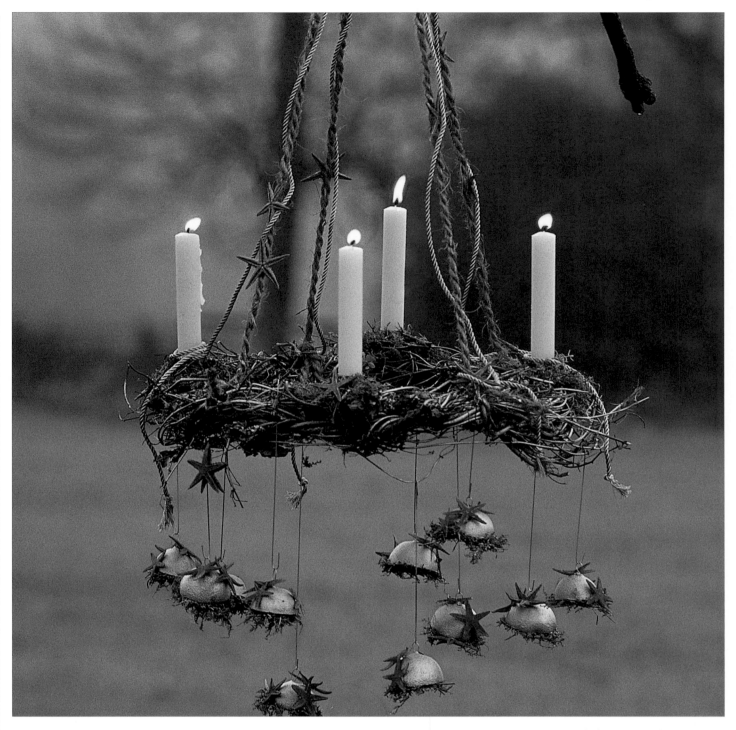

The whole chandelier is brought together by the gold frosting on the ring and the rope.

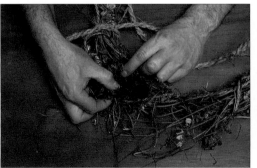

6 Push a handful of green moss on to the ring between two of the ropes. Make a small hole in the centre of the moss with your fingers.

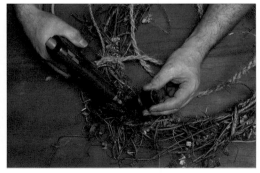

7 Put some glue in the hole and push a candleholder in, keeping it straight. Put a candle into the holder. Add the oranges when the chandelier is positioned.

213

WINTER CANDLE SACK
· · ·

MATERIALS
· · ·

plastic bag

· · ·

sand

· · ·

knife

· · ·

1 block plastic foam for dried flowers

· · ·

fabric offcut

· · ·

.91 wires

· · ·

silver reel (rose) wire

· · ·

preserved (dried) ferns or leaves

· · ·

scissors

· · ·

dried flowers, e.g. carthamus, marjoram

· · ·

plastic candleholder

· · ·

raffia

· · ·

candle

Marjoram adds a full look and attractive texture to displays, and is an ideal background for brightly coloured flowers.

This unusual candle base is simply a plastic bag filled with sand to balance the tall candle. Two alternatives are shown here: deep red roses, marjoram, ferns and leaves in the main photograph, or orange carthamus, marjoram and ferns in the step-by-step photographs. Never leave a burning candle unattended.

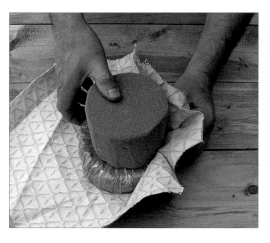

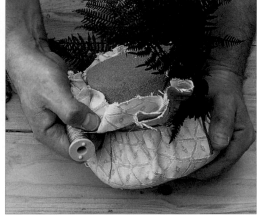

1 Fill the plastic bag with sand to a depth of 2.5 cm (1 in) and a diameter of 13 cm (5 in) when the sand is patted down into a round. Tie a knot to close the bag, squeezing out all the air. Cut a cylinder of foam slightly smaller than the bag of sand. Place the sand bag on the piece of fabric, and the foam cylinder on top of the bag.

2 Gather the fabric up around the foam, while also bringing the sand bag up a little around the base of the foam. Fix the fabric in place with wires bent into U-shapes. Wind the silver reel (rose) wire 2–3 times round the neck of the bag to make a firm starting point. Add the ferns or leaves, holding them in place with the wire around the neck of the bag.

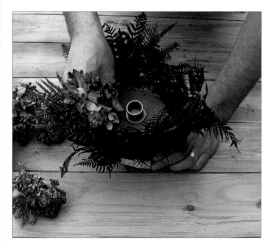

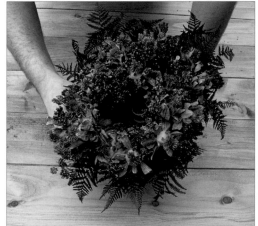

3 Trim the flower stalks to about 15 cm (6 in) then wire the flowers into small mixed bunches (see Techniques). Push the candleholder into the centre of the foam. Add the wired bunches, so that the flowers lean outwards and away from the candleholder.

4 Continue to add the wired bunches of flowers until the foam is completely covered and the bunches are evenly arranged. Fill any small gaps with individual flowers or leaves. Tie a raffia bow around the base. Place the candle firmly in the candleholder.

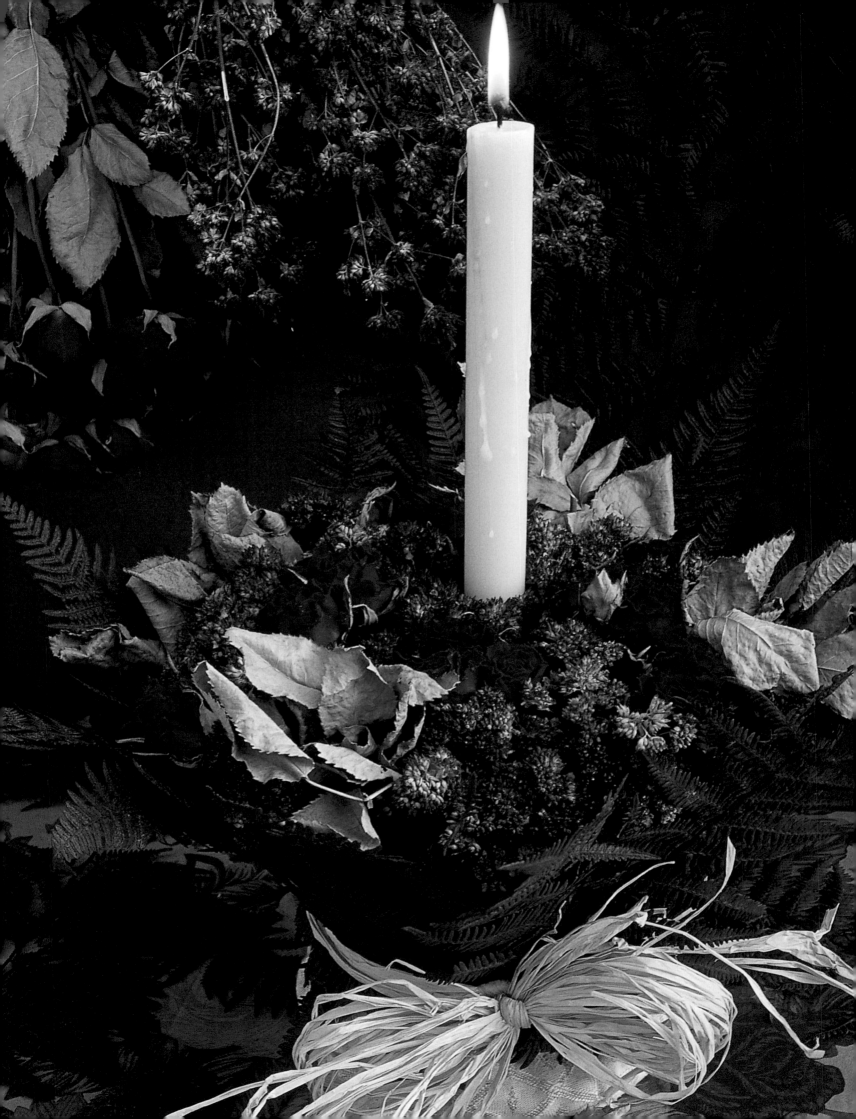

FORMAL TABLE CENTREPIECE
• • •

MATERIALS

• • •

small wire urn

• • •

moss

• • •

knife

• • •

1 block plastic foam for dried flowers

• • •

.91 wires

• • •

florist's tape (stem-wrap tape)

• • •

candle

• • •

mossing (floral) pins

• • •

dried hydrangeas

• • •

scissors

• • •

freeze-dried roses

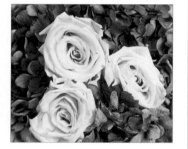

Large roses and hydrangeas are a lovely and very elegant combination.

Hydrangeas dry beautifully and only a few are needed to create a stunning effect. Combined here with large white freeze-dried roses, they make a brilliantly simple arrangement that will look good all year round. Do not let the candle burn down too near to the dried flowers, or leave a lit candle unattended.

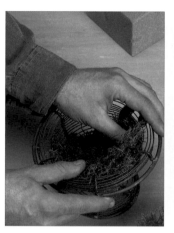

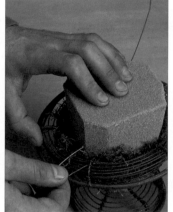

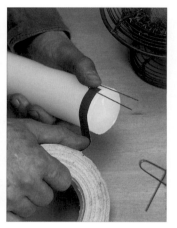

1 Cover the inside of the urn with a very thin layer of moss.

2 Cut a piece of foam and place it in the urn. Hold it in position with wires bent into U-shaped pins and threaded through the urn and pushed into the foam.

3 Tape several bent wires around the base of the candle to form pegs.

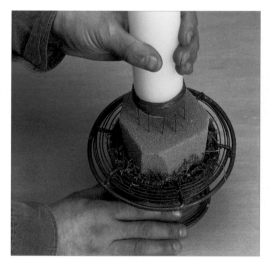

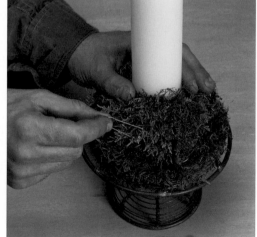

4 Insert the candle in the centre of the foam. Holding the base of the urn, press the candle down firmly until it fits securely and so that it is straight.

5 Cover the surface of the foam with a thin layer of moss, securing it in place with wires bent into U-shapes or mossing (floral) pins. Select a few choice stems of hydrangea and cut the stalks to leave at least 5 cm (2 in). Begin to insert the heads around the base of the candle so that they are nicely touching the moss.

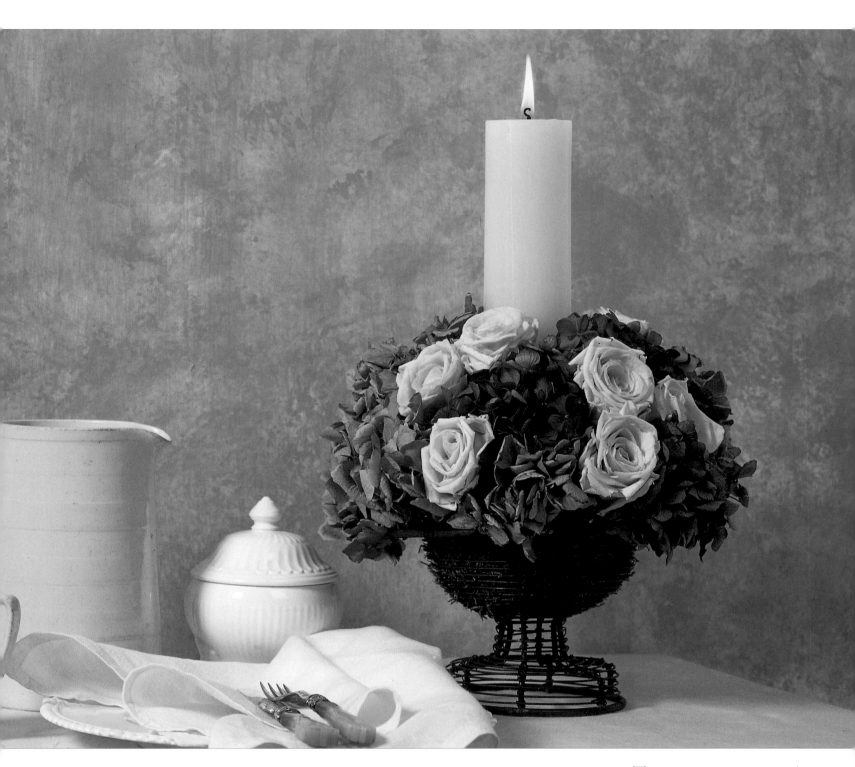

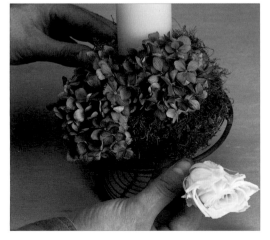

6 Take a short length of wire and make a hook by bending the top of the wire over. Thread the hook through the centre of a rose and pull down gently until the head of the hook is hidden within the petals and the stalk is protruding sufficiently out of the base. Place the roses between the hydrangea heads in small clusters by inserting the wire stalks firmly into the foam.

7 Move the arrangement round as you insert the materials until fully covered.

The centrepiece has a neat, formal, domed shape.

217

SEASIDE TABLE CENTREPIECE
· · ·

MATERIALS
· · ·
knife
· · ·
1 block plastic foam for dried flowers
· · ·
large terracotta candle pot
· · ·
various types of moss, including reindeer, tillandsia and green moss
· · ·
mossing (floral) pins
· · ·
scissors
· · ·
.91 wires
· · ·
dried Eryngium alpinum
· · ·
dried yellow roses
· · ·
raffia
· · ·
small terracotta candle pots
· · ·
starfish
· · ·
shells

You could elaborate on the design with whatever seaside materials you can find.

This impromptu collection of materials can be assembled very quickly for dinner on the beach or an informal buffet, then packed away for another time. The large candle pot gives height and structure to the display, with the rest of the materials cascading away from the centre.

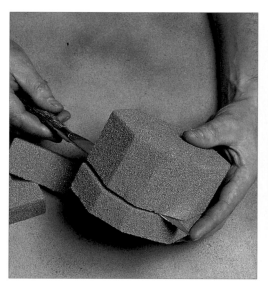

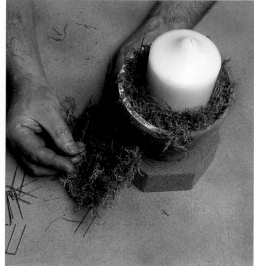

1 Trim the block of foam to produce a base large enough to stand the large candle pot on top.

2 Surround the base of the pot and sides of the foam with green moss, fixing it in place with mossing (floral) pins.

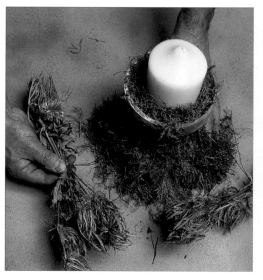

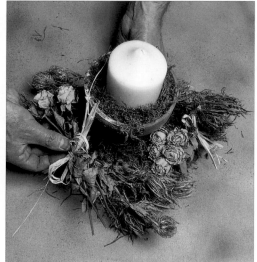

3 Trim and centre-wire bunches of eryngium (see Techniques). Push the wires through the moss into the foam base, placing one bunch on each side of the candle pot.

4 Repeat with the roses, tying them with raffia to cover the wire twisted around each bunch. Move the arrangement to its final position on the table. Place candle pots around the centrepiece and fill the spaces in between with a selection of different mosses. Decorate with starfish and shells.

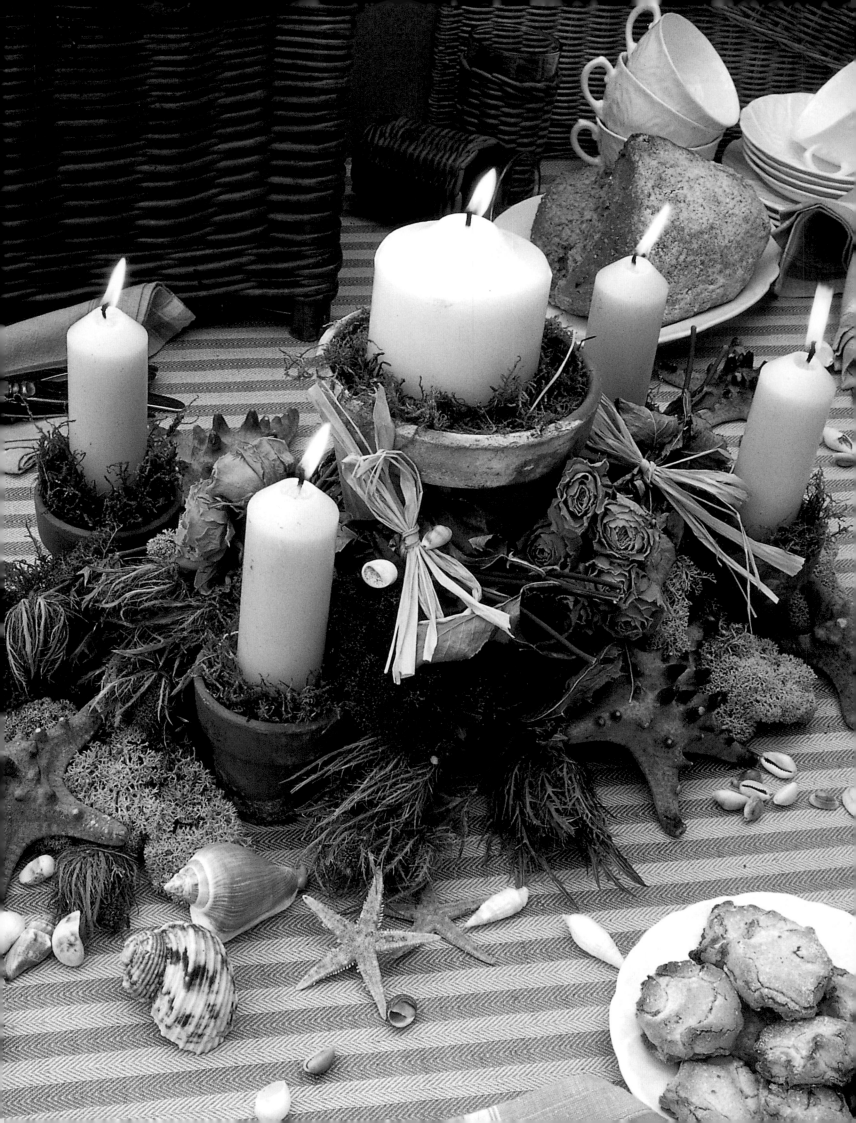

LEAF NAPKIN RINGS

· · ·

MATERIALS

· · ·

*large preserved (dried) leaves,
e.g. cobra leaves*

· · ·

glue gun and glue sticks

· · ·

dried red roses

· · ·

green moss

*You could use a variety of
other flowers here. Bright
yellow roses, for example,
would add a further variation
on the same theme.*

This simple idea uses just two leaves for each napkin, decorated with a few flowers. You can make all the napkin rings to match, or use a different flower for each place setting. Other large preserved (dried) leaves would also be suitable.

1 Roll a large leaf to form a neat tube, with a diameter large enough to allow for a rolled napkin. Using a glue gun, glue the edge down and hold it in place until the glue sets.

2 Choose another leaf that is about the same length as the rolled leaf. Glue the tube to the flat leaf along its centre spine.

3 Steam the roses if necessary (see Techniques). Either side of the rolled leaf, glue two or more rose heads, depending on their size. Trim the roses with a little green moss, carefully gluing it in place.

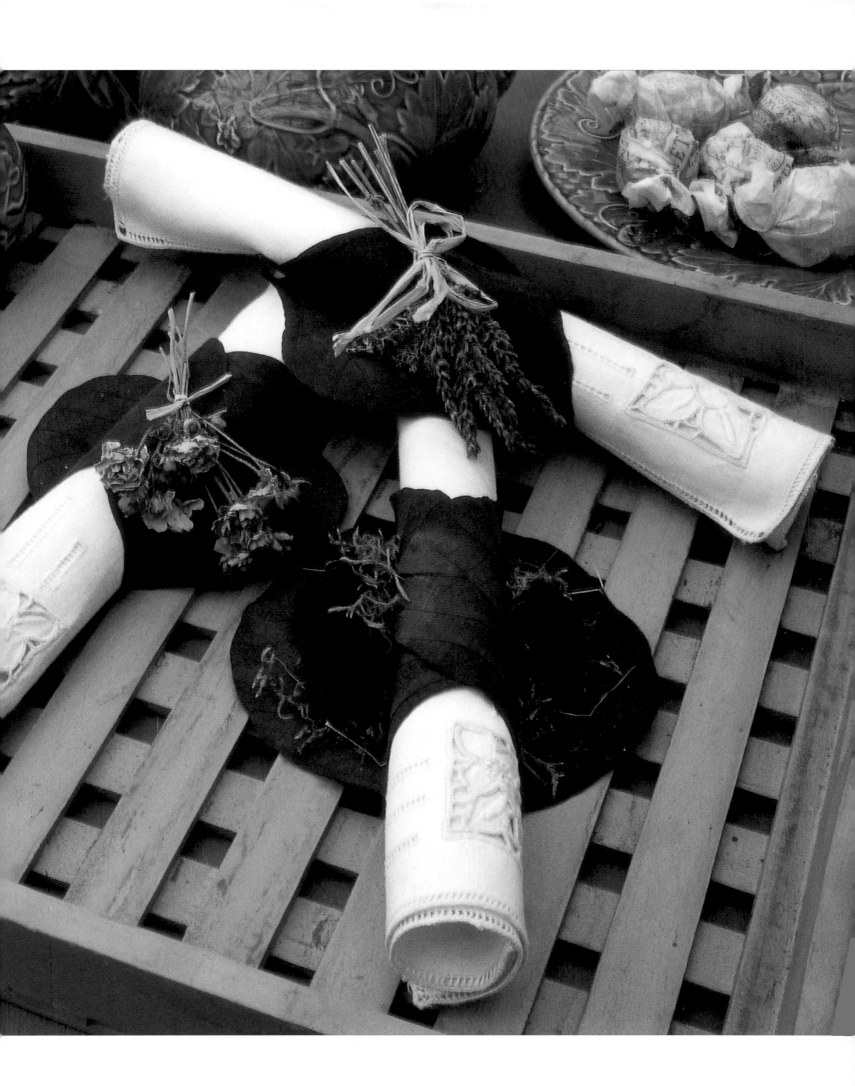

TABLE-EDGE SWAG

· · ·

MATERIALS

· · ·

knife

· · ·

rope

· · ·

secateurs

· · ·

fresh conifer

· · ·

silver reel (rose) wire

· · ·

dried pale pink roses

The pale pink roses make this an ideal arrangement for a wedding table display.

This swag is very simple to make, but looks very impressive hanging in a short loop along the edge of a table for a special occasion. The fresh conifer isn't longlasting, so if you have to make it a few days before the event it is best to store it by hanging it in a cool, dry, dark place.

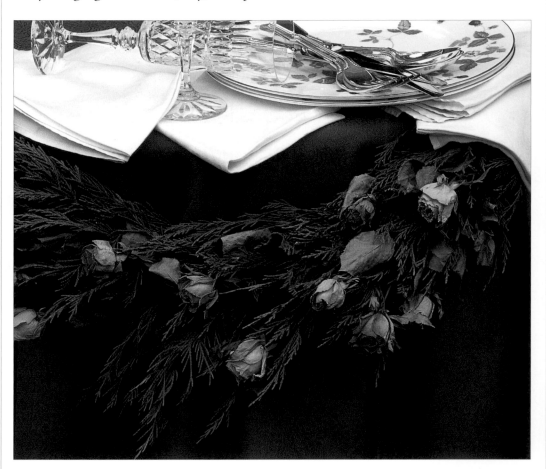

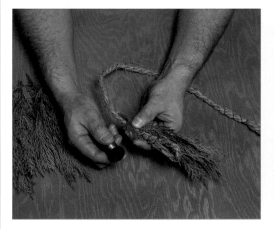

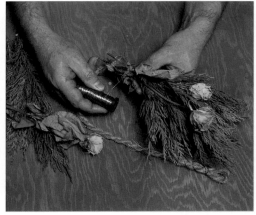

1 Cut the rope to the required length and make a loop at each end for hanging. Trim the conifer to short lengths and bind it to the rope, covering it all the way round, with silver reel (rose) wire.

2 Continue in the same way but adding the roses in twos and threes with a handful of conifer stems at regular intervals. Pack the conifer fairly tightly to produce a thick swag.

LEAF PLACE SETTING

· · ·

This table decoration is very simple and quick to make. You can use any large leaves, with leftover flowers from other displays for the leaf cones. Place the circle so that the flowers are facing across the table to the guest opposite.

MATERIALS

· · ·

dinner plate

· · ·

brown paper

· · ·

pencil

· · ·

scissors

· · ·

large preserved (dried) leaves,
e.g. cobra leaves

· · ·

glue gun and glue sticks

· · ·

wires

· · ·

dried miniature roses

· · ·

dried pink larkspur

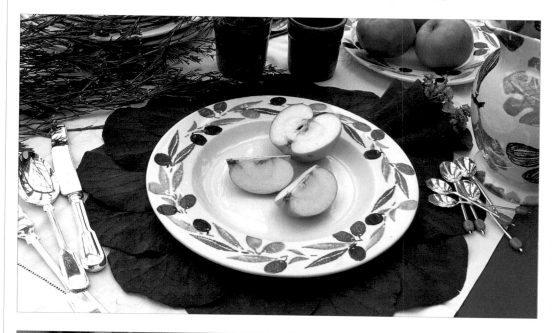

1 Place the dinner plate on paper, draw a circle and cut out. Place the first leaf on the paper, with its tip overlapping the edge. Glue its edge and lay a second leaf on the glue. Repeat around the circle.

2 Fold a leaf into a cone shape and glue the edge so that it keeps its shape. Repeat three times.

The flower-filled leaf cones decorate the side of each guest's plate.

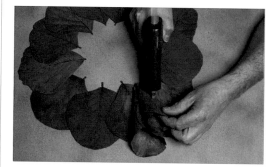

3 Glue two leaf cones on to the edge of the leaf circle. Glue the third on top.

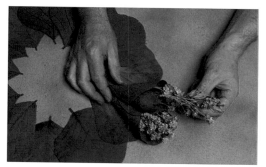

4 Wire three bunches of mixed roses and larkspur and push into each cone.

AUTUMNAL MIRROR BORDER

. . .

MATERIALS

. . .

wire cutters

. . .

chicken wire

. . .

sphagnum moss

. . .

wooden frame, with mirror

. . .

.91 wires

. . .

dried materials, e.g. yellow and red roses, solidago, peonies, lavender, wheat, Achillea ptarmica *and poppies*

. . .

dried fungi

. . .

cinnamon sticks

. . .

pomegranates

. . .

small terracotta pots

. . .

glue gun and glue sticks

. . .

green moss

. . .

mossing (floral) pins

The rich textures of all the different materials create a very opulent effect.

Because of its size, this is a fairly adventurous project, but the techniques are the same as for making a swag, so it is still a reasonably straightforward display to put together. It is important to try to make the fixings as strong as possible so that they will support the weight of the heavy mirror; if the moss is still damp, store the frame in a warm, dry place before putting it up on the wall.

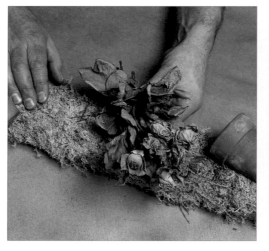

1 Make chicken wire swags to fit round the mirror frame (see Techniques). Group and centre-wire all the dried materials into separate bunches, trimming the flower stems to about 15 cm (6 in) (see Techniques). Push a wire through each pot and over its rim then push the ends into the moss frame and twist them together. Attach the materials to the frame one at a time, spacing them evenly.

3 Continue until nearly all the frame has been covered. Completely remove the stems of some of the flowers and glue them directly on to the framework or over the wires of centre-wired materials. Make sure the glue is in contact with the wire as well as the moss. Work with one material at a time, ensuring that each is evenly distributed throughout the frame.

2 Push the ends of the wires through the frame and twist them together.

4 Trim the frame with moss, using mossing (floral) pins to hold it in place. Pay particular attention to the edges that hang nearest to the wall, which are often forgotten when the frame is flat on the work surface.

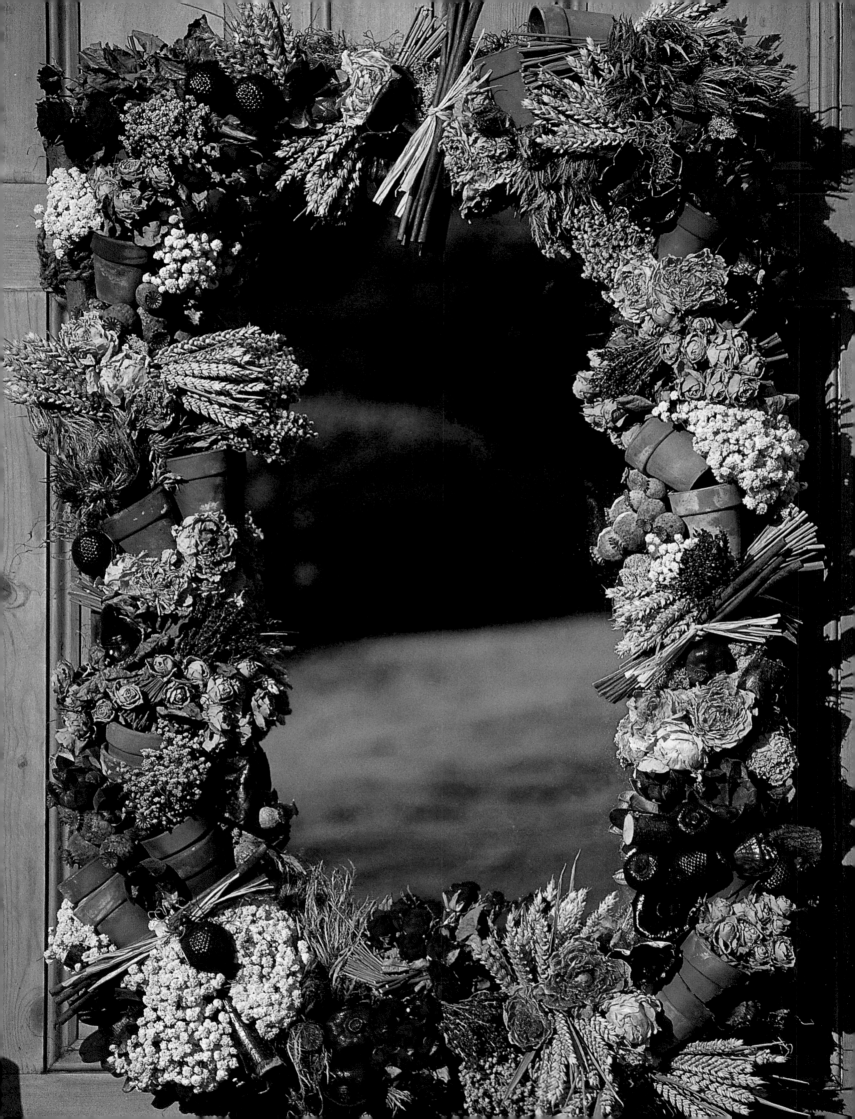

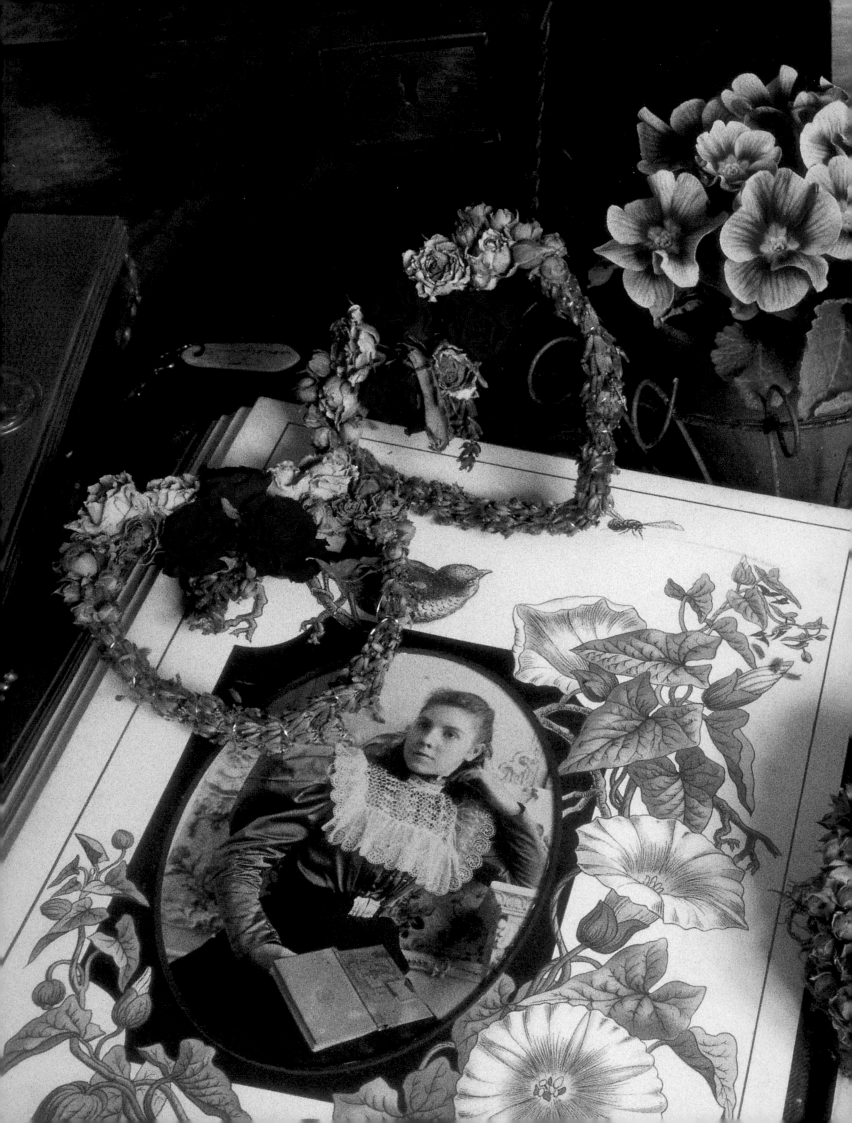

GIFTS MADE TO LAST

. . .

All these small gifts are quick and easy to make, but because they are made of dried materials the pleasure they give is long-lasting. For a romantic Valentine's gift or a "token of affection" at any time of the year, follow one of the lovely heart-shaped designs. Alternatively, you can easily adapt one of the ideas, so that you can be sure of giving a gift that is unique and personal.

INTRODUCTION

· · ·

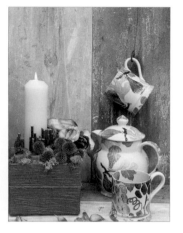

Above: Decorated Display Box

Below: Fabric-covered Lavender Candle Pot

Many dried flower designs, such as candle pots and garlands, would make lovely and very acceptable gifts, and there is certainly a wide choice to select from. The ideas shown here are slightly different in that they are all very quick and simple to make, often requiring no wiring or technical skills and very few dried materials. Most can be made very inexpensively from individual flowers and materials left over from larger projects. However, like many other handmade presents, they have great charm and individual character and you can adapt them as you wish to suit the recipient.

Many of the designs featured here are based on a traditional heart shape. This might be a romantic gift for Valentine's Day, such as the lid of a box sumptuously decorated with red ribbon and flowers. Other heart-shaped gifts are more universal, for example small hearts simply shaped out of garden wire have enormous charm. Cover them with sweet-smelling lavender, bupleurum or roses to make a lovely "token of affection" for friends and relatives of all ages.

Collect decorative gift boxes in which to present your dried flower displays. When you have nothing suitable for a container, you can disguise unattractive cardboard boxes by painting them with a distressed paint effect or wrapping them in remnants of fabric. If you know the room where your gift is likely to be placed,

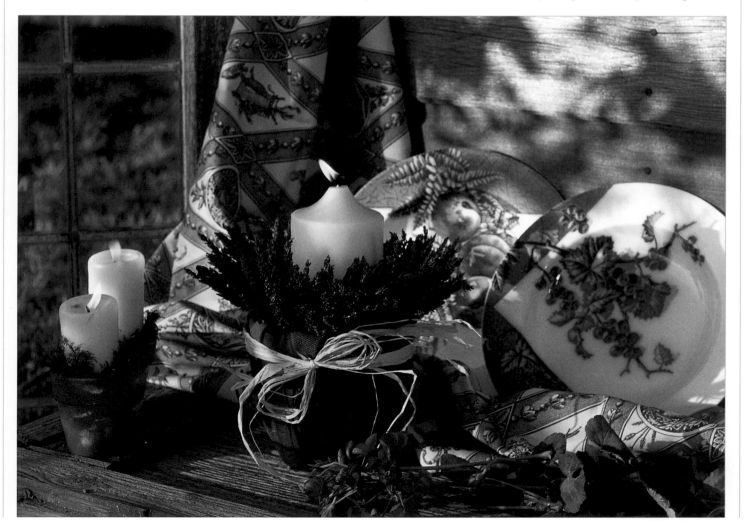

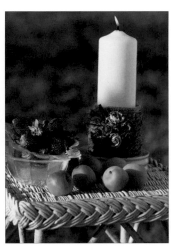

Above: Candle Cuff

Left: Scented Valentine Box

try to choose a co-ordinating paint or fabric to make your gift even more special. Candles can also be chosen to suit a particular setting and there is a wide choice of colours available in specialist candle shops.

A still life display of dried materials, shells and other decorative objects can also be tailor-made to suit an individual person or location. Include in it materials

Below: Lavender Linen Heart

which have special meaning to the recipient, such as favourite flowers, or those which complement their furnishings. Another very personal design is a clipframe containing a photograph; decorate this with flowers and leaves which suit the personality of the person you are giving it to.

All these attractive gifts are so easy to make that you need never again be stuck for an idea, even at the last minute. The chances are you will already have all the materials you need ready to hand, to create personal gifts that will suit all occasions and all styles and tastes, and which are certain to be highly appreciated.

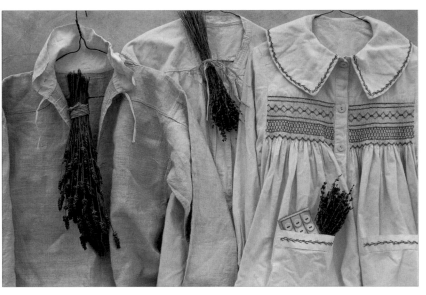

DECORATED CLIPFRAME
. . .

*clipframe, 25 x 20 cm
(10 x 8 in) or larger*

. . .

scissors

. . .

large preserved (dried) leaves

. . .

epoxy resin glue

. . .

glue gun and glue sticks

. . .

preserved (dried) ferns

. . .

dried pale pink roses

. . .

dried pale pink peonies

. . .

.91 wire

. . .

dried lavender

. . .

raffia

*The soft colours of the flowers
will complement old
sepia photographs.*

Transform a simple clipframe into a special gift with preserved (dried) leaves, ferns and a few carefully chosen flowers. If you are including a photograph, place it in the frame first so that you can position the materials around it. Scraps of lace can also be incorporated into the design. You can of course buy any sized frame, according to the size of your photograph, and adapt the design accordingly.

1 Clean the glass of the frame, removing any grease and fingermarks. Cut the leaves horizontally in half. Apply epoxy resin glue to the back of each leaf in turn then lay the straight cut edge along the edge of the frame. Continue placing leaves all around the frame.

2 Using a glue gun, attach ferns on top of the leaves in two opposite corners. Use more ferns in one corner so that the design is not symmetrical.

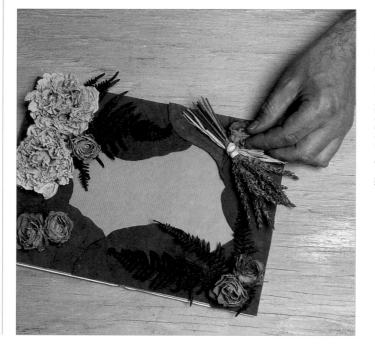

3 Steam the roses and peonies, if necessary (see Techniques). Centre-wire a bunch of lavender (see Techniques). Tie a raffia bow around the lavender, to hide the wire. Position the flowers to create a pleasing design, gluing them in place.

VALENTINE POT-POURRI

. . .

MATERIALS

. . .

box

. . .

dried rose leaves

. . .

dried lavender

. . .

scissors

. . .

reindeer moss

. . .

dried rosebuds

. . .

other dried flowers, e.g. pink larkspur

. . .

rose or lavender essential oil

Sweet-smelling roses and lavender are very popular pot-pourri ingredients.

This is a wonderful way of making use of spare flowers and flower pieces from other displays. Here, an oval cardboard box has been covered with broad red ribbon and a piece of the same ribbon has been cut in half and folded to create the decoration on top. Essential oil will discolour dried materials over a period of time, so only let the drops fall on the moss.

1 Line the bottom of the box with rose leaves and a few lavender stems. Trim the stems of the lavender fairly short, using mostly the flowerheads.

2 Place some reindeer moss in the box, around the lavender flowerheads.

3 Trim the stems from the heads of the remaining flowers and arrange the flowerheads in the box.

4 Gently drizzle a few drops of essential oil over the reindeer moss, but not on the flowers.

SEASHELL SOAP DISH

· · ·

MATERIALS

· · ·

glue gun and glue sticks

· · ·

large shell

· · ·

rope

· · ·

knife

· · ·

selection of small shells

· · ·

reindeer moss

If you do not live close to the seaside, you can buy seashells from specialist shops.

A large, attractive shell makes a perfect soap dish, especially if it already has some natural drainage holes. If not, shells are quite easy to drill, either with an electric drill or by hand. Place a handful of small rounded shells in the bottom of the dish so that the soap does not sit in water.

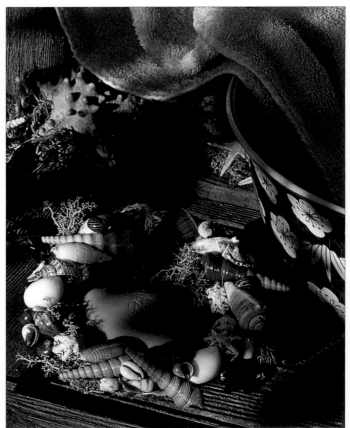

1 Put some glue into the middle of the base of the large shell. Make a coil of rope and press it firmly into the glue, before it begins to set hard. Continue coiling the rope around, adding glue to the shell as you work. Cover about a third of the shell, to provide a soft, stable base. Cut the rope-end at a sharp angle and glue to the edge of the coil.

2 Turn the large shell over and glue another piece of rope in place all round the outer edge. If the shell is wide enough, repeat to provide a lip on which to fix small shells.

3 Put some glue on the rope and press the first of the small shells firmly in place. Continue this process, working around the dish. Add the largest shells first then return to the spaces and fill them with smaller shells. Glue the shells not just on the rope, but to each other. Fill any gaps with tiny pieces of moss.

DECORATED DISPLAY BOX

· · ·

Disguise an ordinary cardboard box with a distressed paint finish then fill it with a collection of dried materials and shells to make a very attractive ornament. Vary the contents of the box to suit the recipient.

MATERIALS
· · ·
decorator's paintbrush
· · ·
dark green paint
· · ·
cardboard box
· · ·
medium-grade sandpaper
· · ·
knife
· · ·
1 block plastic foam for dried flowers
· · ·
secateurs
· · ·
willow sticks
· · ·
string
· · ·
glue gun and glue sticks
· · ·
dried materials, e.g. echinops, seed pods, garlic cloves, dried fungi
· · ·
shells
· · ·
reindeer moss
· · ·
candle (optional)

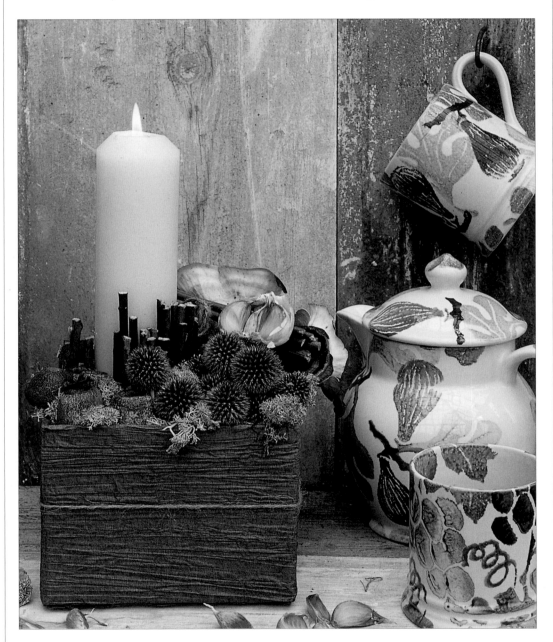

The blue, spiky texture of the echinops contrasts nicely against the smooth brown willow sticks.

1 Paint the cardboard box dark green (or the colour of your choice) and leave to dry. Rub the sandpaper horizontally across the sides of the box, revealing some of the box colour beneath to give a weathered effect.

2 Trim the foam block to fit into the box, slightly lower than the top edge. Cut the willow sticks to length and tie together in two bundles with string. Glue all the materials on to the foam, building up an attractive arrangement. Leave space for a candle if desired. Fill any gaps with reindeer moss, again gluing it in place. Tie string around the centre of the box.

FABRIC-COVERED LAVENDER CANDLE POT

· · ·

MATERIALS
· · ·
terracotta pot
· · ·
fabric
· · ·
dressmaker's scissors
· · ·
knife
· · ·
1 block plastic foam for dried
flowers
· · ·
candle
· · ·
florist's tape (stem-wrap tape)
· · ·
mossing (floral) pins
· · ·
.91 wires
· · ·
lavender
· · ·
moss
· · ·
raffia

The colour and scent of lavender makes it a perfect choice for gift arrangements.

Lavender makes an ideal gift; with its attractive flowers, rich colour and a long-lasting perfume, it is always welcome. Trim the pot with raffia to give a rustic feel or, for a smarter look, use a bow made of the same fabric. It is best to choose a large candle so that it will last a long time. If you are presenting it to someone, remind them that they should not leave burning candles unattended.

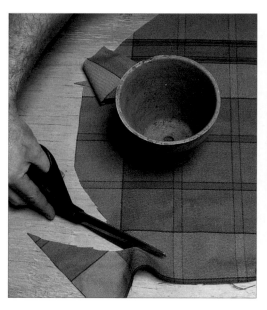

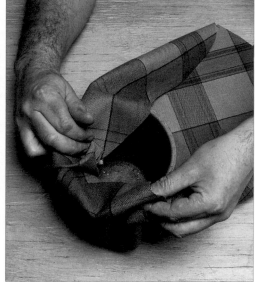

1 Place the pot in the middle of the fabric and cut a circle large enough to wrap up the sides, with 8 cm (3 in) extra all round.

2 Wrap the fabric up over the sides of the pot and tuck it neatly in. Space the creases in the fabric evenly to create a nice folded look.

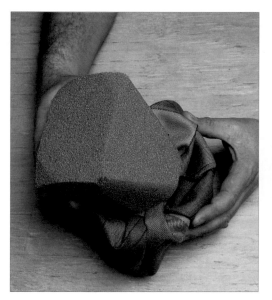

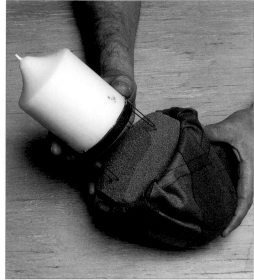

3 Trim the foam to fit the pot tightly. Push the foam firmly into the pot right to the bottom, so that it holds the fabric in place.

4 Prepare a candle with florist's tape (stem-wrap tape) and mossing (floral) pins (see Techniques). Push it into the centre of the foam.

A pretty pot filled with lavender makes a lovely, special present.

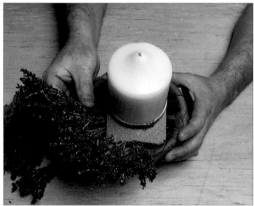

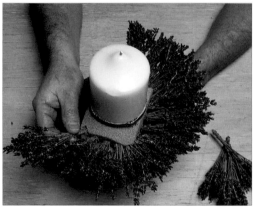

5 Wire the lavender into small bunches (see Techniques). Working round the pot, push the bunches into the foam so that they lean well out, keeping them evenly spaced.

6 Continue until you have made a full circle. Fill the space around the candle with moss, fixing it with mossing (floral) pins. Keep the moss clear of the candle. Tie a raffia bow around the pot.

247

LAVENDER LINEN HEART
. . .

MATERIALS
. . .

1 m (1 yd) garden wire

. . .

blue-dyed raffia

. . .

scissors

. . .

dried lavender

. . .

glue gun and glue sticks

The strong scent of lavender will deter moths, as well as perfuming linen cupboards and wardrobes beautifully.

A lavender-covered wire heart is a charming "token of affection" and a welcome change to the perennially popular lavender bag. Raffia, dyed in a variety of colours, is available from a good florist's.

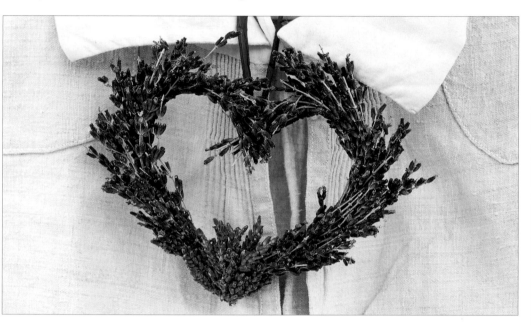

1 Fold the wire in half then in half again. Make a hook at one end and hook into the loop at the other end. Bend a dip in the top to form a heart shape.

2 Bind the heart with the blue-dyed raffia. Start at the bottom, working round the heart. When the heart is fully covered, tie the ends together.

3 Starting at the dip at the top, bind three stalks of lavender to the heart, with the heads pointing inwards and downwards. Continue to bind the lavender in bunches of three, working down the heart. When you reach the bottom, repeat for the other side.

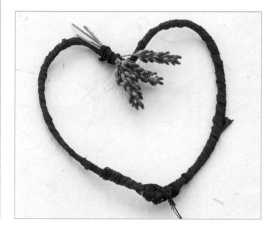

4 For the bottom, make a larger bunch of lavender and glue in position with the flowerheads pointing upwards. Trim the stalks close to the heads.

SCENTED VALENTINE BOX
. . .

Decorate the lid of a heart-shaped gift box with a bunch of roses and solidago flowers, to make a lovely container for a Valentine's present. It is nice to use red roses, complemented by a red ribbon, for a traditional look.

MATERIALS
. . .
dried roses
. . .
dried bay leaves
. . .
dried solidago
. . .
heart-shaped cardboard gift box
. . .
glue gun and glue sticks
. . .
wide ribbon

Aromatic bay leaves give the box a delicious perfume.

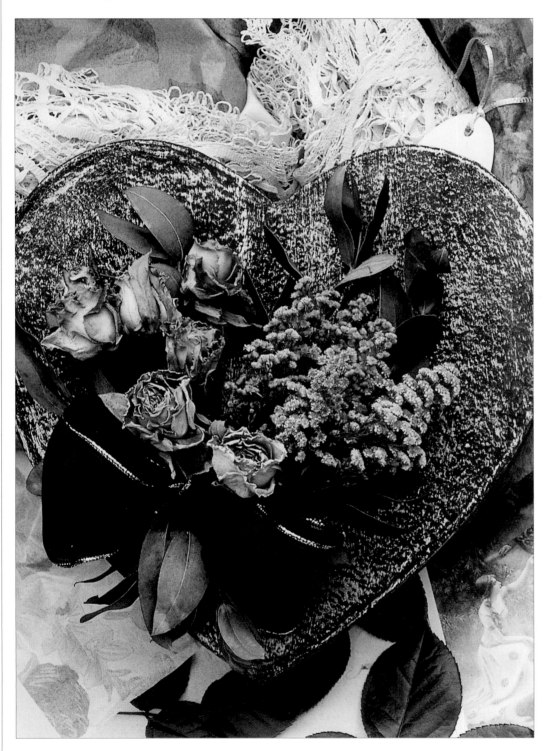

1 Arrange the dried materials on the lid of the box in the shape of a bunch of flowers. Glue them in place.

2 Make a large decorative bow with the ribbon (see Techniques). Glue on top of the bunch of flowers.

CANDLE CUFF

· · ·

MATERIALS

· · ·

candle

· · ·

plain white paper

· · ·

scissors

· · ·

thick brown paper

· · ·

clear tape (cellophane)

· · ·

hessian (burlap)

· · ·

glue gun and glue sticks

· · ·

rope

· · ·

.91 wire

· · ·

twigs

· · ·

green moss

· · ·

dried miniature roses

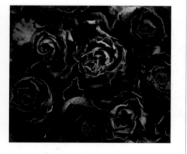

The combination of dark and pale pink roses is exquisite.

Choose a wide candle so that the cuff is large enough to apply the dried flower materials. The candle must be at least twice the height of the cuff, so that it has plenty of room to burn without any danger of setting the hessian (burlap) alight. Wrap the candle well at the start of the project to ensure that it is kept clean and that the hot glue does not melt the wax.

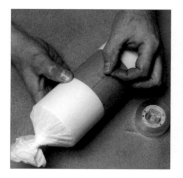

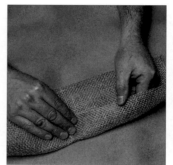

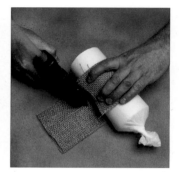

1 Wrap the candle in plain paper. Cut a piece of brown paper approximately 8 cm (3 in) wide and long enough to wrap around the candle. Tape the loose end down; the paper collar must be able to move freely up and down the candle.

2 Cut a piece of hessian (burlap) twice as wide as the brown paper and long enough to wrap round the candle. Fold the two outer quarters up to meet in the middle and glue them down.

3 Lay the candle on the wrong side of the hessian (burlap) and apply a little glue to either side of the candle. Wrap the hessian (burlap) tightly around the candle, smoothing it to fit the paper neatly, and applying glue where necessary.

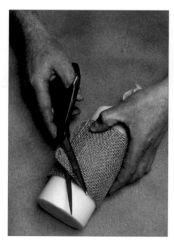

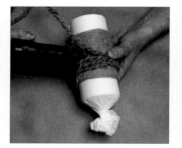

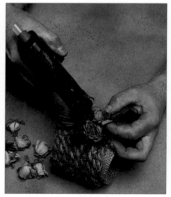

4 Trim the corners of the exposed edge of hessian (burlap) and glue them down sparingly.

5 Wrap the rope around the hessian (burlap) cuff once and hold it in place. Apply glue all the way around the rope, so that the glue comes into contact with both the rope and the hessian (burlap). Wrap the rope around the candle again, as close as possible to the first wrap. Repeat until the whole cuff is covered.

6 Centre-wire a small bundle of twigs (see Techniques). Glue the bundle and some green moss to the cuff at an angle, using the moss to cover the wire. Cut the heads from the roses and glue them in place around the bundle of twigs.

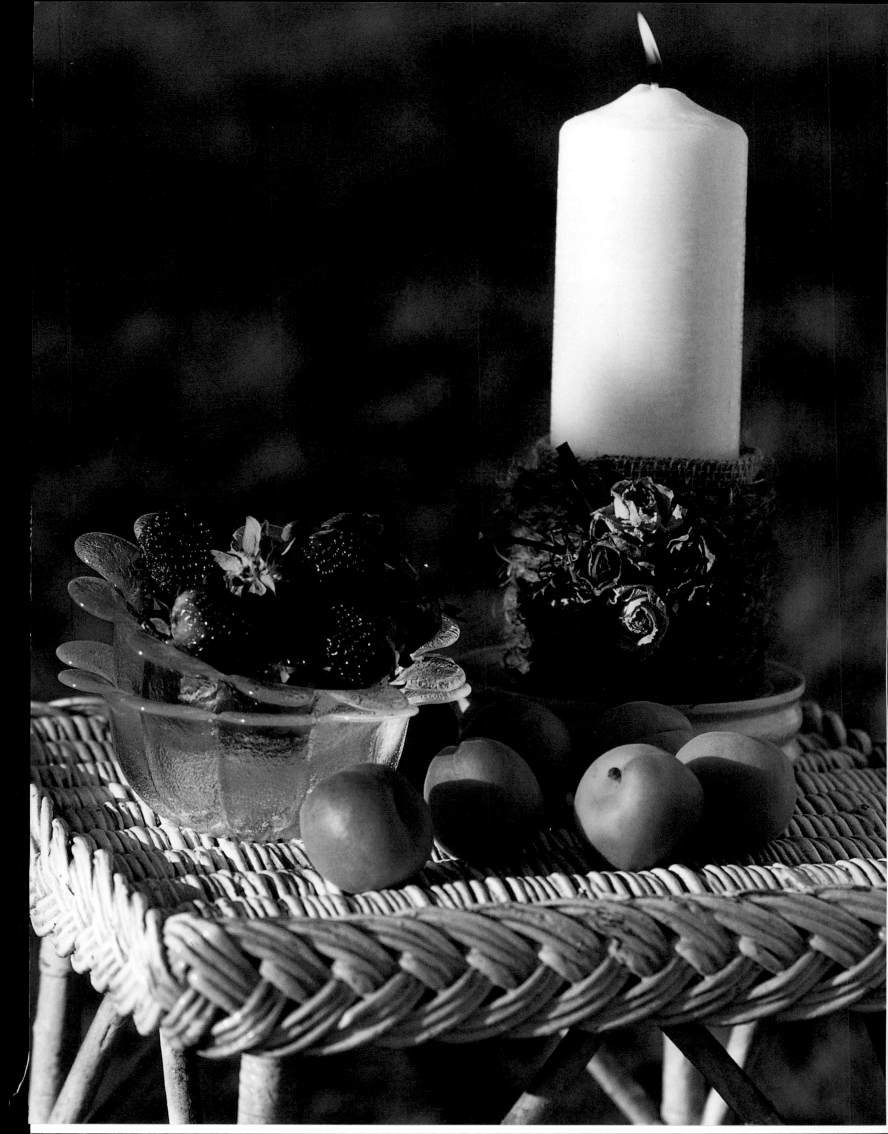

INDEX

· · ·

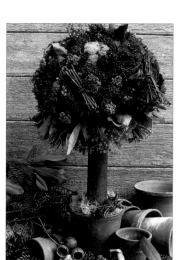

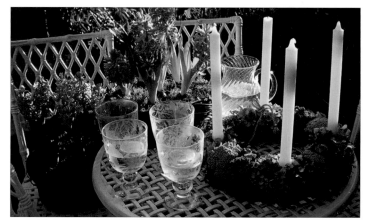

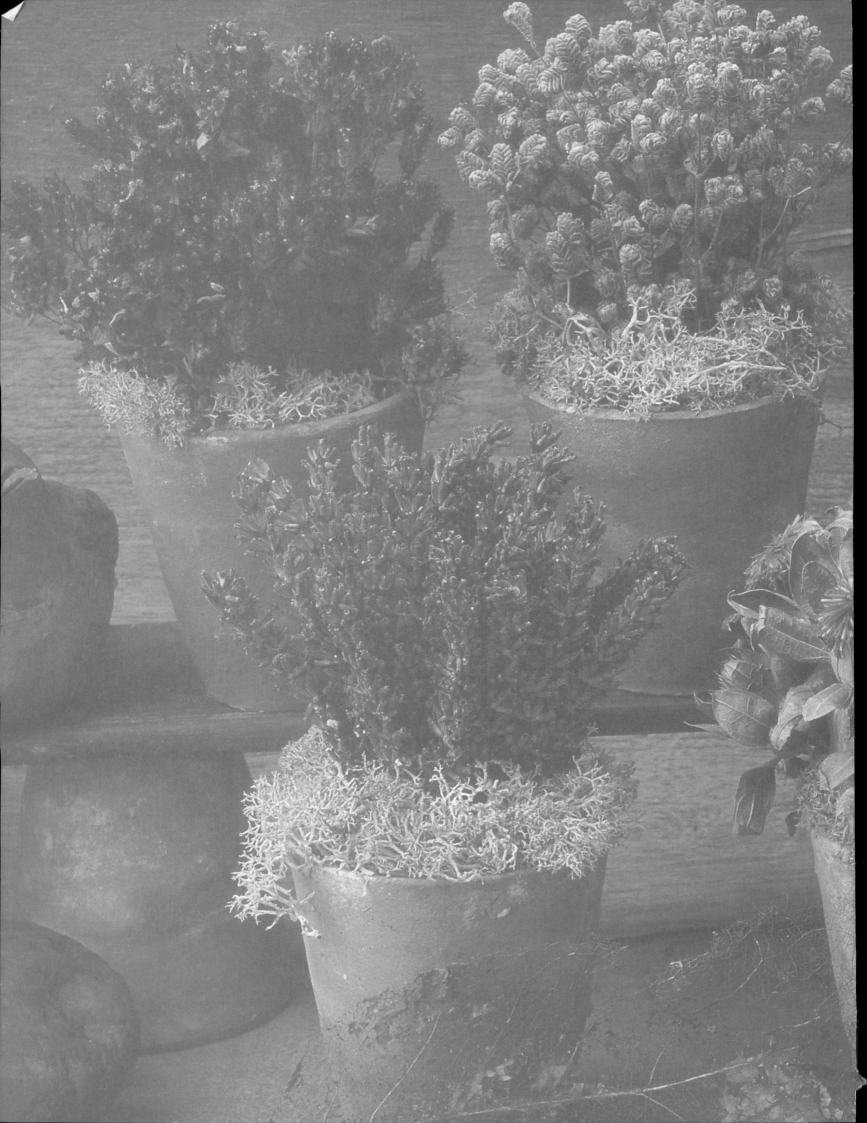